AMERICAN
FOLK PAINTERS

By John and Katherine Ebert

AMERICAN FOLK PAINTERS
OLD AMERICAN PRINTS FOR COLLECTORS

AMERICAN FOLK PAINTERS

JOHN & KATHERINE EBERT

Charles Scribner's Sons New York

Library of Congress Cataloging in Publication Data

Ebert, Katherine, and John
 American folk painters.

 Bibliography: p.
 Includes index.
 1. Primitivism in art—United States—History.
2. Painting, American—History. I. Title.
ISBN 0-684-14339-9
ISBN 0-684-14529-4 (pbk.)

1 3 5 7 9 11 13 15 17 19 C/MD 20 18 16 14 12 10 8 6 4 2
1 3 5 7 9 11 13 15 17 19 P/M 20 18 16 14 12 10 8 6 4 2

Printed in the United States of America

ACKNOWLEDGMENTS

The assistance of others is essential in writing a book like *American Folk Painters*. Employees of several museums helped by showing us material and providing photographs of items in their collections. Institutional credits are included under the illustrations as contractually required and as fairness dictates. On a more personal level, however, we are especially indebted to W. H. Harrison, director of Fruitlands Museums, for permitting us to photograph items in the collection and for the use of existing photographs. We also wish to thank J. Curtis and H. J. Harlow, both of Old Sturbridge Village, for showing us items in the collection; Pauline M. Reynolds of the Museum of Fine Arts, Springfield, Massachusetts, for obtaining photographs; Mrs. Fred R. Herrick of the Springfield Art and Historical Society, Springfield, Vermont, for obtaining photographs; and Mary B. Gifford and Florence C. Brigham, curator and assistant curator respectively of the Fall River Historical Society, for help in locating material in their files on William M. Prior.

We are also indebted to Stuart P. Feld and Jane L. Richards of Hirschl and Adler Galleries, New York, for providing photographs of items in their stock and for obtaining permission to use photographs of items that had been sold from their new owners. Russell and Don Kiernan of Marine Arts, Salem, Massachusetts, were most generous and cooperative in supplying photographs of marine paintings. Mr. George Considine, also, was most patient and helpful in a number of ways.

We were inspired by the special exhibit of items from the collection of Herbert W. Hemphill, Jr., held during the summer of 1974 at the Heritage Plantation of Sandwich on Cape Cod. Mr. Hemphill graciously permitted us to use photographs of items from his collection, and H. R. Bradley Smith of Heritage Plantation supplied the photographs.

The very fine folk paintings in the collection of Howard A. Feldman are well represented here through the generosity and help of Mr. Feldman.

Contents

AMERICAN FOLK PAINTERS

INTRODUCTION

American Folk Painters is a survey of nonacademic paintings and painters in what is now the United States starting about 1700 and ending about 1900, with special concentration on the period from just after the Revolution to the end of the nineteenth century. A wide range of painting types is covered, from the colonial portraits by the Freake Limner to the ship portraits of ocean liners by Antonio Jacobsen. Nineteenth-century portraits by both known and unknown artists are an important class of folk painting and have received commensurate attention. Frakturs, amateur works (including theorems), calligraphy, and ship portraits are other recognized forms of folk art and are discussed and illustrated.

As the title of this book implies, considerable focus is placed on the artists themselves, not just on their paintings. Throughout, an attempt is made to distinguish the professional from the amateur, and many of the social forces that influenced both groups are discussed.

Some masterpieces are shown among the many paintings illustrated, but most were deliberately selected to be good to excellent representations of the artists' work. Frequently, the masterpiece of a folk painter is not characteristic of his usual output. The illustrations cover the full spectrum of painting styles, including those that may be considered flat, three-dimensionally modeled, with enormous distortion, without much distortion, quaint, sophisticated, with a commercial art attitude, and with fine art quality. This was in fact the range of the American folk artist.

CHAPTER ONE Definition, Characteristics, and Background

As we enter the third century of our existence as an independent nation, numerous signs exist to indicate that we are at last acquiring a measure of pride and self-confidence in our cultural achievements and overcoming the feelings of inferiority that have so long hampered us. Until recently the sophisticated attitude toward American art was one of disdain. Legend has it that the magnificent portraits of John Freake and of Mrs. Freake and Baby Mary were snatched from a street in Worcester as they were awaiting the garbage collector. Whether strictly accurate or not, the story is a true reflection of the attitude with which most American art was regarded. Many of our great museums and educational institutions have been more concerned with their Oriental wings or courses in French impressionism than with their native heritage.

No group of American paintings fell into greater oblivion than our folk paintings. Rescued from this state by a small number of farsighted collectors and scholars, a new appreciation for these works has developed. By patient accretion and analysis, information about the range of works and the artists has been slowly assembled, and some of the artists have been identified. Past its infancy, this study and evaluation is now in its early childhood with a long prospect for growth ahead.

Definition Folk painting is an umbrella term under which is crowded a motley group of nonacademic paintings. The academic painters are those associated with and painting in the style sanctioned by the leading established art groups and institutions in the major metropolitan centers. Even this differentiation is fluid since paintings have been executed in styles that range over a continuous spectrum from academic to nonacademic with no clear line of demarcation. The issue is further confused by the fact that many of our fine academic painters were completely or partially self-taught and in their early years painted in a decidedly nonacademic manner. All this is compounded by an artist like William Prior who worked in both styles, adjusting the style to the fee.

Certain professional artists, those deriving either all or part of their livelihood from painting, hold claim to a shelter under this folk art umbrella. Itinerant portraitists painted their way through rural areas with apparently little contact or competition with the Boston, Philadelphia, or New York City portrait painters. Their styles were as different as their clientele. But nonprofessionals must be included as well, and in rather large numbers. At the end of the eighteenth century and in the early decades of the nineteenth, drawing and painting were essential accomplishments of the well-bred person. In the United States these genteel pursuits were more often relegated to young ladies who were instructed in academies and female seminaries to paint on silk, glass, velvet, and paper. From these amateur dilettante beginnings, some women developed into serious artists who pursued painting as an avocation for much of their lives.

Yet another group of amateur artists is composed of naive artists, those innocent of formal instruction. They improvised their own schemes from life for rendering forms and space. Some of these artists later became professionals, either keeping their naive style or developing along more sophisticated avenues.

Most folk artists worked in the rural areas, so folk art is connected with provincialism. Yet the finest female seminaries were located near cities such as Boston where some of the best ladies' work was done, and specialists like the steamboat portrait painters James and John Bard worked in New York City as professionals.

There is no unanimity of opinion as to what constitutes a folk painting since it means different things to different people. It has even been difficult to find a word in the English language about which there is a consensus, although gravitation seems to be toward "folk" at present. In the past it was a word that more comfortably described the art of European peasantry and their traditional decorating schemes. "Primitive painting" conjures up visions of aborigines, tribal rites, and caveman

paintings. With increased interest in primitive cultures, the term has lost favor although it is still useful for describing styles and types of American paintings.

Characteristics

The attitude of the folk artist toward the visible world is frequently described as "conceptual" rather than "perceptual." A perceptual attitude toward art is one that results in representing what is actually perceived or seen while a conceptual attitude is the representation of the mental view of what the artist knows to be there, even if it is not actually seen that way. Thus the folk artist will paint from a single viewpoint aspects of a subject he knows to be there, even if they cannot be seen from that viewpoint. He may include the side of a house while portraying it from the front, or details of a view which cannot be seen at the distance from which the scene is viewed. Symbolic alterations are imposed on reality by such means as making adults proportionately much larger than their children in group portraits to emphasize their relative importance as parents. This approach is a natural and intuitive one for children. When asked to draw their parents in their early school years, they often represent the mother as tall as the father even when he is physically much taller. Not uncommonly, in drawing their fully clothed parents, they punctuate the portraits by drawing in each person's navel. This amusing note is added spontaneously and seriously by the

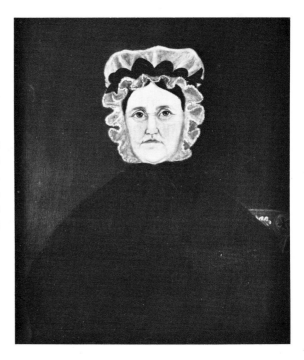

Woman. A "plain" portrait of an unknown woman, ca. 1833, painted in a stiff, elementary, full-face pose. Attributed to S. A. and R. W. Shute. Oil on canvas, approximately 28″ x 24″. (*Heritage Plantation of Sandwich*)

child, who seems to consider it an important feature. As children mature, they abandon this approach to come closer to the actual physical view. Folk paintings are a mixture of perceptual and conceptual, the degree of primitiveness corresponding to the degree of conceptualism.

"Direct vision" is another phrase sometimes used to characterize folk paintings. Sophisticated poses or angles and grandiose gestures or props were seldom used. A group portrait was often painted in the most obvious way, with the family lined up in a row. A portrait of a person with warts on his face details such imperfections. Frequently portraits were painted in elementary full face or in stark profile. Ship portraits were full profile to show major details to best advantage. Sitters were usually posed in their best ensembles in their own or similar surroundings. The repeated use of specific accessories and furnishings indicates that the artist added these background details in some cases rather than portraying the actual possessions of the sitter.

It is inconceivable that a folk artist could blunder in his assessment of the taste of the American people as did Horatio Greenough in his colossal statue of Washington commissioned for the Capitol rotunda by the Congress. The sculptor aimed to present Washington as a classic hero by posing and draping him as the great god Zeus. When the seminude *Washington* was revealed to the public, it was described as "undraped, with a huge napkin lying on his lap and covering his lower extremities . . . preparing to perform his ablutions."

Folk artists often include extraneous detail thereby failing to create a focus and major center of interest. In a landscape, people may be scattered throughout the picture without any special area of concentration. Details of clothing, such as the meticulously rendered lace collar in the illustration opposite, claim the attention of the observer to the disadvantage of the sitter's face. The use of heavy shadows to subdue the less important elements and highlights on the central subject are rarely employed.

Touches of surprise and humor are introduced by unexpected discoveries. An almost hidden pet cat or dog may be tucked under a table or among the folds of a skirt of a charming child's portrait. A portrait of a doctor may show him with the patient's hand looking like a disembodied appendage projecting from what at first glance appears to be decorative drapery. Sometimes the outrageous distortion in rendering figures and perspective is comical, though unintentionally so.

Artistic innocence and spontaneity when applied to folk art indicate an intuitive response to inspiration engendered by the artist's immediate experience or surroundings or from a fertile imagination. Undoubtedly, such works were executed, but far more pervasive sources of inspiration were the widely available, professionally made prints which appeared

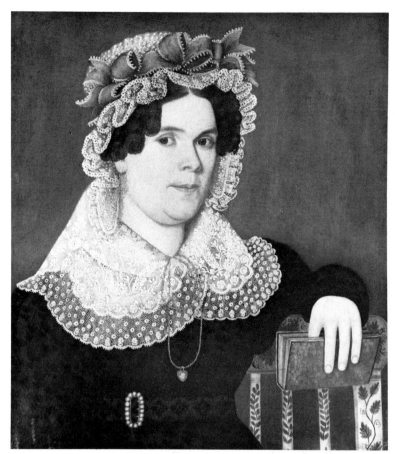

Sara A. Going of Leominster, Massachusetts. A portrait by an unknown artist with meticulous rendition of the lace collar. Oil on wood panel, 25″ x 22¼″. (*Fruitlands Museums*)

as free prints or were bound in many types of publications. Prints were copied from colonial times on when British mezzotints served as the principal source for American portraits. Sometimes the prints were copied by other printmakers and republished several times before filtering down to the folk artist. The views by W. H. Bartlett engraved for *American Scenery* and *Canadian Scenery* were selectively copied by Currier and Ives and republished as hand-colored lithographs. These were popular folk art subjects and copied faithful to detail. Edward Hicks nearly always relied upon a printed source for his paintings, among which are prints of *Washington Crossing the Delaware* by Thomas Sully and *The Peaceable Kingdom of the Branch* by Richard Westall. The sources of Erastus Salisbury Field's biblical paintings have in some cases been identified as prints. The claim of originality and spontaneity cannot be made with assurance until it is possible to eliminate a print as a source. Since some of these prints are now obscure, identification depends largely upon chance.

Printed sources had another effect upon artists: they served as models for a way of painting. The linear qualities of a print, the hard

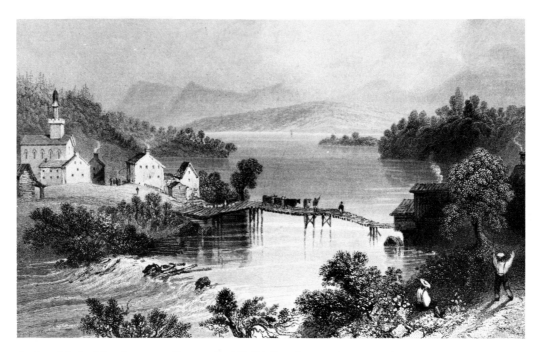

Outlet of Lake Memphremagog. Drawn by W. H. Bartlett and engraved by H. Adlard. A plate from *Canadian Scenery* by N. P. Willis published in 1842 in London by George Virtue. Steel engraving, $4\frac{3}{4}''$ x $7\frac{1}{8}''$.

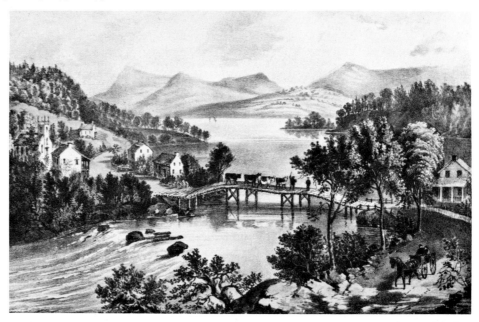

The Bridge at the Outlet/Lake Memphremagog (*Vt.*). Hand-colored lithograph published by Currier and Ives, $8''$ x $12\frac{1}{2}''$.

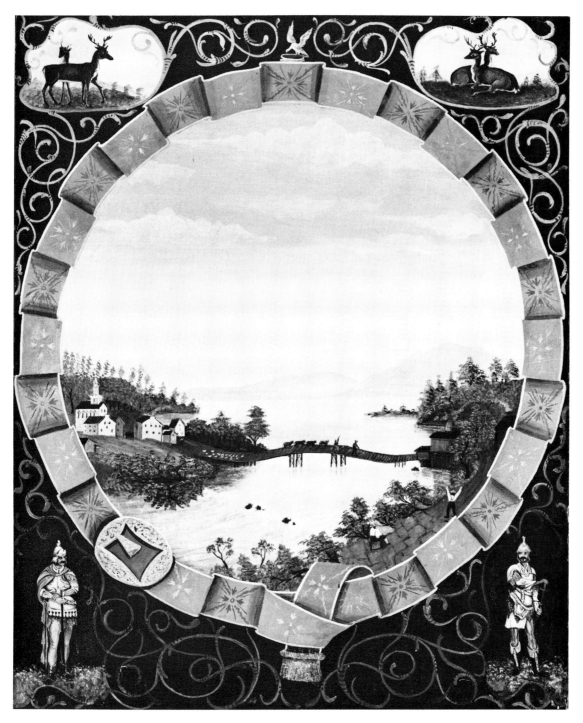

Outlet of Lake Memphremagog, Canada. A copy of the Bartlett print believed to have been painted by a coach decorator. Oil on wood, 22″ x 17¾″. (*Old Sturbridge Village*)

outlines, and the delineation and separation of forms are techniques used by the folk artists. The lack of atmospherics or haziness of distant objects is also a print property.

Most folk paintings have some degree of flatness or lack three-dimensional modeling; this is especially evident in the portraits. The figures have hard edges and clear boundaries marking the limits of the subject in space. The hard edges add to the general effect of flatness. The head and figure are rendered without sufficient shadowing to convey the illusion of three-dimensional solidity. In contrast, an academic master such as Gilbert Stuart executed his figures with disappearing boundaries which are lost and found again as the eye navigates the figure. Part of the figure is shrouded in shadows so that highlights play along the features, breaking up large, flat areas with light. The face is modeled with many subtle shadows which give the illusion of curvature. The facial features also have disappearing boundaries, further adding to the overall effect of softness and roundness. Continuous lines, as in the painting by Field, lead the eye along and around the figure and emphasize the feeling of the plane of the painting, its flatness. In the Stuart the eye does not do this easily since every boundary line leads back into or around to the back of the form, in and out of space and never along the plane. The hard line boundary of the primitive gives an air of crispness to the Field painting while the Stuart looks soft and blurry, like a photograph slightly out of focus.

Flatness is also due to faulty perspective as a result of the artist's inability to foreshorten or create a geometrical space with floors, walls,

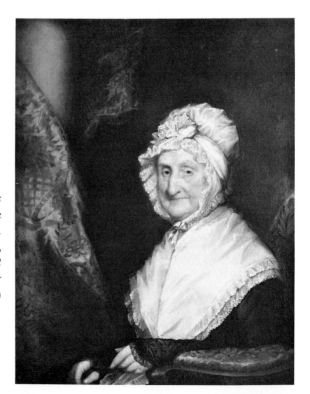

GILBERT STUART. *Mrs. George Williams* (Lydia Pickering). This is typical of the academic-style portraits by this artist. Painted about 1819. Oil on canvas, 36″ x 28″. (*Museum of Fine Arts, Boston, Gift of Mrs. Edward R. Fairbanks in memory of her friend Ellen Williams*)

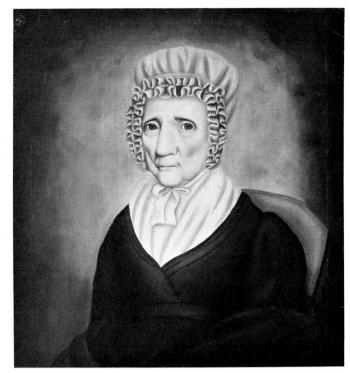

ERASTUS SALISBURY FIELD.
Elizabeth Billings Ashley. Mrs.
Ashley, a grandmother of the
artist, was painted about 1824; the
portrait shows the hard, distinct
outlines typical of the folk artist.
Oil on canvas, 24¼″ x 22½″.
(*Museum of Fine Arts, Springfield,
Massachusetts*)

roads, or other devices. Although much of the flatness is due to ineptitude, just how much is caused by a low level of competence or to conscious choice is not always obvious. All cultures have not always valued three-dimensional illusionism in painting equally. Traditional Chinese painting has little of this quality. Some Chinese ancestor portraits consist of frontal views of flatly rendered figures placed on rugs which appear to be hung vertically and parallel to the picture plane rather than perpendicular to it. Some of the folk artists handled their patterned floor coverings in the same way. In medieval and Byzantine art the flatness of the figures results in a greater feeling of spirituality and idealization than would the naturalistic illusion of human form. Modern artists have turned away from a painting that is a "window" looking into three-dimensional space and seek instead to create a design on the flat plane of the canvas which does not violate its flatness.

One wonders whether the patrons of the American itinerant artist preferred his flat, hard-edge representations to the softer, more highly finished product of the academic portraitist. The style of the successful itinerant Ammi Phillips must have pleased the families he portrayed. Few rural residents would have had an opportunity to view a polished and competent academic painting, but prints were widely available. Since prints use mostly linear techniques depending on lines to outline forms, patrons would have been receptive to visual flatness in paintings.

But it may also be that the patrons saw the folk paintings as more honest and direct representations and the academic ones as falsely and unsuitably pretentious. From the large numbers of portraits executed by the limners, their likenesses must have been considered satisfactory. A good picture of an individual can be achieved by a few lines in a caricature so that three-dimensional modeling is not an essential property. That there was a continuing taste for these portraits is evidenced by the large number of hand-colored, lithographed, idealized portraits of young men and women with titles like *Mary, Emma, John, Charles,* and other common names.

It remains a puzzle why some artists, such as Copley and West, educated themselves out of the folk art category while artists like Ammi Phillips continued. It seems unlikely that Phillips would have been completely unaware of the existence of more modeled and finished work.

Mary. A hand-colored lithograph by N. Currier which shows the "flat" images of prints. Prints were widely distributed and had considerable influence on the styles developed by the folk artist. 12″ x 8″.

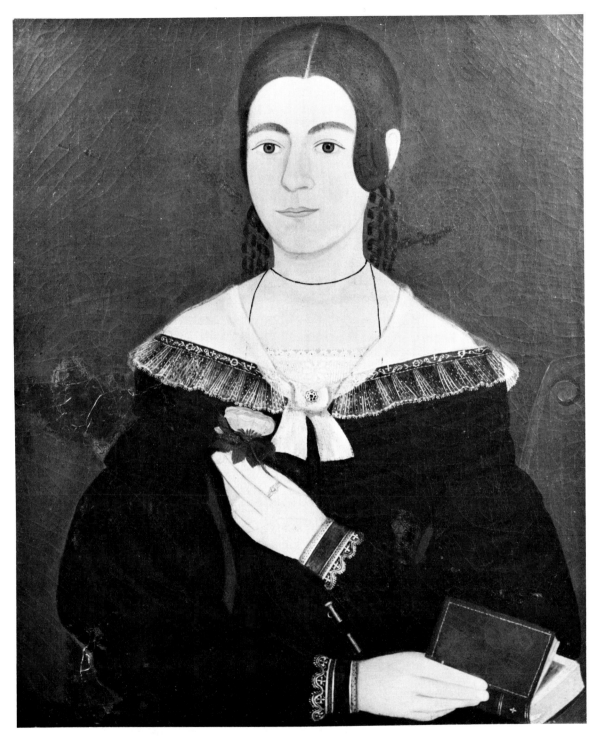

Lucy Leeds. A portrait of a young girl from Pepperell, Massachusetts, by an unknown artist. Country artists were often strongly influenced by what they saw on prints in books or free prints by Currier and Ives and others. Oil on canvas, 29½″ x 24½″. (*Fruitlands Museums*)

Granted that itinerant training, if any, was short and haphazard, it still remains a mystery why he could not have picked up the tricks of the trade as he worked in order to make his forms more three-dimensional. The techniques are not exceptionally profound and should be fairly obvious to a practicing artist with many years of experience.

Some artists who began as primitive painters changed to become essentially academic artists, but William Matthew Prior played it both ways and painted either flat or round depending upon the price the client was willing to pay. By doing this, he put style on an economic basis. Possibly only his most prosperous customers would even entertain the thought of paying the higher price for the modeled portrait, and then only to have something equivalent to the academic paintings in the homes of their friends. If this was the case, then style would be put on a class basis.

Academic techniques were acquired by some folk artists, proving them capable of artistic development. But to us these later paintings are often drab and uninteresting alongside their primitive works. It may be that their clients saw them that way also and that their academic style was not well received. It may never be known whether the style of "arrested development" was forced upon the professional folk artist or whether that was the best that he could do. In the case of most amateurs, such as the schoolgirl, the woman of leisure, or the dilettante, such style was probably set by their own limitations and not by a conscious decision. In any event, desirable art is only peripherally connected with technical mastery.

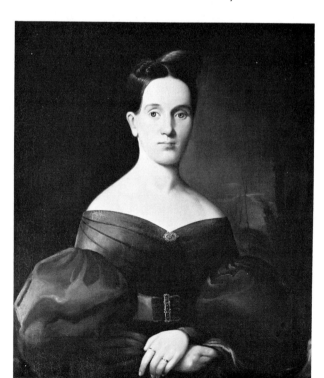

WILLIAM MATTHEW PRIOR. *Mrs. Winslow Purinton.* Painted in 1835, this is one of the modeled or round portraits painted by Prior. Oil on canvas, 31½″ x 27½″. (*Fruitlands Museums*)

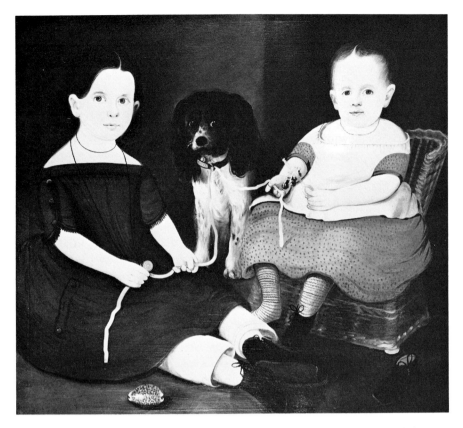

WILLIAM MATTHEW PRIOR. *Two Girls with Dog*. Attributed to Prior, this is painted in the "flat" style usually associated with him. Oil on canvas. (*Old Sturbridge Village*)

English Folk Paintings

The tradition of the early New England limner was a transplant from England or the Continent where nearly anonymous craftsmen painted coats of arms on coaches, decorated wagons and ships, ornamented household furnishings, painted shop and tavern signs, did lettering, and painted portraits. The limner was an artisan, not an artist, and all types of painting and decorating fell within his jurisdiction. In England, as here, the provincial nonacademic painter worked well into the nineteenth century painting for middle-class and rural families. The commission of the itinerant was more likely to be a portrait of a successful farmer's livestock than of his family. Not so many portraits were done by the nonacademic painters in England as here, since the English farmer or rural resident had a tendency to seek the services of the professional academic painter in the nearest town rather than those of the itinerant who portrayed the livestock. An English vogue for animal portraits began about 1760 when mezzotints of animals circulating in rural areas stimulated interest and established a form. Genre scenes, ships, naval engagements, and landscapes were other popular subjects.

Many of the English instruction books on drawing and painting found their way here and were copied and reprinted in this country for use by both amateur and professional. London was not the only origin for these manuals. In Manchester, in 1801, *The Complete Young Man's Companion or Self Instructor* included a section entitled "The Artist's Assistant" which covered drawing, perspective, etching, engraving, and painting among other aspects of art. Amateur work such as painting on silk and velvet was often more refined and elaborate than the work done in this country.

As here, the English nonacademic works varied widely in quality and proficiency of execution with many exhibiting the same inability to manage perspective and anatomical details. Often the inclusion of elements of English dress, background, or landscape prevent a painting from being mistaken for an American one, but many others have found their way into this country and have been assumed to have been painted here.

Other countries including Italy, Spain, and Mexico produced primitive paintings with similarities to the American works. Artists in ports around the Mediterranean and in China painted ships' captains and sometimes their wives and families in addition to the vessels.

Random Comments on Quality

Quality, "excellence in kind," is a relative term and applies logically only to comparisons among like items. Folk art and academic art are incomparables since they have differing aims, differing audiences for whom they were created, and different types of artists who created them. A work must first pass the test of time and be held in high esteem by several generations before it can safely be considered a work of high quality. Even then, the buffeting waves of fads and fashions bring about continuing reevaluations. American folk art is too recently discovered and too lately appreciated to have undergone a sifting of its enduring values.

Since the category of folk paintings includes a rather diverse group of works, no one set of criteria is applicable to the whole group. Viewing a fine painting is an aesthetic experience and the aesthetics are usually obvious. The recognition of a painting of quality leads to an identification of its memorable features, but a checklist of memorable features will not assure that a painting that fulfills those requirements has great merit.

Large numbers of folk art portraits were executed during the late eighteenth century and the first half of the nineteenth. The second-rate

professional academic artist may be eliminated from consideration here. His digestion or partial digestion of academic techniques was sufficient to produce no more than a dull portrait, and at the same time the academic approach stifled his inventiveness and originality. The best folk artists compensated for their lack of academic techniques by creating lively patterns and well-balanced, harmonious designs. Some developed highly individual styles either to overcome their shortcomings or to shorten the time it took to paint a more labored work. Unable or unwilling to model forms with the illusion of three dimensions, artists of some much-admired paintings shaped forms into a flat abstract pattern.

Folk art portraits may be tentatively classified as one of three types: flat, modified flat, or modeled. The flat style is epitomized by William Matthew Prior's flat portraits. In this type the flatness is most desirable when it is part of a well-balanced design. Often this style projects less of the sitter's personality than the other two types. The modified flat style is extremely effective when developed by artists like Ammi Phillips who used flat areas of color to form arresting abstract designs yet projected a distinct personality for the sitter. The modeled portrait becomes a successful folk art vehicle in the hands of a stylist like William Jennys who employed exaggerated shadowing to portray strength and character.

Similar thoughts may be expressed about other types of paintings by the professionals. Some of them that were made to glamorize an object have elements in common with commercial art. The steamboat portraits by the Bards project an idealized vessel while still adhering to accurate scale and detail. The distinctive landscapes by Thomas Chambers are executed in his highly individualized and imaginative style.

Still-life and other paintings on velvet and paper executed by amateurs must be judged on an individual basis. Those that rise above the average possess unusual originality of design achieved by greater complexity or greater simplicity. A velvet painting with a rich, intricate design offers new discoveries over a long period of time. A simplified abstract design finds a sympathetic eye in the modern viewer. In order for the naive approach to become a successful folk art painting, it must be more than a crude picture. There must be vitality, originality, sincerity, and keen observation. Such qualities have a timeless human appeal.

CHAPTER TWO Paintings before 1800

A viewpoint that narrowly defines a folk painting as one unspoiled by academy-based rules and conventions would classify most paintings produced in America before 1750 as merely provincial. Within today's broader boundaries, however, many are now viewed as folk paintings. Artists working in this country were usually the second- or third-rate ones who migrated from Europe, together with the native Americans who were trained by these people—provincialism squared. Later in the century some of the more talented and ambitious American artists, such as Gilbert Stuart and Ralph Earl, went to Europe for training by the English academicians. The fresh approaches in the provincialism of these painters in some cases developed into works that were important contributions to art. In London, for example, Benjamin West ignored the precepts of Sir Joshua Reynolds, president of the Royal Academy, by painting the figures in his *Death of General Wolfe* in clothing contemporary with the event—boots and uniforms—instead of in classical drapery. Although he was not the first painter to paint history in the present tense, West's more lifelike rendition had a strong impact in art circles.

The general level of portraiture was from the first provincial, somewhat naive, and in a style developed by the artist as his own or one that lagged behind European styles by ten or more years. The influx of the mezzotint prints of portraits acted as an equalizing factor in keeping the American artist aware of the latest trends in England and on the Continent. The lack of training or skill often resulted in pictures painted with only the most rudimentary modeling. The absence of shading to give the illusion of three dimensions to the sitter was reinforced by the use of hard, well-defined outlines so that the effect was one of a flat plane divided into various areas of color. Some artists, the exceptions, became adept at rendering rounded forms, but other characteristics of naiveté still maintain them in the folk art category. A poor command of perspective on the part of many artists endowed their paintings with an overall air of awkwardness. The sitter was usually presented in a straightforward manner, but even in America, plainness and facial imperfections were not clearly painted, even when warranted, until after the mid-eighteenth century. In England, Sir Joshua Reynolds in his lectures on the grand style in the 1770s pronounced an excellent portrait to be one that presented "the general air" rather than rendering a true likeness. Americans were more realistic. Grand gestures were rarely used and extremely elaborate backgrounds were usually toned down to be more American in character.

In the seventeenth and eighteenth centuries, the patrons for portraiture were mostly the wealthy—the professionals, the government officials, the merchants, and the landowners. Since these people were cognizant of standards of taste and current styles, they were unwilling to depart very far from these. They demanded some level of competence, and outrageous distortion of anatomy or perspective found few sponsors. After the Revolution, the clientele changed, and experimentation and innovation became quite acceptable. The farmers and country people who had their portraits painted early in the nineteenth century lacked familiarity with academic portrait traditions and, without preconceived ideas, they were more tolerant of the local artist's product.

Early American Portrait Artists from 1663 to 1869 (Historical Records Survey, WPA, New Jersey, 1940) lists a few over two hundred portrait artists in America before 1800. Today, which of these should be considered folk painters? Their works range over the spectrum from naive to rather sophisticated. The decision on which painters to include cannot be completely objective and depends largely on personal opinion. A pitfall to avoid is attributing the appellation of "folk art" to the output of the merely incompetent, to mere crudity. A worthwhile primitive must have artistic and human merit.

Earliest Portraits

Of the very few seventeenth- and eighteenth-century American paintings executed, only a fraction survive. Most were not signed. Where possible, attributions have been made to particular artists on the basis of style, provenance, and such physical evidence as thickness of paint layer and undercoating. Many remain unattributed, and in the case of primitive portraits, the artists of some of the best works remain unknown. Among the earliest portraits discovered so far are those by the Freake and Mason limners who worked in and around Boston in the 1670s. These names derive from the Freake and Mason family portraits which these limners painted. Best known and most impressive in this group is the double portrait of Elizabeth Clarke Freake and Baby Mary which was probably painted in 1674. A companion portrait of Elizabeth's husband, John, was painted about the same time. John Freake is shown in extremely

FREAKE LIMNER.
Elizabeth Freake and Baby Mary. ca. 1674.
An unusually fine early portrait painted with great sensitivity.
Oil on canvas, $42\frac{1}{2}''$ x $36\frac{3}{4}''$.
(*Worcester Art Museum*)

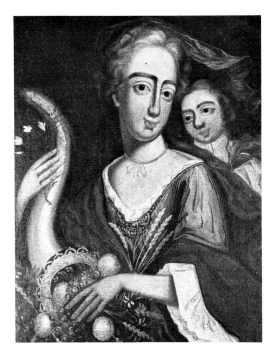

J. COOPER. *Ceres with an Attendant Page.* Believed to have been a sign painter, Cooper produced pictures of personages from history or legend. He was active during the first half of the eighteenth century, but it is not known whether he painted in England or America. Oil on canvas, 22″ x 18″. (*Lyman Allyn Museum*)

elaborate finery with lace, ruffles, and jewelry—in no way a representation of our preconceived notions of austere New Englanders. He was a prosperous merchant and shipowner who was born in England about 1635. He migrated to New England where in 1661 he married Elizabeth Clarke, a native of Massachusetts. The couple had eight children and the two paintings of Elizabeth and her latest child, and of John, were executed about a year before the death of John Freake in 1675.

The name of the Freake Limner is unknown. It is speculated that he came from England soon after the Massachusetts colony was founded and spent the next forty years or so as a sign and house painter. When the colony prospered enough for some members to afford portraits, he painted them in a style he remembered from his youth in England. Approximately seven portraits can be attributed to him; their style is more closely related to the British portraiture of the 1620s than to that of the 1670s. Although formal and rigid, his portraits have a quality of intimacy and charm set off by an eye for color and costume detail. Between the doll-like Baby Mary and her mother there is a feeling of tenderness not obscured by the stiff poses and heavy clothing.

It is estimated that between five and ten portraitists worked in Massachusetts before 1700 including the Freake and Mason limners, John Foster, the printer and printmaker, and Thomas Smith, once a sea captain. All of their works have a high proportion of naiveté. Only a handful have survived the years.

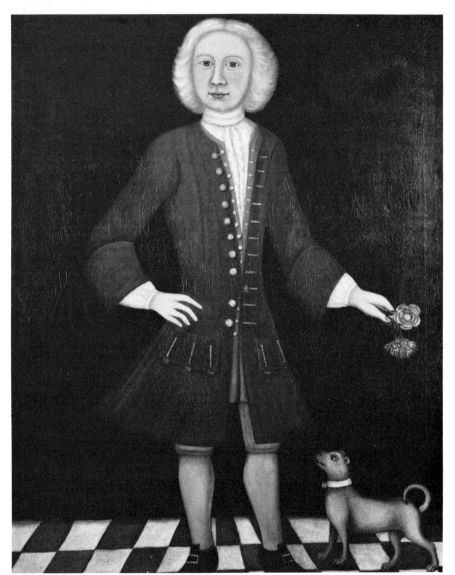

Jonathan Benham. By an unknown American artist, painted ca. 1710. Oil on canvas, 45⅞" x 35". (*National Gallery of Art, Gift of Edgar William and Bernice Chrysler Garbisch*)

Patroon Painters

A somewhat later group worked along the Hudson River in New York State producing pictures of primitive beauty between 1715 and 1730. James Flexner in his *First Flowers of Our Wilderness* christened them the Patroon Painters, after the patroon system of landownership established by the Dutch, and stated that they form the first clearly recognizable school in American art. These painters, a nameless half-dozen or so, catered to the Dutch families then still powerful in New York.

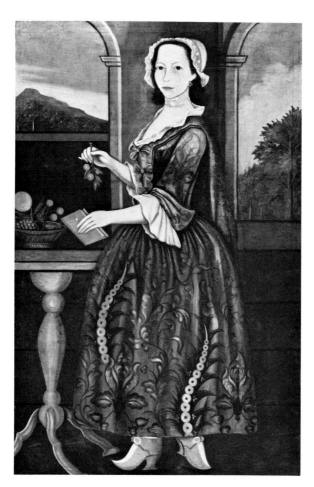

Magdalena Douw (*Gansevoort*). Painted by an unknown artist in the Hudson River valley ca. 1729. Oil on canvas, 51″ x 33″. (*The Henry Francis du Pont Winterthur Museum*)

PATROON PAINTER, DE PEYSTER MANNER. *Moses Levy* (1665–1728). A successful merchant with ships, presumably his, shown in the background. (*Museum of the City of New York*)

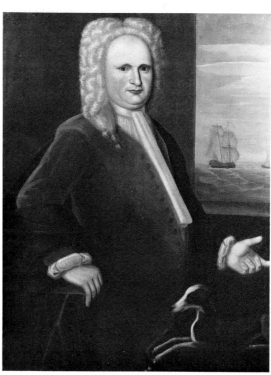

The canvases are large and the sitter is generally shown in half- to full-length pose. They are simple and decorative pictures characterized by long straight or curved lines which unify the composition. The faces reflect innocence and contentment.

Within the general descriptive envelope of Patroon Painters, there is a further sorting into several subgroups based on the general style and feeling of the pictures. Some of the paintings in the De Peyster manner, most successful in representations of youth, are believed to have been painted by Pieter Vanderlyn. Perhaps the masterpiece of this group is the often reproduced *De Peyster Boy with Deer* showing a boy of about ten contentedly petting an attentive fawn.

The Schuyler and Gansevoort limners are two other important subdivisions of the Patroon Painters. Pastoral calm describes the mood often portrayed by the Gansevoort Limner, who worked in the vicinity of Albany. He often included a bird or flower in the hand of the sitter, an iconographic symbol derived from European sources but whose significance was often altered here because of the wild nature of the country.

Joseph Badger (1708–65)

Toward the middle of the eighteenth century, Joseph Badger became for a short while the leading portrait painter in Boston, even though his paintings were executed in a solemn, pedestrian, realistic style. His sitters look out from the paintings with an air of distaste. Badger gained his position by default since there was no one ready to step in after the deaths of the fashionable John Smibert, Peter Pelham, and Robert Feke. Until the appearance of Joseph Blackburn on his visits to Boston, Badger painted members of prominent Massachusetts families as well as people of lesser station, apparently to their satisfaction.

In his essentially primitive style, Badger painted directly what he saw. If a face was plain, he painted it that way, as would most of the nineteenth-century itinerants seventy-five years later. His modeling was simple in form, showing three-dimensional roundness mainly at the outer edges of the body and face. His backgrounds were simple, his poses fairly standard, and his colors dull. However, Badger was able to relieve this starkness to some extent when he painted children. Most of them are shown with a pet bird or squirrel, and one imagines the use of a small amount of idealized beauty to blunt the impression of an unattractive child.

Joseph Badger was born in Charlestown, Massachusetts, on March 14, 1708. By trade a house painter, glazier, and sign painter, he apparently began painting portraits in the 1740s. Little is known of his life, and for many years he was virtually forgotten. By 1834 his image had become so dim that he was not even mentioned by Dunlap in his *History of the Rise and Progress of the Arts of Design in the United States.* None of the perhaps one hundred pictures he produced is signed. He died in 1765. The *Boston Gazette* of November 11, 1765, advertised to receive claims against the estate of "Joseph Badger, late of Boston, painter, deceas'd, represented insolvent."

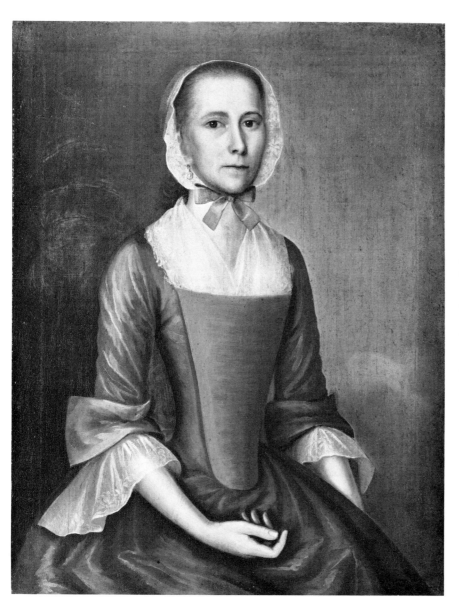

JOSEPH BADGER. *Mrs. Isaac Foster.* Painted in Badger's usual somber style. Oil on bed ticking, 36⅛″ x 27¾″. (*National Gallery of Art, Gift of Edgar William and Bernice Chrysler Garbisch*)

John Durand (active 1766–82)

John Durand, a somewhat shadowy figure in the portrait field, was active between 1766 and 1782, using a light-toned palette to paint pleasant-looking people. Even William Dunlap in 1834 could find little to say about him, although his books include voluminous details of many other early artists and their careers. Dunlap says that his only knowledge of him is from Robert Sully, Thomas Sully's nephew, who says, "He painted an immense number of portraits in Virginia; his works are hard and dry, but appear to have been strong likenesses, with less vulgarity of style than artists of his *calibre* generally possess." The "hard and dry" comment probably refers to the hard outlines used by Durand and the "dry" to the fact that his flesh tones are pastel light and there is only

JOHN DURAND. *Robert Ray* (1759–82). This portrait, attributed to Durand, was painted ca. 1765 and shows the sitter with the bright, pleasant expression that is characteristic of Durand's work. (*Museum of the City of New York*)

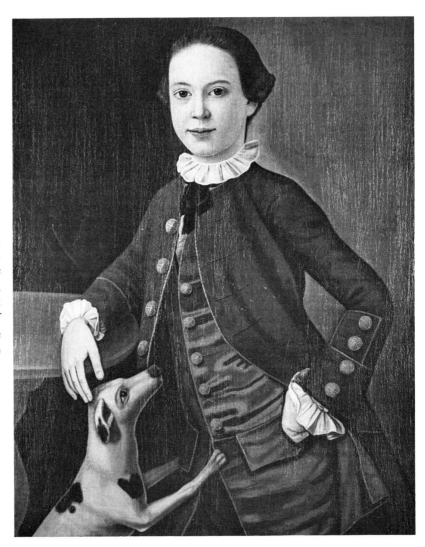

rudimentary modeling. Today these comments are not regarded as unfavorable but rather as a reflection of the essentially primitive character of his painting.

Probably of French birth or parentage, Durand first appeared on the American scene in 1766 when he painted the portraits of the six children of James Beekman in New York City. He advertised there in 1767–68 as a painting and drawing teacher and during this period also solicited patronage for a projected series of historical paintings. No information has come to light concerning the success of this venture, but it is known that after a brief visit to Connecticut he went to Virginia in June 1770. He was painting in Virginia as late as 1782. There is also some evidence that he may have exhibited in London in 1777–78. There is no record of him after 1782.

Ralph Earl (1751–1801)

Ralph Earl, Loyalist, drunkard, bigamist, wife deserter, and one of the foremost American painters of his era, was born in Leicester, Massachusetts, on May 11, 1751. He is one of the few American artists who had academic training in England, yet some of his work fits comfortably with that of other native and more naive artists. A year after his marriage to Sarah Gates in 1774 he opened a portrait studio in New Haven. During the summer of 1775, after fighting against the British had broken out, he and Amos Doolittle visited the sites of the battles of Lexington and Concord where, it is said, Earl used Doolittle as a model in the preparation of a series of sketches of the battles and the countryside. Based on paintings made from the sketches, Doolittle then issued his famous set of four engravings in December 1775. Some of the awkwardness and childlike primitiveness of these prints can be laid to Doolittle since the one extant painting of this group, *A View of the Town of Concord*, is more accomplished than the print. Other signed and dated portraits of this period show Earl to be an artist of considerable skill. His portrait of Roger Sherman, one of his best, was painted during this period.

In the spring of 1778, Loyalist Earl, as well as his wife and two children, escaped the war by sailing for England to improve his art under the tutelage of Benjamin West and Sir Joshua Reynolds. He became a member of the Royal Academy in 1783 and exhibited four or five portraits there between 1783 and 1785. During his stay in England he was active in London and the County of Norfolk. In the fall of 1785 he and his new wife returned to America where he continued his work of painting portraits and an occasional landscape. He worked mainly in western Connecticut

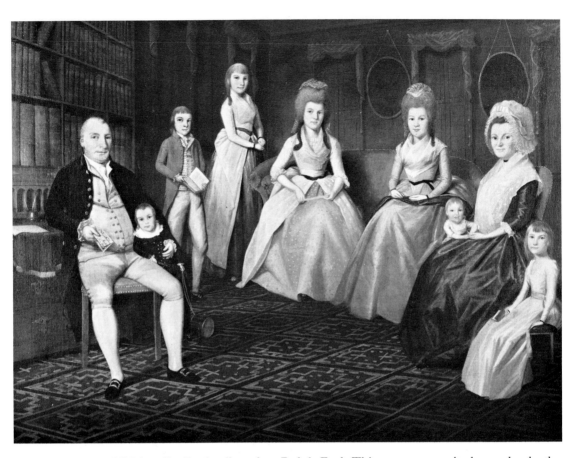

Angus Nickelson Family. Attributed to Ralph Earl. This group portrait shows clearly the distortion that is evident in some of Earl's work. Oil on canvas, 42″ x 58″. (*Museum of Fine Arts, Springfield, Massachusetts*)

but was also active in New York City, Long Island, and later in Vermont and Massachusetts. Ralph Earl died August 16, 1801, in Bolton, Connecticut.

He was an uneven painter who produced works that varied widely in quality. In some he had an obvious and losing battle with perspective. Since he died of "intemperance," it is possible that its earlier manifestations may have contributed to his variable output. His training in England resulted in a more formal and finished painting compared with his American counterparts who lacked the advantage of such training. In fact, he apparently created a fashion for portraits with the sitter in a plush but American setting with details carefully rendered, a demand that was also met by other folk painters in Connecticut who followed his lead. In general, neither he nor his followers went as far as the European artists who customarily placed their subjects in dreamlike surroundings dominated by artificial classicism.

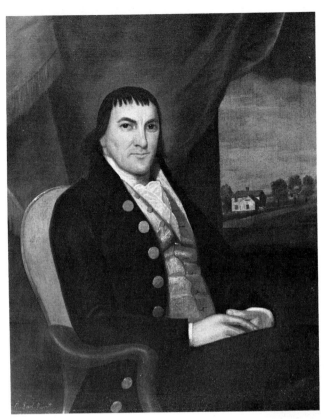

RALPH EARL. *Mr. David Hubbell.* Signed and dated 1795, this portrait shows a typical simplified, Americanized background used by Earl. Oil on canvas, 36″ x 29″. (*Hirschl and Adler Galleries, New York*)

RALPH EARL. *Mrs. Jabez Huntington and Child.* Signed and dated 1796. The sitter, born Mary Lanman, married Major Jabez Huntington of Norwich, Connecticut, in 1792. Oil on canvas, 47″ x 35″. (*Hirschl and Adler Galleries, New York*)

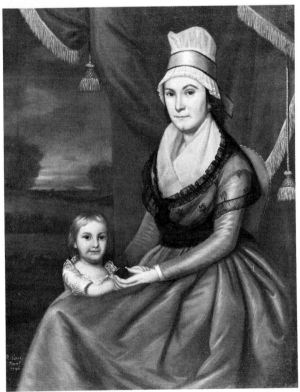

Winthrop Chandler (1747–90)

Winthrop Chandler is another in the group of artists whose careers spanned the Revolution. He, too, achieved a style of such individuality and interest that he must be considered as one of America's important eighteenth-century artists. Chandler was born at "Chandler Hill," Woodstock, Connecticut, on April 6, 1747. It is believed that he was apprenticed to a house painter in Boston and then returned to Connecticut where he worked as a house and sign painter. Apparently, he did not travel seeking portrait commissions; most of his portraits are of friends and relatives in the town where he lived. He spent most of his life in or near Woodstock but late in life lived for five years in Worcester, Massachusetts. He never earned much money and died in poverty in Woodstock on July 29, 1790.

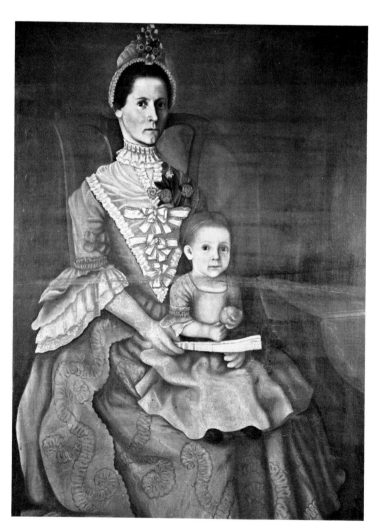

WINTHROP CHANDLER. *Eunice Huntington Devotion and Child.* A fine, prim New England portrait. Oil on canvas, 52" x 37". (*Lyman Allyn Museum*)

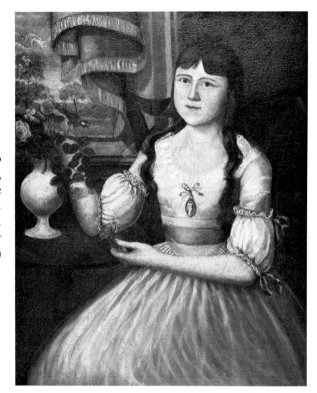

Amelia Martha Daggett. Attributed to Reuben Moulthrop. This portrait, ca. 1795, is done in one of the styles associated with Moulthrop. Oil on canvas, $36\frac{1}{8}''$ x $28\frac{1}{2}''$. (*National Gallery of Art, Gift of Edgar William and Bernice Chrysler Garbisch*)

Chandler's first portraits, painted in May 1770 when he was twenty-three years old, are of Reverend and Mrs. Ebenezer Devotion of the Third Church of Windham (now Scotland), Connecticut. Perhaps his best-known portraits, now in the National Gallery of Art, are of his older brother and sister-in-law, Captain Samuel Chandler and Mrs. Samuel Chandler. Chandler also painted landscapes, mostly as overmantel panels and fireboards. Since he painted primarily friends and relatives, his output was much smaller than contemporaries like Ralph Earl who were full-time portraitists.

Reuben Moulthrop (1763–1814)

"Experimental," "uneven," and "inconsistent" are adjectives often used to describe the work of Reuben Moulthrop. Undoubtedly lacking in formal instruction, as were most local limners, Moulthrop relied heavily on the styles of others as he studied paintings available to him by such artists as Winthrop Chandler, John Durand, and Ralph Earl. There is no evidence of a progression toward a style distinctly his own. His variability and the fact that few of his paintings are signed make attributions to him difficult and controversial.

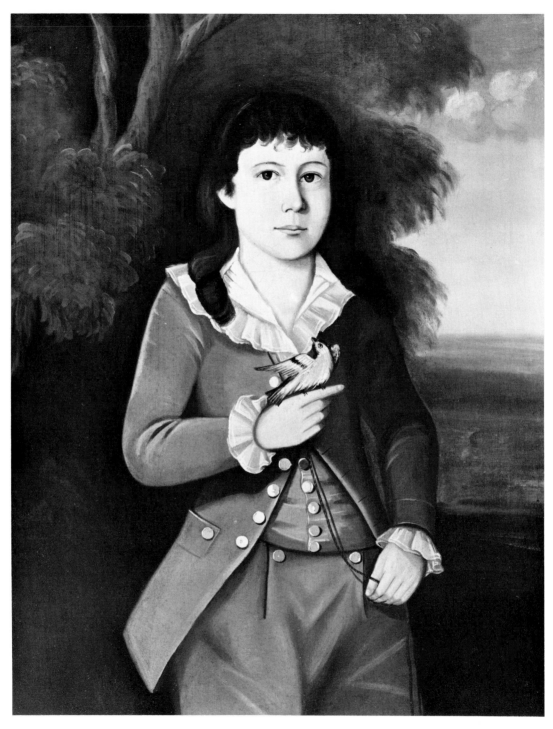

Alexander Dix. A bright-eyed portrait of a young boy attributed to the Beardsley Limner. Oil on canvas, 36″ x 27″. (*Hirschl and Adler Galleries, New York*)

Reuben Moulthrop was born in East Haven, Connecticut, in 1763. He named his first child, born in 1794, after Daniel Bowen who was a wax sculptor and proprietor of a wax museum in New York. Moulthrop, too, became a modeler of portraits in wax and also the proprietor of a waxworks museum and traveling waxworks exhibition. Although his waxworks were exhibited from Boston to Harrisburg, he seems to have painted only in Connecticut, perhaps between tours. He was active as a painter from about 1788 to 1812. Moulthrop died at East Haven on July 29, 1814.

Beardsley Limner (active ca. 1785–ca. 1805)

About 1788 an unidentified portrait painter in Connecticut completed a pair of stunning portraits of Dr. Hezekiah Beardsley and his wife, Elizabeth, then living in New Haven. Each of these large portraits, forty-five inches by forty-three inches, now in the Yale University Art Gallery, shows the sitter in fine clothing seated at a table and with a landscape shown through a window in the background. The accouterments indicate that the couple had obtained a substantial level of culture and prosperity.

The portrait of Alexander Dix, illustrated here, was originally attributed to Ralph Earl, but additional study has indicated that an attribution to the Beardsley Limner is more justified. The portrait was painted about 1795, presumably in either Worcester or Watertown, Massachusetts, where Alexander lived.

Many of the paintings attributed to the Beardsley Limner show the sitters against a background that is a simplified version of the more grandiose English prototypes. This more natural setting was used by Ralph Earl, presumably to satisfy his prosperous middle-class clientele who claimed republican citizenship and rejected aristocratic pretension. The large number of portraits painted by Earl undoubtedly had great influence on his American contemporaries.

Characteristically, the Beardsley Limner placed his subjects close to the front of the picture in what appears to be a confined space in front of the background. The symmetrical, almond-shaped eyes of the sitters are a striking, distinguishing feature.

The search for the identity of the Beardsley Limner goes on. What little is known was discovered through the efforts of Nina Fletcher Little and others who over the years have expanded the attributed oeuvre of this artist to about fourteen portraits executed between 1785 and 1805. All are of sitters from Connecticut and Massachusetts communities along the Boston Post Road.

Portraiture after the Revolution

Other folk artists of note who worked in the late eighteenth century include Captain Simon Fitch of Lebanon, Connecticut; John Brewster, Jr., born in Hampton, Connecticut; and William Jennys and Richard Jennys, both of whom worked in Connecticut. Add to this list the four other artists already mentioned—Ralph Earl, Winthrop Chandler, Reuben Moulthrop, and the Beardsley Limner—all of whom worked in or were from Connecticut, and it is apparent that this state was an important center for what little portraiture of sitters other than the very wealthy was painted in America between the Revolution and 1800.

The Revolution was a pivotal event which permanently altered the economy of the country. The new freedom to trade, the immigration to America, and the opening of new territories to the west by an expanded road system led to the emergence of an enlarged, prosperous middle class. As a consequence the demand for portraits started to grow and the geographic area over which such demand existed also grew. This demand was met by an increasing number of self-trained or poorly trained artists who used the new roads to search for commissions from this new, affluent clientele. Unlike the more aristocratic sitters, this group lacked the background to judge the merits of a painting beyond recognizing from the image the person being portrayed. In a sense the blind led the blind, and the result was a vast outpouring of portraits especially after about 1815, most of them of no great merit but some of exceptional beauty in a distinctive style unique to the limner who made them.

It is interesting to speculate on what type of person the traveling limner was and also what his position may have been in his home-base community. Artists and limners were considered craftsmen, probably less respected than such artisans as blacksmiths, cabinetmakers, and cobblers, since their skills were a luxury compared with the latter, which were essential to a comfortable life. Even today, the traveling salesman, a frequenter of taverns (hotels), out of sight of his family, is surrounded by a light haze of suspicion. Yet it takes a strong personality and great motivation for a person to move from one new area to another seeking to convince strangers to part with their money for a service not really needed. This strength of personality and motivation must be one of the factors at the root of good folk paintings.

The conditions that they encountered are documented by Alexander Wilson, the ornithologist, who early in the nineteenth century traveled extensively throughout the United States collecting material for his book *American Ornithology*. During this period he frequently sent letters

to his friend, the engraver Alexander Lawson, in Philadelphia. Part of one such letter, dated November 3, 1808, details a rather sour view of the conditions he faced while traveling through the rural parts of New England:

> My journey through almost the whole of New England has rather lowered the Yankees in my esteem. Except for a few academies, I found their school-houses equally ruinous and deserted with ours; fields covered with stones; stone fences; scrubby oaks, and pine trees; wretched orchards; scarcely one grain field in twenty miles; the taverns along the road, dirty and filled with loungers, brawling about law-suits and politics; the people snappish and extortioners, lazy, and two hundred years behind the Pennsylvanians in agricultural improvements. I traversed the country bordering the river Connecticut for nearly two hundred miles.

Wilson migrated from England in 1794 and during much of his stay in America was part of the community of scholars. This background no doubt caused him to look down upon the rudimentary life in rural New England, but his views about accommodations probably reflect rather accurately the conditions of travel.

Paintings Other Than Portraits

Surviving examples of pre-1800 landscapes, still-life studies, ship portraits, and seascapes are so few in number that one could easily conclude that these were never painted. Yet inventories of the early estates of some prosperous Dutchman in New Amsterdam list religious pictures, battle scenes, ships, and other nonportraits. Although most of these were imported from Europe, there are some surviving American paintings from the period including a very early watercolor view of New Amsterdam painted by Laurens Block about 1650. Advertisements and obituaries of artists often refer to the individual as supplying "paintings in all its branches."

But considering all the hazards to which a painting is exposed over a span of two hundred years or so, it is hardly surprising that so few remain. A landscape has none of the sentimental value attached to a portrait of a family member, and so money is usually not spent to have it cleaned and restored. After fifty years or more in a room heated by a fireplace, any picture loses its luster and sparkle. Great changes in temperature and humidity with the subsequent contraction and expansion of canvas and paint cause the paint to flake off the canvas and produce other damage. An added blow to early landscapes was the

advent of the Hudson River school of painting in the nineteenth century. In comparison to these later polished, professional works, the early primitive renditions of the landscape appeared comical, archaic, and trashworthy. What did survive were the overmantels, the firescreens (the summer shields on fireplaces), and the small works on paper that were stored and forgotten.

Landscapes

The professional portraitist often included a landscape as background, usually seen through a window. When a landscape was used as an auxiliary to a portrait, a primitive and sketchy rendition was acceptable and somehow expected. However, the few surviving landscapes that are not part of portraits, painted by artists such as Ralph Earl and Winthrop Chandler, show the same primitive representation as their window views, a degree of competence not consistent with the much higher level of skill they achieved in painting the portraits. Apparently, portrait painting had been reduced to a formula, whereas each landscape presented new difficulties.

On the landscape level, the "House, Sign and Fancy Painters" as well as the amateurs were more nearly equal to the professional portraitists. These craftsmen were probably responsible for most of the overmantels and firescreens. The house, sign, and fancy painters were usually town residents who were taught by apprenticeship and supplied the fancy and ornamental work beyond the capabilities of the town residents themselves. In addition to signs, they painted coaches, heraldic devices, clocks, furniture, trappings for funerals, and sometimes "likenesses." Gilding, japanning, varnishing, lettering, and sometimes decorating plaster walls with stencils and paintings were among the services offered.

The amateur artists, both men and women, who had the leisure time either attended drawing schools or taught themselves from one of the many books available for home study. A typical advertisement for professional instruction appeared in the *Maryland Journal and Baltimore Advertiser* for November 8, 1785;

> James Campbell; Coach, Sign, House, Landscape and Ornamental Painting in the newest and most elegant Taste . . . intends to teach an Evening Drawing School and, proposes to take only 12 or 15 Scholars, at Two Dollars per Month . . . Drawing, Hand-sketching and Architecture.

From early in the eighteenth century on, the young lady of leisure also added to the decoration of the house with her pictorial needlework, the designs for which were often based on English or French engravings. Designs were first drawn on the silk or canvas cloth and then filled in by the needleworker with worsted or silk floss. Later in the eighteenth century, such work frequently combined painting and needlework, sky, faces, and hands being painted in watercolor and the rest stitched as before—a form of mixed media. Needlework was so important an accomplishment that when a young lady painted a watercolor on paper she often used brush strokes that simulated embroidery stitches and pinpricked areas of the paper to obtain a textured surface in imitation of cloth.

Ladies' Work

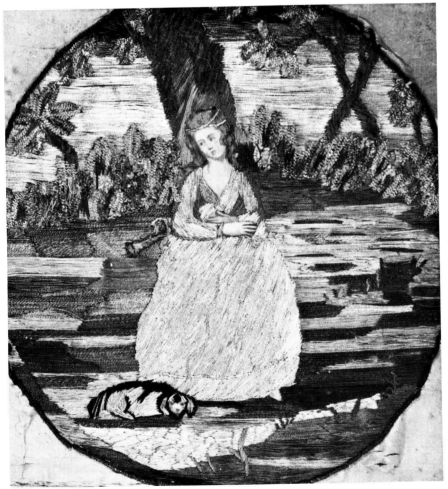

Maria. A needlework picture of one of the characters from *A Sentimental Journey* by Laurence Sterne, published in 1768. Executed in silk floss by "Mrs. Frazier of near Red Bank," New Jersey, ca. 1800. 9″ diameter circle with painted hands and face. Typical lady's work of the period.

Religious Pictures Religious subjects were not commonly painted in America. One of the first artists to do so was the German-born John Valentine Haidt (1700–1780). At the insistence of his father, his early career was as a goldsmith although his inclination was to be a minister or painter. His deeply religious feelings prevailed, and in his early forties he became a preacher. His artistic career started only when he was about forty-five years old, and shortly thereafter he devoted all of his time to painting. In 1754 he came to Bethlehem, Pennsylvania, crossing the Atlantic on the *Irene,* a ship owned and operated by the Moravian church.

The greater part of his life in America was spent in the service of the Moravian church, acting as a painter, pastor, and a church official. His work took him to Philadelphia and other communities with Moravian churches; but his home was Bethlehem, the center of the Moravian church. The church supported him in his artistic work so that it was unnecessary for him to solicit commissions. He was Bethlehem's official painter and did portraits of church members, nativity scenes, other scenes from the life of Jesus, and similar religious pictures. His paintings have substantial errors in perspective and scale. He used a uniform, stylized formula for drawing faces. Haidt painted until at least 1774 and died in 1780.

In the nineteenth century there was a vast outpouring of all types of paintings, a distinct change from the pre-Revolutionary paucity in this area. This eruption is all the more remarkable because it involved the entire financial spectrum of society, from the humblest rural household to the wealthiest industrialist.

CHAPTER THREE Portrait Painters of the Nineteenth Century

Gilbert Stuart and other artists painting in the prevailing European academic fashion catered to America's wealthy, supplying portraits in the tradition of the European aristocracy. Until late in the eighteenth century, most of the country folk had more pressing demands on what little cash money they had, so they could not afford even a country version of these luminaries. But after the Revolution the economy of the country changed rapidly as American merchants became free to trade with China and the rest of the world, roads and canals were built to encourage commerce, the frontier was pushed farther west and settled, and the population exploded. Immigration to this free land with enormous opportunity, together with large families, more than tripled the number of inhabitants between 1790 and 1830.

Approximate Population of the United States

YEAR	POPULATION (in millions)
1790	3.9
1800	5.4
1810	7.24
1820	9.64
1830	12.85

With such growth came a measure of prosperity for the settled parts of rural, agrarian America whose residents then sought some of the luxuries, including "likenesses for posterity." But why shouldn't they? Thomas Jefferson said that they were the equals of anyone.

A group of talented but largely self-taught artists emerged to fill this demand. Some of them had some brief instruction from academic artists such as Samuel Morse who taught Erastus Salisbury Field. Morse studied at Benjamin West's studio in London hoping to engage in the more noble aspect of art—history painting—when he returned to America. But when his grandiose paintings failed to sell, he, too, went off to New Hampshire and traveled from town to town to do portraits, or face painting. In addition to well-trained artists like Morse, there were others, less well trained, with a minimum of instruction or self-taught with the aid of numerous publications who served as teachers of artists. Aspects of painting readily learned from books such as the physical preparation of canvas and paint were generally satisfactory, but artistic subtleties were often lost.

Most of the portraits made by these artists are characterized by the simple, unsophisticated, and direct pose of the subject, without the gestures, grand architecture, or landscapes of the formal European style. One extreme, a full-face view with the sitter looking directly at the viewer, is not uncommon. Some artists also used the even more elementary profile. Edges of the face, hair, and clothing are usually hard lines with very little of the painterly Stuart-like fuzziness to blend the edges into the adjacent area. Frequently, the facial features were painted as flat planes with color on the cheeks but little or no shading to denote three-dimensional roundness. The apparent source of light is often inconsistent, as manifested by the shadows in various sections of the picture. The illusion of depth is usually faulty with the insufficient "room" allowed for the sitter in the picture making him appear pressed against the background or the front of the picture. Distortion in the portrayal of hands and arms is legendary and emphasizes the artist's lack of training and often, ability. The sitter is arrayed in his Sunday best, often with a book, telescope, compass, or some other accessory to indicate accomplishment or profession. Children are commonly shown with conventional accessories: girls hold a flower or toy and boys hold whips. During this pre-Freudian period, both young boys and girls wore dresses, but their sex can usually be identified by hair style. The boys generally have side parts and the girls, center parts.

Folk portraits were usually painted on canvas but sometimes on wood panels of poplar, pine, or maple, and occasionally even bed ticking served when canvas was not available. Academy board and cardboard were frequently used for small portraits painted after about mid-century. A small number of portraits have paper or gold or silver foil glued to

the canvas to represent books, papers, or jewelry. Although most paintings are in oils, a few artists specialized in watercolor and pastel portraits. Oil and watercolor miniatures on ivory and paper were other forms of portraiture. These were often framed and used as jewelry in the form of lockets.

A constant demand for portraits after death was an unwelcome chore for many artists. It may seem a grisly task, but it was a way to secure the memory of a child who died after a short life or a young wife who died in childbirth. Records on two charming children's portraits in the Fall River Historical Society—one of Helen M. Wilbur who was born May 1, 1846, and died April 6, 1848; and the other of George H. Wilbur, born March 21, 1844, died April 9, 1848—state that both were painted after death by William M. Prior. The children died within a few days of each other, at two and four years of age. The portraits are pleasant, but very pale in hue, and they give no indication of the tragic circumstances under which they were painted. Even William Sidney Mount, an academic painter of cheerful genre scenes, found these commissions so important to him that he always accepted them although he disliked such tasks and complained about them.

Surviving examples of folk portraits are mostly from New England and eastern New York State with only a smattering from other sections of the country. The South is especially poorly represented. One conjecture is that there was a smaller demand so that fewer were made. It is possible that many were destroyed during the Civil War. Some may have been used to decorate slave quarters and were subsequently thrown out; it was a practice in the South to relegate unwanted household items to this use. Pennsylvania is also poorly represented since the attitudes of the Quakers and Pennsylvania Germans inhibited self-glorification.

Many portraits were painted by artists for whom this was a part-time activity combined with occupations such as sign painting or coach or furniture decorating. Such painters may have produced only a few canvases of local residents, either from life or after death as a memorial. The wide range of services offered by a typical local painter and decorator is listed in a newspaper advertisement placed by George Dame in 1806 in Portsmouth, New Hampshire, which reads in part:

George Dame . . .

Painting business in its various branches Varnishing, Gilding, Etc. Coaches, chaises, signs, fire buckets, fancy chairs, standards, etc., painted in the neatest manner. Looking glass and picture frames painted and gilded, gilding on glass, etc., painting in water colors and gilding on paper, vellums, silks, etc.

also

Portraits and Miniatures paintings, warranted likenesses
Specimens may be seen at his shop

. . .
Drawing school to commence April 17 if sufficient encouragement.

Full-time professionals such as Ammi Phillips and Erastus Salisbury Field were forced by the lack of a concentrated market to become itinerants, to travel constantly to search out new customers. The usual approach was to go to the inn or boardinghouse in a town and then advertise in the local paper or by handbills that they were available to make portraits. Sometimes the artist lived with a family while doing their portraits. A letter from the family of one of his customers describes William Prior's method of operating. The writer states that his grandparents were frequent visitors to Newport and that they met there "one Pryor or Prior an artist in 1848 who was painting portraits" of Newport people. Prior was invited to New Bedford to paint the children, of which there were nine. He came in 1849 and painted seven of the children, ranging from two to seventeen years old. Prior was a guest in the home for many weeks and the writer's family said that his method was to draw a very sketchy outline of his subjects and then paint them while they were in school. "The paintings look more like the old-fashioned canvas dolls with the painted faces and almost no expression. Still, they are very cute and everyone admires them."

Prices varied depending on the commission. A cut profile or silhouette, if the artist did them, was typically twenty cents. A colored profile was one dollar, a front view in oil three to ten dollars, a miniature on ivory about eight dollars, and a large family portrait in oil brought about twenty-five dollars. One of the paintings illustrated, of a young girl painted on academy board about $13\frac{1}{4}$ inches by $17\frac{1}{2}$ inches, has the following inscription written in pencil on the backboard:

Painted by Wm. M. Prior
July 7, 1855, New Bedford
Painting 4.00
Frame 3.00

By contrast, in 1809, John W. Jarvis, a fashionable academic artist from New York City, advertised his portraits at the following prices: full-length portraits, three hundred dollars; portraits with hands, sixty dollars; portraits without hands, forty dollars; colored profiles, three dollars. Most Americans could not afford such prices.

A typical simple front or three-quarter view in oil took the folk artist one to three or more days to complete, depending on the quality contracted for and the speed of the artist. After receiving a commission, the artist often moved in with the family, an allowance being made in the price for room and board. When they lacked portrait commissions some artists painted signs for local merchants, decorated coaches, painted murals and fireboards for taverns and homes, and executed landscapes,

either from prints or from their imaginations. When business ran out in one community, they packed up and went to another. During their careers many moved their entire families several times in order to have their home base close to a likely area for new business.

Not everyone considered this nomadic life unpleasant. In 1825 John Vanderlyn, a successful academic artist himself, wrote to his young artist nephew encouraging him and perhaps suggesting a course of action when he noted the success of Ammi Phillips and that "moving through the country as Phillips did and probably still does must be an agreeable way of passing one's time." The successful full-time professional limner seems to have supported himself well and probably often better than country doctors who were committed to minister to all without regard to their ability to pay.

These artists painted tens of thousands of portraits from about 1800 to the close of their era, the Civil War; the prime years were from 1825 to 1850. Of the several factors that contributed to the rapid decline after 1840, the most important was the introduction of photography. It had a drastic effect on the production of miniature portraits for which the daguerreotype was a satisfactory replacement. For many, the daguerreotype completely fulfilled the desire for a likeness although a few still preferred the impact of a large oil painting and had painted copies made of daguerreotypes. By 1850, daguerreotypy was well established in this country. The *New York Daily Tribune* in 1853 estimated that three million were produced annually. Brady and others opened elaborate and luxuriously appointed studios where prominent people had daguerreotypes made. The smaller towns and villages were also covered by traveling daguerreotypists with horse-drawn vans.

A less obvious cause for the decline of portraiture was the mood of the country. Andrew Jackson, president from 1829 to 1837, was considered the embodiment of the triumph of the common man. It is reasonable to assume that in such an atmosphere many could not accept painted portraits which might be construed as emulation of the wealthy and aristocratic. Whatever the reasons, having family portraits hanging on the walls ceased to be fashionable, a custom that prevails to this day. Instead, painted landscapes, colored lithographs by Currier and Ives, engravings, and similar wall decorations were commonly used after about 1850. Many ancestral portraits were discarded or put away in attics as the great era of folk portrait painting ended.

A somewhat delayed obituary for the itinerant portraitist appeared in *Harper's Weekly* on December 16, 1871. The paper was commenting on a wood engraving which illustrates an itinerant photographer taking a picture of an old man and his family sitting in a wagon (see illustration on p. 44).

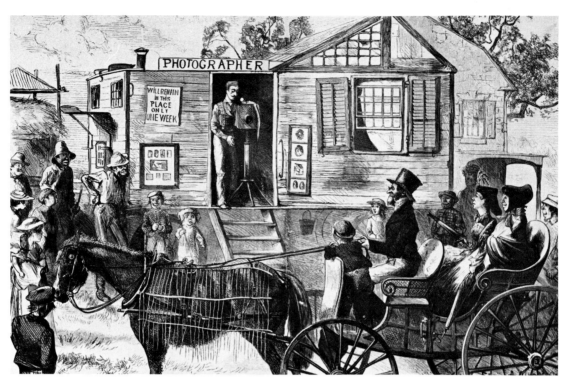

The Traveling Photographer in the Country, from a sketch by Thomas Worth. Wood engraving in *Harper's Weekly,* Supplement, December 16, 1871.

THE TRAVELING PHOTOGRAPHER

Years ago, before the days of the daguerreotype and photography, two classes of artists used to appear occasionally in retired villages—the oil-portrait painter and the silhouette or shadow-portrait cutter. The former was always the more popular of the two. His pictures were bigger and more striking, and when hung up in the parlor—an apartment sacred to visitors, and opened only on grand occasions—made an impressive show. The silhouettes were merely the outlines of the head and shoulders cut in profile out of blackened paper, and, being diminutive, the likeness, however perfect, was not so easily recognizable. Now and then, in old-fashioned country parlors, we see specimens of these shadow portraits hanging over the fire-place which have held their own against the faded glories of the more ambitious life-size pictures in oil, in fly-specked gilt frames, which are supposed to adorn the walls.

The art of photography has, in great measure, superseded the rude attempts of these itinerant artists with something infinitely better than any thing that can be done by any but the most skillful masters. The sun is a most faithful artist. All he requires in his human assistant is a little skill in posturing, a little deftness in manipulation, and he will do all the rest with a beauty and fidelity beyond the reach of the most patient handiwork of man.

After World War I there was a great revival of interest in Americana which included Currier and Ives prints and American furniture and accessories. It was in this climate that local exhibitions of family or ancestral portraits were organized, among which was a historically important but otherwise minor one in Kent, Connecticut, in 1924. Many, particularly some of the leaders in the modern art movement, saw merit in the paintings. In a few years, interest had grown to the point where special exhibitions were held in metropolitan museums. The Newark Museum mounted one in 1930–31. "American Folk Art, the Art of the Common Man, 1750–1900" was the title of the 1932 exhibit at the Museum of Modern Art in New York City. That same year the Whitney Museum of American Art held a showing of "Provincial Paintings of the Nineteenth Century." The Albright-Knox Art Gallery in Buffalo called its exhibit "Centennial Exhibition of American Folk Art." In 1935 Abby Aldrich Rockefeller gave the major part of her collection to Colonial Williamsburg where many of the items have been displayed since that time. These exhibitions, particularly the one in the Museum of Modern Art, were extremely influential in sorting out and establishing a "style" of American folk art.

Attributions

Unfortunately, only a very small percentage of folk portraits are signed or identified. As an example of the statistics, of 309 paintings recently listed as having been painted by Ammi Phillips, only 12 are signed. This is not surprising since an artist then was considered only a craftsman, and craftsmen as a rule did not mark their work. On this point John Singleton Copley complained that "the people generally regard portrait painting as no more than any other useful trade as they sometimes term it, like that of a carpenter, tailor or shoemaker, not as one of the noble arts of the world." Today, through research and study, some of these unsigned paintings can now be attributed with varying degrees of assurance to particular artists.

Since there were no big-name stars, the selection of paintings for the early exhibits was made solely on the basis of quality, a practice that should govern the wise even today. It was clear from their exhibitions, however, that sometimes a single artist painted a group of the canvases. This was particularly true of the show in Kent, Connecticut. Since the identity of the artist was lost, in this instance he was called simply the Kent Limner. Several dedicated researchers then took up the task of finding out more about him as well as about the other artists. It was not until 1942 that a body of work was ascribed to Erastus Salisbury Field and not until 1958 for Ammi Phillips. These two are

now among the best-known and most highly regarded American folk artists. Each is estimated to have painted over one thousand canvases.

This work continues today. An example is the Beardsley Limner, named for the portraits of Dr. Hezekiah Beardsley and his wife, Mrs. Elizabeth (Davis) Beardsley, painted ca. 1788. In 1957 six portraits attributed to him were included in an exhibition of the Connecticut Historical Society. Nina Fletcher Little and others continued research on this artist, and in 1972 the Abby Aldrich Rockefeller Folk Art Collection held a new exhibition at which fourteen paintings attributed to the Beardsley Limner were shown. Hopefully, sometime soon a signed example will be discovered revealing the identity of this major folk artist.

From the scholar's point of view, attributions serve the valuable function of bringing together a pool of paintings with similar characteristics so that they can be more easily studied and evaluated. Such comparisons often serve to refine further the basis for attribution and to remove incorrect attributions from fringe pictures. It should always be kept in mind that a statement of attribution is only an opinion of authorship of a painting, made presumably by someone qualified by training and experience to make that judgment. It is not a guarantee, but the probability of its being correct is greatly increased if the attributer is especially familiar with other works by the artist.

It is not possible to define here all of the points each attributer looks for in making an attribution. In the first place, some points are not fully agreed on by all, and secondly, the colors, brush strokes, and other subtleties cannot be described satisfactorily in a few words. However, there is a consensus about a number of factors which can be grouped into the following categories:

1. Provenance—Is there any believable history to support that the painting was executed by a particular artist or that it was painted in a geographical area where the artist is known to have worked?
2. Style and composition—Does it look like and have the style and composition of other paintings known to have been painted by the particular artist during the *same time period?* Clothes, hair styles, and furniture are helpful in dating a picture.
3. Color—Is the general color tone one generally used by the artist?
4. Proficiency—Are the levels of draftsmanship, skill in applying paint, rendering three-dimensional forms, and use of space consistent with the practice of the artist during the time period the picture was painted?

5. Special details—Are the hands, ears, mouth, hair, lace, cloth, and other details painted in a way peculiar to that artist? For example, Erastus Salisbury Field usually painted hands with a reddish ring on the knuckles.

6. Physical evidence—Is the size of the canvas one that was commonly used by the supposed artist? Are the construction of the stretchers and frame and the mounting of the canvas typical of his other paintings? Also, are the undercoating, sizing, and amounts and method of applying paint consistent with his usual practice?

It is obvious that an attribution by a qualified and experienced person which scores well in all six categories is more likely to be correct than one that scores well in only two.

In the discussion of individual artists in the next section, some of the points of attribution are given. It should be clearly recognized that this is a very fluid area and further research may show some to be incorrect or only partially true. At this time, however, it represents the best information on these artists that has been published. Other still unpublished studies will undoubtedly present more complete information.

The Artists

Some were full-time limners; some had additional jobs such as decorating houses or furniture. Some were professional painters; some worked in other fields and did only an occasional portrait. Some worked at it all of their lives; some only for a few years. Some were very good artists; most were not. With such diversity and with so few of the paintings signed or attributable, it is not meaningful to try to name the best ten or so artists. The following list, therefore, includes the names of recognized artists who either painted a substantial number of portraits or who are represented in notable collections. Many additional names are included in the appendix, "Selected List of American Folk Painters."

Painters in Oil
Belknap, Zebakiah (1781–1858)
Bradley, John (active ca. 1832–47)
Brewster, John, Jr. (1766–1854)
Bundy, Horace (1814–83)
Field, Erastus Salisbury (1805–1900)
Hamblen, Sturtevant (see also Prior) (active ca. 1837–56)
Hartwell, George G. (see also Prior) (1815–1901)

Jennys, William (active ca. 1795–1807)
Peck, Sheldon (1797–1868)
Phillips, Ammi (1788–1865)
Powers, Asahel Lynde (1813–43)
Prior, William Matthew (1806–73)
Sheffield, Isaac (1798–1845)
Stock, Joseph Whiting (1815–55)

Painters in Watercolor and Pastel
Bascom, Ruth Henshaw (pastel) (1772–1848)
Davis, Joseph H. (watercolor) (active ca. 1832–37)
Evans, J. (watercolor) (active ca. 1827–34 and possibly ca. 1840–50)
Davis, J. A. (watercolor) (active ca. 1838–54)
Ellsworth, James Sanford (watercolor) (ca. 1802–74)
Maentel (or Mantel), Jacob (watercolor) (1763–1863)
Shute, R. W. and S. A. (pastel and oil) (active ca. 1830–40)
Williams, Micah (pastel, a few oils) (1782–1837)

Examples of the works of most of these artists are illustrated along with the works of others.

Ruth Henshaw Bascom (1772–1848, active ca. 1819–ca. 1837)
Worked mostly in north-central Massachusetts and lower New Hampshire

Unlike other artists in this section, Ruth Henshaw Bascom was not a professional itinerant artist. During her art career she was the wife of a minister, and since his pastorate changed several times during his life, her portraits, like those of an itinerant, are scattered over a large area in north-central Massachusetts and lower New Hampshire. In keeping with the tradition of the other artists of the period, few of them are signed.

Mrs. Bascom seems to have executed only full-size or nearly full-size profiles on paper, colored with pastel crayons. She usually traced the projected shadow of the subject in pencil, added ears, eyes, and other features in pencil, and then colored the picture. The face is without modeling and usually in one color with, perhaps, a trace of red on the cheeks. Backgrounds are almost always plain with blue being a favorite color, but on occasion she included a landscape or a drapery. Some of the pictures attributed to her are cutouts with the face and head pasted to a colored sheet of paper, again often blue. Now and then she also pasted on bits of metal foil for jewelry or spectacles.

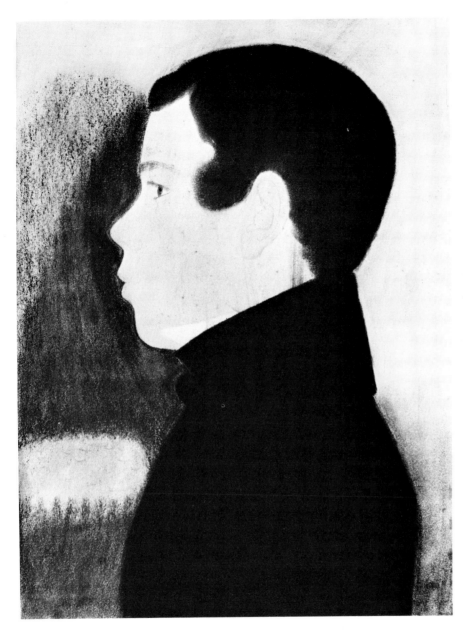

RUTH H. BASCOM. *Edwin Davis.* On the back of this pastel portrait is written in pencil "Mr. Edwin Davis. N. Marlboro, New Hampshire, sketched November 1838 by Mrs. R. H. Bascom." Paper, 19″ x 13½″. (*Old Sturbridge Village*)

Ruth Henshaw Bascom was born in Leicester, Massachusetts, a suburb of Worcester, on December 15, 1772, and spent her childhood in that area. She married her first husband, Dr. Asa Miles, a Dartmouth professor, in 1804. He died shortly thereafter, and in 1806 she married the Reverend Ezekiel L. Bascom. During the rest of her life she lived in Deerfield, Gill, and Ashby, Massachusetts, and Fitzwilliam, New Hampshire.

A diary which she kept most of her adult life makes mention of her portrait work. The first notation is on September 14, 1819, when she was forty-six years old and the last, in 1837, when she was sixty-five. Family tradition is that she never charged for her work although she apparently charged some customers twenty cents for a likeness, presumably to cover the cost of materials. She died in 1848 in Ashby, Massachusetts.

The profile illustrated of Edwin Davis of North Marlboro, New Hampshire, is typical of Mrs. Bascom's work and is one of the few that she signed.

Zebakiah Belknap (1781–1858, active 1810–40 and after)
Worked throughout New England

Zebakiah Belknap worked for at least thirty years as an itinerant artist throughout New England. He was prolific and competent, but not outstanding. Some of his work is signed but much of it is not.

Throughout his career he heavily favored the use of wood panels although some of his work is on canvas. The customary preparation of his tulipwood or pine panels was to score them with

Portrait of a Woman.
Attributed to Zebakiah Belknap. Oil on canvas, 27″ x 22″. (*Collection of Herbert W. Hemphill, Jr., Photograph courtesy of Heritage Plantation of Sandwich*)

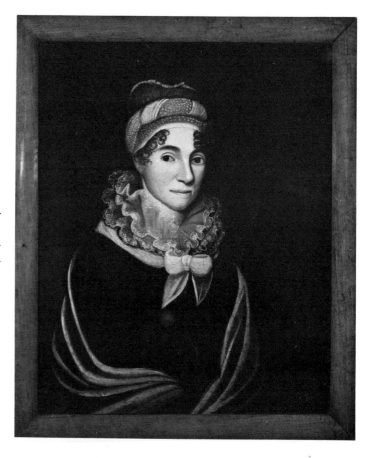

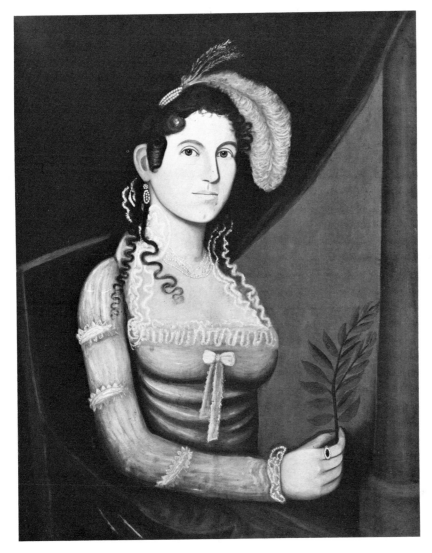

Mrs. Thomas Harrison.
Attributed to
Zebakiah Belknap.
Painted ca. 1815. Oil
on tulipwood panel,
$33\frac{1}{2}''$ x $25\frac{5}{8}''$. (*Abby
Aldrich Rockefeller Folk
Art Collection*)

a rowel—a wheel with sharp points or spurs. This treatment pro-
duced a characteristic textured surface on the painting. His faces
generally have heavy reddish shadows around the nose, sharply
defined eyes, and prominent ears.

Belknap was born March 8, 1781, in Ward (now Auburn),
Massachusetts. In 1807 he graduated from Dartmouth College and
shortly thereafter became an itinerant artist. He lived in
Weathersfield, Vermont, with his wife, the former Sophia Sherwin,
a native of Maine, and died there on June 8, 1858.

The rather stiff portraits illustrated of Mrs. Harrison and an
unidentified woman are relieved by prominent repeated curves in
the dress and scarf. Clearly the clothing worn by the women is an
important part of the composition and not merely a reflection of
the fashions of the period.

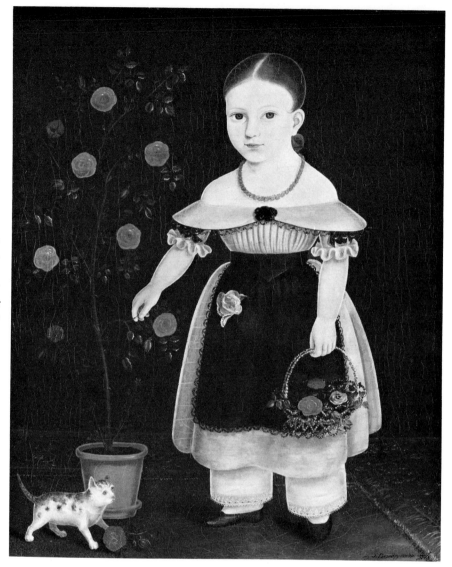

JOHN BRADLEY.
Little Girl in Lavender.
Signed on front: "by
J. Bradley 128 Spring
St." Oil on canvas,
34" x 27⅜". (*National
Gallery of Art, Gift of
Edgar William and
Bernice Chrysler
Garbisch*)

John Bradley (active ca. 1832–ca. 1847)
Worked in New York City, Staten Island, and surrounding areas

"No unsigned picture can be convincingly attributed to him," wrote
Mary C. Black and Stuart P. Feld in 1966 after careful study of
John Bradley and his works. It is rare indeed to find a nine-
teenth-century limner who so consistently signed his paintings.
Before 1836 his signature was "I. Bradley" using the then archaic
I for *J*, but after this date he switched to "J. Bradley."

His style is sufficiently close to that of the Kent Limner that for fifteen years he was believed to be that artist; but as a result of the work of Barbara and Lawrence B. Holdridge, published in 1960 and 1961, the Kent Limner is now generally conceded to be Ammi Phillips. Bradley typically outlined faces and hands with a narrow line of whitish paint. In common with many of his contemporaries, his portraits are quite flat with little modeling. He was fond of dark green, red, and medium brown.

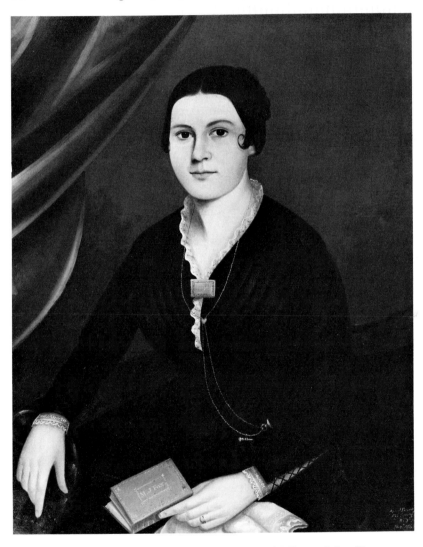

JOHN BRADLEY. *M. J. Fox.* This portrait of Miss or Mrs. Fox is signed on the front: "by J. Bradley/134 Spring St/N. Y./Dec 1845." (*University Art Museum, Berkeley, Gift of Mr. and Mrs. W. Bliss Carnochan, Photograph courtesy of Hirschl and Adler Galleries, New York*)

Almost nothing is known of John Bradley's life. He signed some paintings "I. Bradley from Great Britton," so we can take his word for that; but no other positive information regarding his background has come to light. From 1836 to 1847 he was listed in New York City directories as a portrait painter and sometimes, in addition, as a painter of miniatures. However, some of his works are dated before 1836 and *The Cellist,* one of his best-known works, is dated 1832. It is probable that before 1836 he lived close to New York City but not in the city proper and consequently was not listed in the city directory. Most of his sitters were from New York City, Staten Island, and New Jersey.

John Brewster, Jr. (1766–1854, active ca. 1795–1832)
Worked in Connecticut, Maine, and Massachusetts

John Brewster, Jr., was a transitional artist who worked in both the rural interpretation of the eighteenth-century portrait style and the simple bust portrait typical of the nineteenth-century limner. His early works from 1795 to 1810 are frequently full-length portraits and some, such as the early painting of his father and stepmother illustrated, show his subjects seated at a table with a landscape seen through a window in the background. Characteristically, his portraits display a sensitive interpretation of the sitter's personality rather than the stylized characterizations used by many contemporaries. His sitters, painted life-size, project serene beauty, solid self-confidence, or a debonair devil-may-care attitude, depending on the particular personality.

Brewster used only a thin layer of paint on a canvas that was primed with a dark gray undercoating. The canvas used early in his career tended to be coarse; his later paintings are on a finer-textured weave. The flesh tones on his earlier paintings are pinkish so that his sitters appear healthy with a ruddy complexion. There is little modeling of the features. In his later paintings the facial expressions are more somber and there is heavier shadowing. Almost none of his earlier works to about 1805 are signed, but a high percentage of his later paintings are signed on the stretcher.

It boggles the imagination to understand how John Brewster, Jr., a deaf-mute from birth, could have traveled and negotiated commissions in a largely illiterate countryside. He was born in Hampton, Connecticut, on May 30 or 31, 1766. His father, a respected physician, provided him with a good education, which included reading, writing, and an ability to communicate in sign

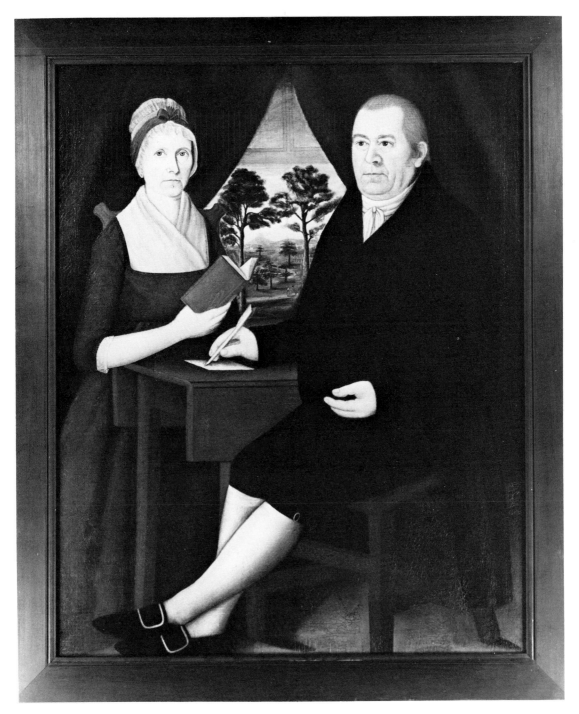

JOHN BREWSTER, JR. *Dr. and Mrs. John Brewster.* This portrait, ca. 1795, of the artist's father and stepmother, the former Ruth Avery, is painted in Brewster's early style on coarse-textured canvas, $49\frac{5}{8}''$ x $40\frac{1}{2}''$. (*Old Sturbridge Village*)

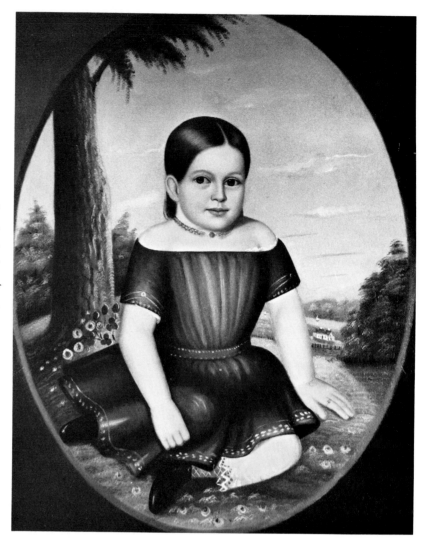

HORACE BUNDY. *Girl in Blue Dress.* Signed on back: "H. Bundy, painter, April 1850." Oil on canvas, 33″ x 26″. (*Heritage Plantation of Sandwich*)

language. In 1791, at the age of twenty-five, he studied with the portrait painter and minister the Reverend Joseph Steward. It is speculated that Winthrop Chandler may also have provided some instruction.

From about 1795 to 1797 he painted in Connecticut and then apparently moved into the household of his newly married brother, Dr. Royal Brewster, in Buxton, Maine. Thereafter, this served as his home base. Except for the years from 1817 to 1820 when he was a student at the first American school for the deaf and dumb in Hartford, Connecticut, Brewster traveled and painted from Maine to Connecticut. His last dated picture discovered so far was painted in 1832. Dr. Royal Brewster died in 1835 and nothing of consequence is known of John, Jr.'s, life from that time until his death on August 13, 1854.

Horace Bundy (1814–83, active ca. 1837–ca. 1859)
Worked in Vermont, New Hampshire, and early in his career in the vicinity of Boston, Massachusetts

Horace Bundy painted landscapes, embellished sleighs and signs, and painted oil portraits. Almost all of his portraits are signed in large script on the back, often including the date and the sitter's name. As might be expected of a self-taught artist, his early portraits have little modeling and considerable distortion. As his career progressed, he increased the amount of modeling, and the rendition of faces and perspective improved. His rare late portraits, especially a group of his family, ca. 1878, show clearly the effect of the daguerreotype. A fairly high percentage of his paintings show the sitter in a painted oval, often with the inner edge painted to give the effect of a bevel. Landscapes and other backgrounds were frequently used. His best works were painted in the 1840s.

Bundy was born in Hardwick, Vermont, on July 22, 1814. He married Louisa Lockwood of North Springfield, Vermont, in 1837, and over the years the couple had eight children. During the 1840s

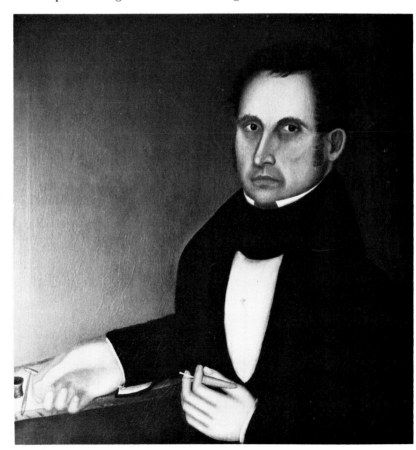

HORACE BUNDY. *N. W. Goddard, Watchmaker.* Signed on reverse: "by H. Bundy, Nashua [New Hampshire], Sept. 1837." Oil on canvas, 28″ x 26″. (*Heritage Plantation of Sandwich*)

and 1850s his principal occupation seems to have been that of itinerant artist. In 1842, Bundy, like William Prior and Joseph G. Hamblen, became an Adventist and spent much of his time preaching and conducting revival meetings. The Adventist movement was started by William Miller, who believed that the Second Coming of Christ and the end of the world would occur in 1843–44. After 1859, in a world not yet ended, Bundy seems to have entirely abandoned painting as an occupation in order to devote himself to the movement. In 1863 he was appointed pastor of the Second Advent Church in Lakewood, New Hampshire.

Little is known of his life after 1870, when he gave up the pastorship and moved to Concord, New Hampshire. His wife did not accompany him since before this move she had left him to live with a daughter. In his later life he is known to have painted a few portraits of members of his family. He died in Concord on June 15, 1883.

Joseph H. Davis (active ca. 1832–37)
Worked in southeastern corner of New Hampshire and adjacent areas in Maine

J. Evans (active ca. 1827–34 and possibly ca. 1840–50)
Worked close to Portsmouth, New Hampshire, and the Boston-Roxbury area of Massachusetts

J. A. Davis (active ca. 1838–54)
Worked in New Hampshire as well as Rhode Island and adjacent parts of Connecticut

Joseph H. Davis, itinerant, left-handed, professional watercolor artist, painted profiles with great style and flair enhanced by patterned floor coverings and accents on clothes, painted furniture, and accouterments. A typical Davis watercolor shows the subject or subjects in profile with special emphasis on the style and details of clothing, furnishings, and accessories such as dainty footwear, painted furniture, patterned floor coverings, books, pictures on the wall, and sometimes the family's pet cat or dog. Although the face is in profile, the body is turned slightly so that the viewer can see the fronts of dresses and suits. Single portraits are always drawn with the profile facing the right-hand side of the paper. Presumably Davis found this preferable since he was left-handed, as he revealed

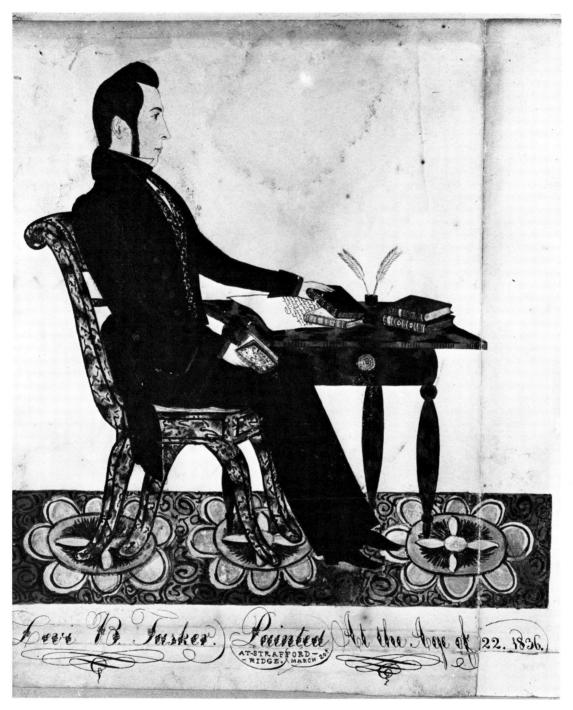

JOSEPH H. DAVIS. *Levi B. Tusker—At the Age of 22, 1836. Painted at Strafford-Ridge March 20th.* Pencil, inks, and watercolor on paper. (*Old Sturbridge Village*)

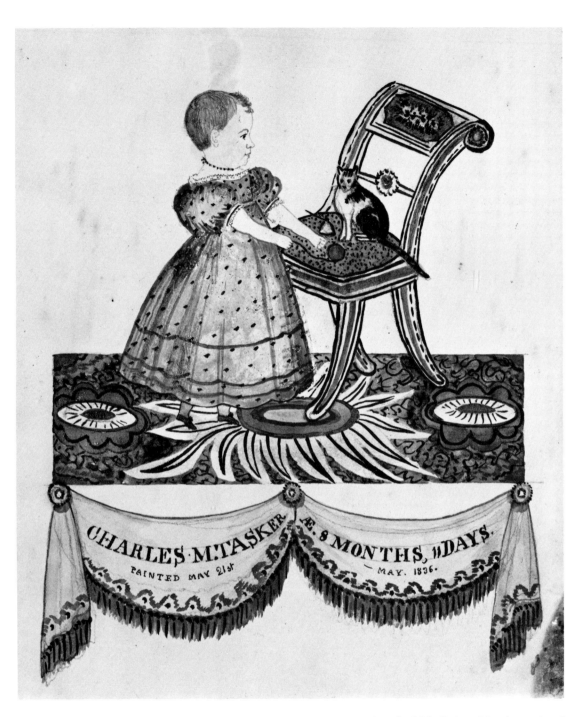

Charles M. Tasker. A charming watercolor on paper dated 1836. Painted in the style of Joseph H. Davis but with uncharacteristic calligraphy. (*Collection of Howard A. Feldman*)

in the signature on one of his pictures. Double portraits show the sitters facing each other. Below the picture is decorative calligraphy which gives the subject's name and age as well as the date of the painting. Davis usually did not sign his paintings.

All the major details, such as the profile, facial features, and floor pattern, were first outlined in pencil and then sometimes again in black ink. Watercolor was then applied to this outline picture. Pencil guidelines often remain on the calligraphic legend in the lower margin. No shading was given the face although the cheeks may have some color. All of this meticulous detail was put on a sheet of paper which rarely exceeded twelve by sixteen inches.

The emergence of Joseph H. Davis as an artistic personality can be credited largely to the work of Mr. Frank O. Spinney who published his findings in the October 1943 issue of the magazine *Antiques*. Nothing concrete is known of Davis's background. Local legend gives his place of birth as Newfield, Maine. About 120 of his paintings have been recorded.

J. Evans also produced small watercolor profile portraits, few of which are signed. Unlike those of Joseph H. Davis, the Evans sitters are not shown with elaborately painted furniture. When furniture is shown, it is a more formal type. Patterned rugs are occasionally pictured, but Evans did not use the decorative calligraphy so typical of Joseph H. Davis, and he seldom wrote on the front of the pictures. His portraits are painted in watercolor without evidence of any pencil sketch underneath.

Nothing concrete is known of the life of J. Evans. Only twenty-eight of his paintings have been recorded.

J. A. Davis also produced small watercolor portraits, but unlike J. Evans and J. H. Davis who preferred profile portraiture, J. A. Davis's work typically shows the sitter full face and bust length, although a few portraits are full length. In general, the J. A. Davis portraits are smaller than those produced by the other two artists in this group. They are not as elegant and well done as the Evans portraits nor so decorative and charming as those made by Joseph H. Davis. The mood is more somber than the sprightly work of the other two.

Many of the J. A. Davis portraits identify the sitter in a calligraphic script on the bottom of the picture. The style of the

letters is similar to that of Joseph H. Davis, leading one to the conclusion that J. A. Davis may have seen one of his portraits and adopted it for his own work.

The emergence of J. A. Davis as an important miniature watercolorist is in large measure the result of the work of Norbert and Gail Savage, who first published their findings in the magazine *Antiques* for November 1973. Until that time many of the J. A. Davis portraits were attributed to Eben P. Davis, a carpenter and amateur artist of Byfield, Massachusetts.

About fifty paintings by J. A. Davis have been recorded. Few are signed.

James Sanford Ellsworth (ca. 1802–ca. 1874, active ca. 1835–55)
Worked in Connecticut and western Massachusetts

Ellsworth is best known for his distinctive watercolor miniature portraits, almost all of which are half-length profiles of Connecticut and Massachusetts sitters, executed mainly between about 1835 and 1855. These small images on paper usually show the sitter with a cloudlike formation about the head and sometimes also at the waist. Of the 256 portraits recorded so far, only 7 are full face; the rest are profiles. Only one is a full figure; the remainder are mostly half-length studies. The subjects are frequently shown seated in Victorian chairs which seem to wrap around the hips. Draftsmanship is often meticulous and realistic with even minute details shown on the lace caps of the ladies. Curiously, none of Ellsworth's recorded paintings show a sitter holding or wearing glasses. He signed about half of his paintings, usually somewhere on the front.

James Sanford Ellsworth was born in Connecticut (probably Windsor) in 1802. He is believed to be a self-taught artist. Early in his career he did some portraits in oils and also made a copy of Gilbert Stuart's *Washington*. His very tardy marriage on May 23, 1830, to Mary Ann Diggs of Hartford was apparently an unhappy one and about 1833 it is thought that he left Hartford and wife for the West. During his travels he seems to have painted some pictures including one attributed to him and painted in St. Louis called *A Wounded Grecian Racer*. He returned to Connecticut about 1835 and for the next twenty years or so earned an apparently poor living as an itinerant painter of miniature portraits. In 1861 he made a trip from Connecticut to Ohio, coming back through Pennsylvania and New York. He is believed to have died in an almshouse in Pittsburgh, Pennsylvania, in 1874.

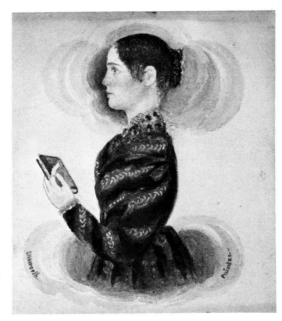

JAMES SANFORD ELLSWORTH. *Mary Ann Morgan.* Signed on front: "Ellsworth/Painter." Painted ca. 1845. Watercolor on paper, $3\frac{1}{8}$" x $2\frac{3}{4}$". (*Museum of Fine Arts, Boston, M. and M. Karolik Collection*)

Erastus Salisbury Field (1805–1900, active in portrait painting ca. 1828–42, in other subject areas ca. 1842–1900)

Worked in central Massachusetts, northern Connecticut with some commissions in Hartford, New Haven, and possibly also eastern New York State and Vermont

Today paintings by Erastus Salisbury Field are among the most widely sought-after and admired, by both collectors and museums, of the nineteenth-century folk portraits. He painted in a moderately rugged style and with a broad brush stroke without dwelling unduly on fine detail. Field rarely signed his portraits. Of the 227 in the October 1963 *Bulletin of the Connecticut Historical Society,* only 2 are listed as being signed.

Some often recurring characteristics in the portraits by Field include a stiff formal pose, a light-colored cloud around the subject's head, elflike ears, and peculiar red knuckles, almost like pimples. He often placed his sitter in a chair with bright red upholstery, and on the rare occasions when he painted a full-length portrait or a family group, his favorite scheme was to pose them standing on boldly patterned stenciled or carpeted floors. In his rendition of the body, he tended to make the waists too short, the shoulders too narrow and with too much slope, and the arms too long. His sitters usually hold some object in their hands.

Many of his canvases have blue-green blotches on the back, possibly from the sizing. The canvas is mounted on a stretcher

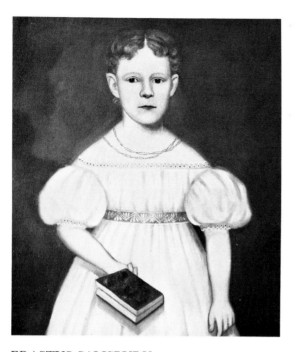

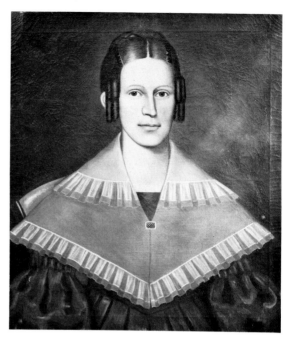

ERASTUS SALISBURY FIELD. *Portrait of Thankful Field.* Painted ca. 1836 in oil on canvas, 31″ x 25½″. (*Museum of Fine Arts, Springfield, Massachusetts*)

ERASTUS SALISBURY FIELD. *Portrait of a Young Girl.* Painted ca. 1835. This charming portrait of a young girl exhibits many of the identifying characteristics of Field's paintings. Oil on canvas, 26″ x 24″. (*Heritage Plantation of Sandwich*)

handmade by Field and the undercoat is generally a light gray. Flesh tones on faces and hands are usually applied in thickish dabs of runny paint in a technique not unlike that used later by the pointillists. Often the gray undercoat shows clearly between the dabs of flesh-colored paint, giving the flesh tones a grayish hue. Upon close inspection the surface reminds one of the texture of an orange peel with the pinkish color on the ridges and the gray in the valleys.

Field's paintings were exhibited as early as 1932 by the Museum of Modern Art in New York City, but it was not until 1942 that he ceased to be an "anonymous artist." This metamorphosis was brought about mainly by the work of Agnes M. Dods and Frederick B. Robinson. Mr. Robinson of the Museum of Fine Arts in Springfield, Massachusetts, organized an exhibition of many of Field's paintings in that year.

Erastus Salisbury Field was born to a farm family in Leverett, Massachusetts, on May 19, 1805, but other than that little is known of his early life. In 1824, at nineteen years of age, he spent three months in the studio of Samuel F. B. Morse in New York City where he apparently received the bulk of his artistic education. This brief training was cut short by the sudden death of Morse's young wife.

One of Field's earliest portraits after this training was of his grandmother, Elizabeth Billings Ashley, which was painted about

1825, shortly before her death in 1826 (see illustration, p. 11). Field married Phebe Gilmer (or Gilman) of Ware, Massachusetts, in 1831 and in 1833 the couple had a daughter, Henrietta, their only child. There is no record of where they lived during each of the periods of their married life but it is known that they moved often.

Field's most productive period is from about 1828 to 1842. During this time he worked as an itinerant artist producing perhaps a thousand canvases, mostly throughout central Massachusetts and northern Connecticut with some commissions in Hartford, New Haven, and probably western New York State and Vermont. From about 1842 to 1848 he lived in New York City and it is assumed that among other things, he learned about photography, possibly again from Samuel Morse. Portraits by Field after 1848 exhibit a change in style and look like copies of daguerreotypes. By 1854 he was back in Massachusetts in Palmer, experimenting with a device to produce mechanically a "likeness" from a photograph. After the death of his wife in 1859, he settled in Sunderland and spent the remainder of his long life as a teacher, as a photographer perhaps, and as a painter of patriotic, biblical, and other subjects, some on a grand scale. He painted only a few portraits during this time. He died in 1900.

His distinctive portraits painted during his prime period represent an important facet of American art.

ERASTUS SALISBURY FIELD. *Mr. and Mrs. John Hollister of Glastonbury, Conn.* Oil on canvas, 31" x 24". (*Old Sturbridge Village*)

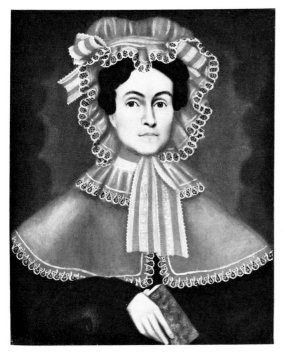
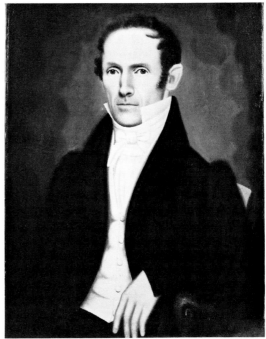

William Jennys (active ca. 1795–1807)
 Worked in Connecticut, Massachusetts, Vermont, and New Hampshire

Richard Jennys (active ca. 1783–ca. 1798)
 Worked mostly in Connecticut

At the other end of the spectrum from most of his competitors, William Jennys produced a distinctive, high-contrast portrait with strong character and exaggerated modeling of the facial features. Whereas other itinerant limners usually painted in a flat style with little use of shadow, Jennys adopted the opposite extreme. His portraits look as though the sitter has been illuminated with a brilliant point source of light located at eye level that throws sharp shadows on the face.

Almost all of his portraits are half-length views in oil on canvas, usually in painted ovals on a rectangular canvas. In a recent exhibition of nineteen of his works, sixteen are ovals. Only three of these are signed, in all cases on the reverse. The sitters' hands are generally out of sight either below the canvas edge or tucked into the vest in the case of gentlemen. Clothing is very important in Jennys's paintings and is shown in detail. Like the faces, it is shown with sharp contrast. His women frequently wear fancy beribbonned bonnets or caps and a lace collar or shawl. He usually

WILLIAM JENNYS. *Mr. and Mrs. Hewitt.* An example of Jennys's early softer style. Oil on canvas, 30″ x 25″. (*Museum of Fine Arts, Springfield, Massachusetts*)

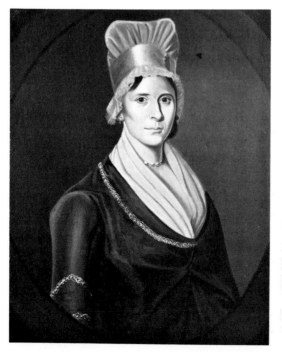
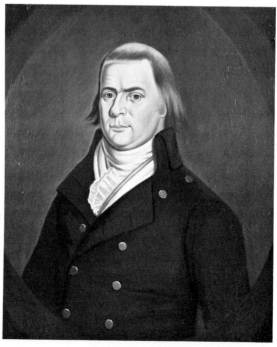

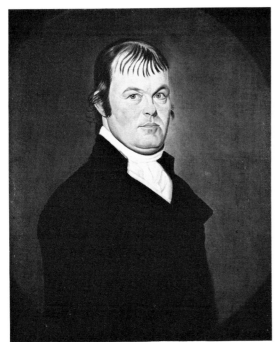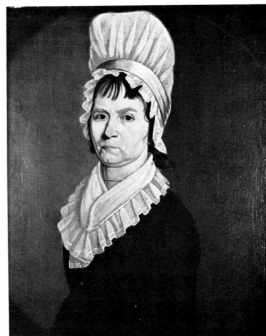

WILLIAM JENNYS. *Major and Mrs. Ruben Hatch.* Examples of
the artist's later style, ca. 1805. Oil on canvas, 30″ x 25″. (*Lyman
Allyn Museum*)

painted over a greenish undercoating which gives the faces a
greenish cast. It has been suggested that William Jennys had three
distinct styles of painting, developing along the same general theme
to his final hard and quick formula, a transition from conventional
flattery to startling realism. The transition was probably forced to
meet a price.

Nothing is known of William Jennys other than the fact that
he worked as an itinerant artist from about 1795 to about 1807.
From the identity of the sitters he is known to have worked in
Connecticut, Massachusetts, Vermont, and New Hampshire. No
advertisement of his offering to paint the local residents has been
found. Many additional portraits have been located since 1956
when the Connecticut Historical Society compiled a checklist of
ninety-seven portraits attributed to him.

Some of his paintings are almost indistinguishable from those
produced by Richard Jennys. Although it has yet to be demon-
strated, the similarity in style as well as name has led to the
assumption that the two Jennyses are somehow related. From about
1792 to 1798 Richard also worked in Connecticut. Sometime before
that, in 1783, he is known to have advertised for commissions in
the papers of Charleston, South Carolina. A Boston mezzotint with

a credit line to a painting by Richard Jennys, Jr., indicates that he also worked in Boston as early as 1766. A fair number of portraits have been found in Connecticut, but so far none have been discovered from either Boston or South Carolina. The lives, careers, and relationship, if any, between the two Jennyses remains elusive.

Jacob Maentel (or Mantel) (1763–1863, active ca. 1810–ca. 1825 in profiles, 1825 and later with full faces)

Worked around Philadelphia, Pennsylvania, and New Harmony, Indiana

Maentel is best known for his distinctive full-length watercolor portraits of Pennsylvania German country people done with great style. His subjects are shown with a proud bearing, good detail of facial features and clothes, small feet, and always with something in their hands. The farm or house interior sometimes included as background is rendered with the distortion in perspective common to unschooled painters. When a background is not included, the subject is shown standing on a rounded piece of land, perhaps to suggest the spherical shape of the earth. Such pictures on paper that averages ten by twelve inches in size are outlined in ink and painted in watercolor. They were executed between 1810 and 1825, after which time Maentel switched to a less interesting full-face style. Portraits are usually unsigned, but in some combinations of portraits with birth records he included his name in the fraktur lettering below the picture.

Jacob Maentel was born in Germany in 1763. Some say that he was trained as a physician and later served as a secretary to Napoleon before coming to America sometime before 1810. From 1810 to about 1830 he painted in Pennsylvania and then settled in New Harmony, Indiana, where he died in 1863. He lived to be nearly one hundred years old.

Sheldon Peck (1797–1868)
Worked in Vermont and Illinois

Peck is believed to have been born in New England where in 1824 he painted portraits on wooden panels of Mr. and Mrs. Alanson Peck of Cornwall, Vermont. In the 1830s he moved to Illinois and settled in the small town of Lombard, close to Chicago. There in the 1830s and 1840s he painted a series of double portraits in room settings which have since become his best-known portrait style. In

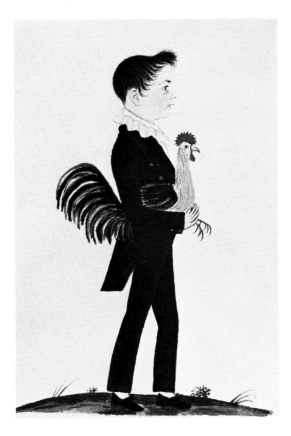

JACOB MAENTEL. *Boy with Rooster.* Typical of the artist's simpler compositions. Painted ca. 1815–25 in watercolor on paper, 7⅞″ x 5¾″. (*The Henry Francis du Pont Winterthur Museum*)

JACOB MAENTEL. *Mr. Brenizer, Lancaster County, Pennsylvania.* Painted in watercolor on paper, 11½″ x 7⅝″ (sight). (*Collection of Howard A. Feldman, Photograph courtesy of Hirschl and Adler Galleries, New York*)

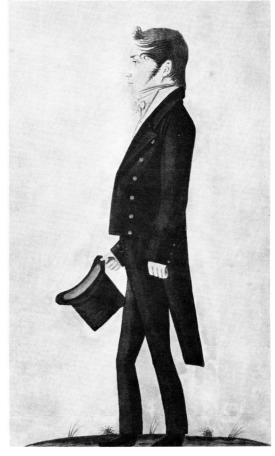

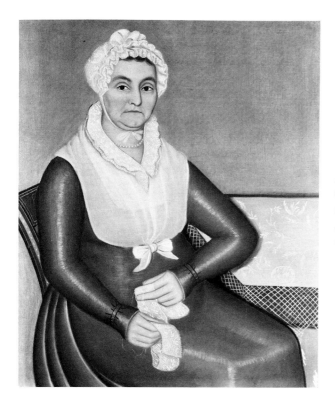

AMMI PHILLIPS. *Alsa Slade.*
Oil on canvas, 40″ x 33″.
(*National Gallery of Art, Gift of
Edgar William and Bernice Chrysler
Garbisch*)

AMMI PHILLIPS. *Joseph Slade.*
An example of Phillips's "Border
Limner" style. Painted in oil on
canvas, 40″ x 33″. (*National
Gallery of Art, Gift of Edgar
William and Bernice Chrysler
Garbisch*)

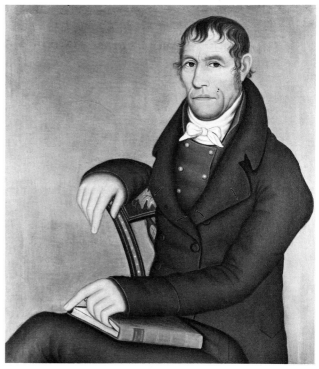

these compositions he often painted a simulated frame directly on the canvas. The subjects are generally stern faced and rendered with much distortion in perspective and anatomy. The floor is often painted as a simple, uncovered series of wide boards angling in from the frame. The front edge is sometimes shown in cross section as if the front of the room had been cut off with a saw, leaving the sitters on a theaterlike stage.

Ammi Phillips (1788–1865, active 1811–65)
Worked in western Massachusetts, western Connecticut, and adjacent areas in New York State from just north of New York City to Keesville near Lake Champlain

To many the portraits by Ammi Phillips are the embodiment of all that is most desirable in American folk portraiture. In Phillips's case there are two distinct and admired styles, both of which are well represented in major museums and prominent collections. From about 1811 to 1820 he worked in his "Border Limner" style. His later "Kent" style with its sophisticated, stylized composition peaked in the period from 1830 to 1840.

His "Border Limner" style is characterized by an almost pastel palette of thinly applied paint. The sitter is typically shown with thick "thyroid" swollen necks, "sliding pond" laps when seated, wide, prominent lips, and poorly drawn hands. Facial features are essentially flat and bordered by bold outlines. Yet there is a dreamlike, almost ethereal feeling in some of these, especially in the portraits of children.

His "Kent" period portraits are an order of magnitude more sophisticated than the earlier ones, so much so that it is difficult to imagine them as the work of the same person. The thyroid-swollen neck is replaced by one of swanlike delicacy, the sliding-pond lap is under control, lips are smaller and less prominent, hands are often cupped and well drawn. The faces have pinkish-ivory flesh tones and project a sophisticated and reserved attitude, sometimes even haughty. The palette is darker and the paint has been applied more heavily and smoothly with the features of the more sculpturally modeled face outlined with whitish highlights. There is a fondness for exquisitely rendered, semitransparent fabric and flat lace on female models which softens the stark silhouettes. The women lean gracefully to one side in a characteristic pose. The whole is a stylized composition with the hands, faces, and collars or cravats serving as accents against the dark colors of the clothing.

There is a strong feeling for geometry with sharp angles, and particularly triangles. Phillips's finest female subjects have egg-shaped heads supported by slender necks that rise from sharply sloping shoulders. The triangle of the shoulders and the top of the dress is often further reinforced by triangular lacy or filmy collars. In contrast with the porcelainlike faces of the women, the men are rugged with sharper features. They sit upright, often with hands hanging limply from the wrist or the elbow, resting on the back of a chair or on a table. Each person is given some degree of individuality despite the formulalike composition.

Throughout his career Phillips favored a strainer to hold the canvas rather than the adjustable stretcher used by many other artists. This rigid frame was probably made by the artist himself. Early ones, before 1820, are distinctive in that they often used two wooden dowels at right angles to secure the corners. Later strainers have screws and nails instead of wooden dowels. The frames were usually simple moldings which were nailed to the strainer.

Much of what we know about Ammi Phillips is from the efforts of Barbara and Lawrence B. Holdridge. Before Mr. and Mrs. Holdridge began their quest, it was generally believed that the "Border Limner" and the "Kent Limner" were different artists.* Phillips rarely signed his paintings, but two key signed portraits, one of Mrs. Ephraim Judson painted in 1811 and the other of George C. Sunderland painted in 1840, were found and became the Rosetta Stone that tied the periods together for the Holdridges. It was not until 1958 that they discovered the latter painting.

Phillips was born in Colebrook, Connecticut, on April 24, 1788. Very little is known of his early life or of who may have instructed him in painting. It has been speculated that the works of Reuben Moulthrop and other painters working in the Litchfield-Colebrook area sparked his interest in painting and that J. Brown, a minor portrait artist, provided instruction. In any event, by 1811 he had finished the signed portrait of Mrs. Judson.

On March 18, 1813, he married Laura Brockway and they had at least five children before she died in 1830. Some six months later he married Jane Ann Caulkins and eventually had four more children. During his working life, it apparently was Phillips's practice to move his family to a likely area for new business and then to make painting forays from his new home base. He is known to

*Some remain unconvinced that the Border and Kent limners are the same artist. Their contention is based on the great stylistic differences and the absence of a group of transitional paintings. This case is bolstered by some anomalies and gaps in the information uncovered by the Holdridges.

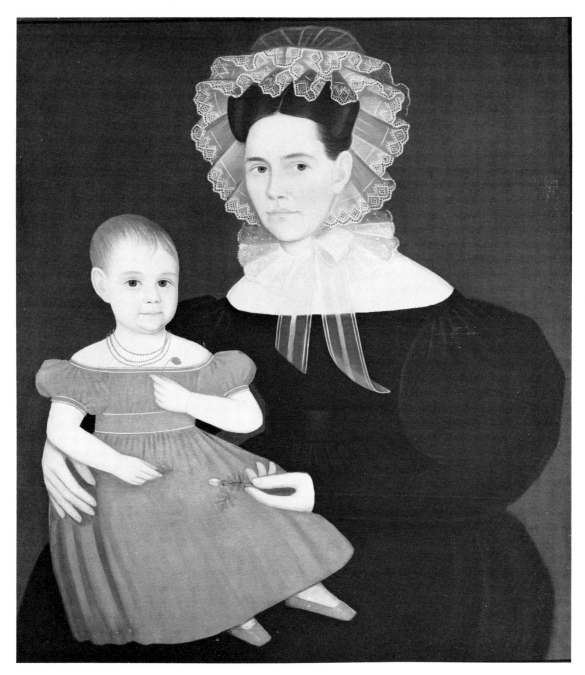

AMMI PHILLIPS. *Mrs. Mayer and Daughter.* An example of Phillips's later "Kent Limner" style. Painted ca. 1835 in oil on canvas, 38″ x 34½″. (*Metropolitan Museum of Art, Gift of Edgar William and Bernice Chrysler Garbisch, 1962*)

have lived in Colebrook, Connecticut; Troy, Rhinebeck, America, Fishkill (or Beacon), and North East, all in New York; and Interlaken, Massachusetts.

Ammi Phillips's portrait commissions included town professional men and their families, farmers, wealthy landowners along the Hudson, and a wide variety of other rural inhabitants. Comparison of his portraits with daguerreotypes of the sitters shows that he was capable of capturing a good likeness. Several hundred of his portraits are known to exist, but it is estimated that he must have completed over one thousand canvases during his lifetime. His most famous foray was to Kent, Connecticut, in 1836 where he painted many of the inhabitants of this small village. It was here in 1924 that his paintings were rediscovered and the artist dubbed the "Kent Limner," a term that is now applied to him in his mature style.

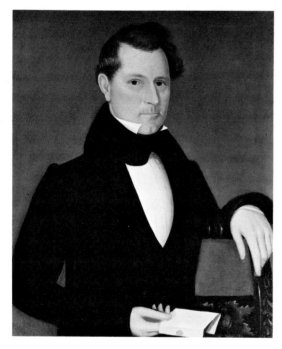

AMMI PHILLIPS. *Captain Isaac Cox.* Painted ca. 1836 in the Kent County, Connecticut–Amenia, New York area. Oil on canvas, 32″ x 27″. (*Collection of Mr. and Mrs. Frank J. Miele, Photograph courtesy of Hirschl and Adler Galleries, New York*)

AMMI PHILLIPS. *Mrs. Isaac Cox.* A fine example of the artist's "Kent" style. Painted in oil on canvas, 32″ x 27″. (*Collection of Mr. and Mrs. Frank J. Miele, Photograph courtesy of Hirschl and Adler Galleries, New York*)

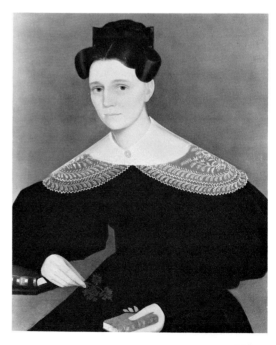

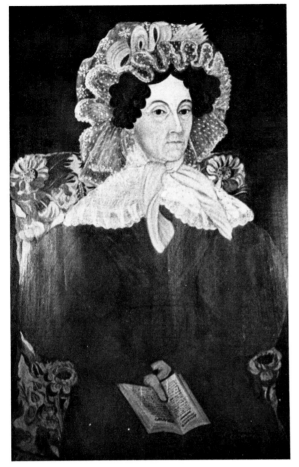 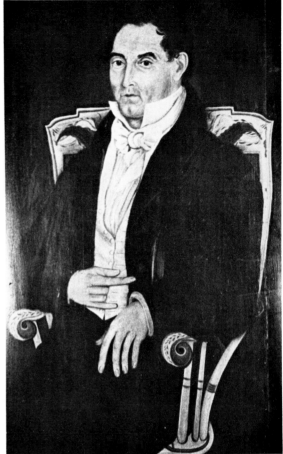

ASAHEL POWERS. *Mrs. Jonathan Chase* (Susan Fisher Chase). Signed on reverse: "S. Chase—AE 34 y 2 m/Springfield Vt Sept 22 1832/Asahel Powers." Oil on wood, 37" x 25⅜". ASAHEL POWERS. *Jonathan Chase.* Signed on reverse: "Jona Chace. AE, 42'y—11 m/Springfield—sept 22d 1832/Asahel Powers painter." A portrait of a solid country citizen who was probably the proprieter of a general store. Oil on wood, 38" x 25¼". (*Springfield Art and Historical Society, Springfield, Vermont*)

Asahel Lynde Powers (1813–43; active 1831–40)

Worked in and around Springfield, Vermont, and in the northeastern part of New York State

"Itinerant Artist, Asahel Powers" is the title of the 1973 exhibit of his work at the Abby Aldrich Rockefeller Folk Art Collection in Williamsburg, Virginia. Like many other self-taught artists, his early work is in the naive folk art tradition with little modeling of features, flagrant distortion of anatomy and perspective, and a predilection for bright colors. Later work in his short career is in a style more closely allied to the academic tradition. His paintings are relatively scarce.

A good number of his portraits are signed and dated on the reverse. Up until about 1835 he used his full name, Asahel Powers,

but then he switched to the use of initials and signed himself "A. Powers" or "A. L. Powers." During the first half of his career he usually painted on wood panels, but his later portraits are on canvas or ticking.

Asahel Powers was born the son of a farmer in Springfield, Vermont, on February 23, 1813. By the time he was eighteen he was a traveling artist painting portraits in the vicinity of Springfield. Little is known of his life or activities, but it is recorded that he died in Olney, Illinois, on August 20, 1843, survived by his wife, Elizabeth, and his mother and father. It is also known that his parents had moved to Olney in the early 1840s. No signed portraits have yet been reported in Illinois.

William Matthew Prior (1806–73)
Worked mostly in southern Maine, eastern Massachusetts, Rhode Island, and, ca. 1855, in Baltimore, Maryland

Prior-Hamblen group including
Sturtevant J. Hamblen (active 1837–56)
Jacob Bailey Moore (1815–93)
George G. Hartwell (1815–1901)
G. Alden (1804–62)

The name William Matthew Prior together with that of Sturtevant J. Hamblen represents only the tip of what is now called the Prior-Hamblen group; much of the rest is still submerged. An undetermined number of artists painted in styles so similar, and with so few of their works signed, that attributions to any one in particular are tentative. For convenience they have been lumped together under the umbrella of the Prior-Hamblen group. Prior is best known for his very flat, posterlike portraits painted in oil or gouache on canvas, academy board, or cardboard. For those willing to pay more, he also painted portraits in the academic tradition with shading and modeling, but today these are regarded as rather dull. Others known to have painted in an almost identical flat style include Sturtevant J. Hamblen, Jacob Bailey Moore, George G. Hartwell, and G. Alden.

William Matthew Prior was born in Bath, Maine, on May 16, 1806. Little is known of his early life, but in 1824, at the age of eighteen, he signed a portrait of a young man that he painted in Portland. Starting in 1827 there are advertisements in Maine newspapers showing that he worked in Bath principally as an

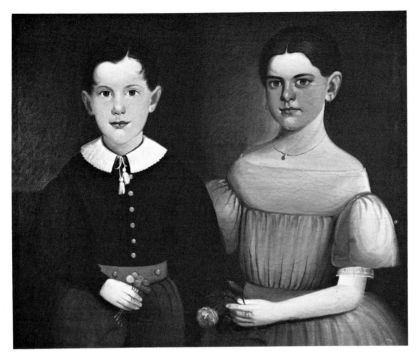

ornamental and sign painter. In 1831 he advertised that "persons wishing for a flat picture can have a likeness without shade or shadow at one quarter price." Even early in his career he had two standards for painting, the very flat primitive style and the modeled academic style. It is also evident that the flatness of American folk portraits was not necessarily a result of ineptitude but in some cases may have been a conscious choice.

On April 28, 1828, he married Rosamund Clark Hamblen. About 1833 they moved from Bath to Portland where he lived with his brother-in-law, Nathaniel Hamblen, also a painter. He soon obtained his own quarters and in 1837 two other brothers-in-law, Joseph G. and Sturtevant J., also painters, were listed as living with him. After the death of a fourth Hamblen brother, Eli, in 1839 the group moved to Boston. In 1846 Prior moved to his own house at 36 Trenton Street, East Boston, which he named "The Painting Garret." The Hamblens called themselves "house, sign and fancy painters," but Sturtevant J. also set himself up as a portrait painter following the example set by Prior.

Both Prior and Joseph G. Hamblen became deeply involved in William Miller's Adventist movement which predicted the Second Coming of Christ and the end of the world between 1843 and 1844. The failure of these prophecies left Prior undaunted and in 1863 he wrote his first book in support of Miller's theories, *The King's Vesture.*

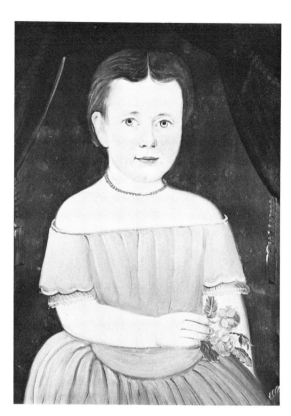

WILLIAM MATTHEW PRIOR. *Girl with Flowers.* Inscribed in contemporary hand on backboard: "Painted by Wm M. Prior July 7, 1855 New Bedford. Painting $4.00, Frame $3.00." A rare example of a "flat" portrait with something more than an attribution to Prior. Oil on academy board, 17½″ x 13¼″.

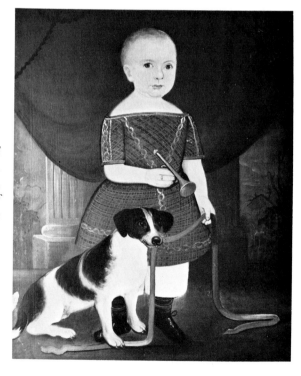

Child with Red Dress, Trumpet, and Dog. Attributed to William Matthew Prior. Oil on canvas, 34″ x 28″. (*Heritage Plantation of Sandwich*)

William Prior earned his living as an itinerant portrait artist going out on trips from his East Boston home by horse and wagon to towns in nearby New England and by train to more distant places, including Baltimore around 1855. Additional income came from his landscapes and especially his paintings on glass. His most successful portrait was *George Washington,* a copy of the Gilbert Stuart work which hung in the Boston Athenaeum. On paydays he would sell his patriotic portraits to the workers in the shipyards, in hotels, and in other sections of Boston. His sons, Gilbert and Matthew, helped him in the business, and in an interview with Matthew in the 1930s Clara Endicott Sears found the old man still painting on glass as his father had taught him.

Prior's first wife died in 1849 after bearing him eight children. He married Hannah Frances Walworth a year later and continued painting at his "Garret" until he died in 1873.

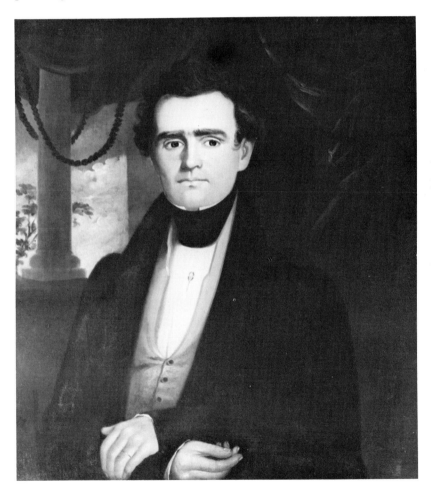

WILLIAM MATTHEW PRIOR. *Winslow Purinton.* Signed on back: "Painted by Wm Prior 1835." An example of Prior's "modeled" portrait style. Oil on canvas, $31\frac{1}{2}$" x $27\frac{1}{2}$". (*Fruitlands Museums*)

Sturtevant J. Hamblen worked as a portrait painter from about 1837 until 1856 when he went into the clothing business with his brother Joseph. As many as six Hamblens were listed at one time as painters in Boston in the 1840s and 1850s. Some of these were children of the original group.

George G. Hartwell, another member of the Prior group, was a relative by marriage of the Prior family. He painted signs and portraits in Bridgewater, Massachusetts, and Auburn, Maine.

Jacob Bailey Moore was still another who painted portraits in the flat Prior style. He was a painter as well as a phrenologist and journalist during different periods of his life. A native of Candia, New Hampshire, he went to Boston where he lived for a time before returning to his home state.

A letter which casts some light on the Washington portraits on glass was written by Matthew Prior on April 2, 1932, and is in the files of the Fall River Historical Society. It reads in part:

> Before taking up painting on glass, my father painted portraits on canvas in oil. As a child I remember of a few weeks visit at Fall River where he was engaged in painting portraits there. I can remember other Massachusetts towns where we moved from town to town during these sittings. During the Civil War times changed and he found it more profitable to paint professional subjects.
>
> Being skilled in this glass painting from early training on mirrors and clock work, he turned to portraits on glass. You see as it was hard to make a living in those days and by working on glass he could get along faster, as he could seal them up by putting on the back and did not have to wait for them to dry, but could sell them wet without damage.
>
> In those days paint would not dry in two or three hours but took three or four days and this was a great help in not being obliged to wait.
>
> We lived in East Boston and as he could paint a picture in a day the next evening he could go to the hotels in Boston and generally could sell one for about three or four dollars. He took me many times for the company.
>
> . . .
>
> P.S. For three years he tried time after time to get permission to copy the original Gilbert Stuart's George Washington. At last they allowed him to copy it. And this was the painting that all glass paintings were copied from. He signed this oil painting "Copy from G. Stuart by William M. Prior 1850."

STURTEVANT J. HAMBLEN.
Hannah M. Jewett. Signed and
inscribed on backboard:
"H. M. J. aged 16 yrs/Painted by
S. J. Hamblen/1841." A rare
signed example of the work of
S. J. Hamblen. The flat style is
very similar to the work of
William Prior, his
brother-in-law. Oil on academy
board, 14" x 10⅛". *(Collection of
Howard A. Feldman, Photograph
courtesy of Hirschl and Adler
Galleries, New York)*

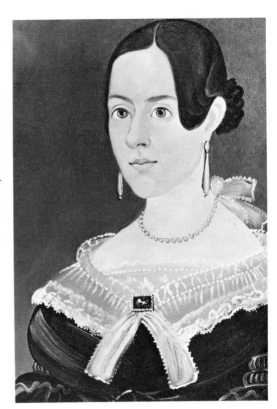

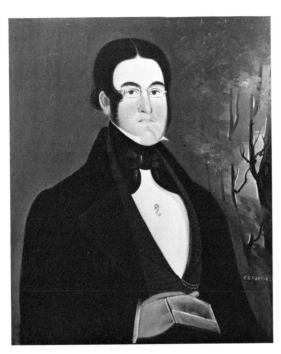

G. G. HARTWELL. *Man.* Another
signed "flat" portrait by a member of
the Prior-Hamblen group. Signed on
front: "G. G. Hartwell." Painted in
oil, 26¼" x 21½". *(Fruitlands Museums)*

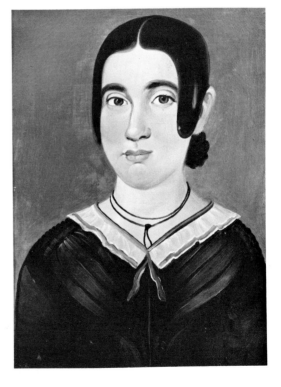

G. ALDEN. *Woman.* A signed
"flat" portrait by a member of
the Prior-Hamblen group.
Signed on front: "G. Alden."
Painted in oil on academy
board. *(Fruitlands Museums)*

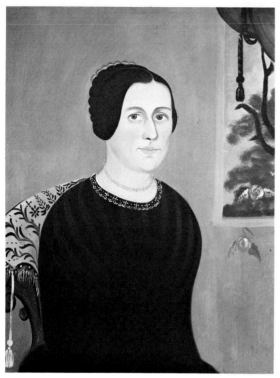

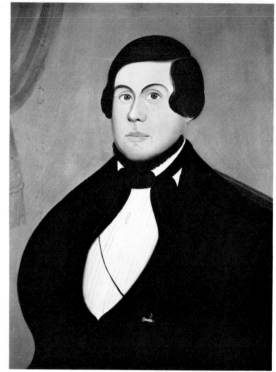

Woman with Gold Necklace. By one of the Prior-Hamblen group, ca. 1850. Oil on canvas, 27¼″ x 22¼″. (*Collection of Herbert W. Hemphill, Jr., Photograph courtesy of Heritage Plantation of Sandwich*)

Man with Gold Pencil. Painted by a member of the Prior-Hamblen group, ca. 1850. A fine example of the "pigeon-breasted" style. Oil on canvas, 27½″ x 22¼″. (*Collection of Herbert W. Hemphill, Jr., Photograph courtesy of Heritage Plantation of Sandwich*)

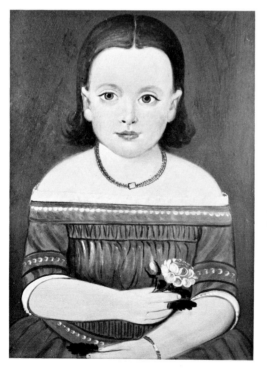

Luella Chace of New Bedford. A charming portrait of a small girl painted ca. 1850 by a member of the Prior-Hamblen group. Gouache on academy board, 15¼″ x 11½″.

Isaac Sheffield (1798–1845)
Worked mostly in and around New London, Connecticut

In 1927 Richardson Wright in his book *Hawkers and Walkers in Early America* stated that Sheffield specialized in portraits of sea captains and "they were all painted with red faces, all standing before a red curtain, and each holds in his hand a single telescope." He could also have mentioned that a ship, presumably that of the captain, can be seen in the background. Although this is an over-simplification of his style and palette, it is nevertheless true that Sheffield is best known for his portraits of whaling families and sea captains. He painted on both canvas and wood and in full size as well as in miniature.

Isaac Sheffield was a native of Guilford, Connecticut, but settled in New London about 1833. He worked in that area until his death in 1845. Little is known of his life.

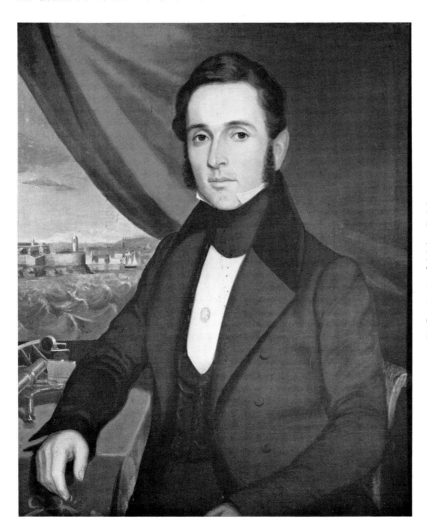

ISAAC SHEFFIELD. *Captain Benjamin R. Latham.* The town of New London and Fort Trumbell are shown through the window in the background. Oil on canvas, 30″ x 25″. (*Lyman Allyn Museum*)

Perhaps his best-known work is the full-length portrait of James Francis Smith at the age of five years and ten months. He is shown in a penguin-skin coat just after landing from a whaling expedition to the South Seas. The portrait was painted in 1837.

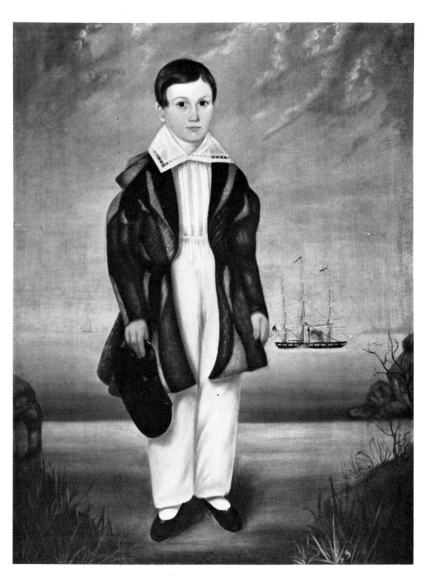

ISAAC SHEFFIELD. *James Francis Smith.* The young boy is shown in his penguin-skin coat after returning from a South Seas whaling expedition. Oil on canvas, 48" x 35½". (*Lyman Allyn Museum*)

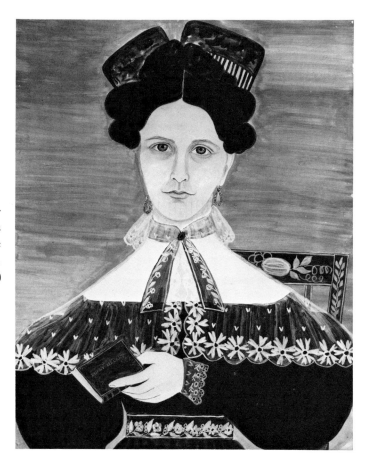

THE SHUTES. *Dolly Hackett.* This large watercolor on paper uses the full-front pose that is characteristic of the work of the Shutes. Paper, 23¾″ x 19″. (*Fruitlands Museums*)

R. W. and S. A. Shute (active 1830–40)
Worked in Massachusetts, New Hampshire, and Vermont

The Shutes, possibly husband and wife, painted many portraits in both oil and watercolor during the 1830s, working in the central part of New England. The watercolor portraits are on large sheets of paper averaging eighteen by twenty-two inches and were drawn in pencil before being painted. A typical picture is a waist-length portrait of the subject sitting on a stenciled chair. A frontal pose with a full or almost full face is usual.

Many of both the oils and the watercolors are signed on the back in one of a variety of signatures. Some of the combinations are:

Mrs. R. W. Shute
S. A. and R. W. Shute
Drawn by R. W. Shute—Painted by S. A. Shute

Signature and inscription on the back of the portrait *Dolly Hackett.* (*Fruitlands Museums*)

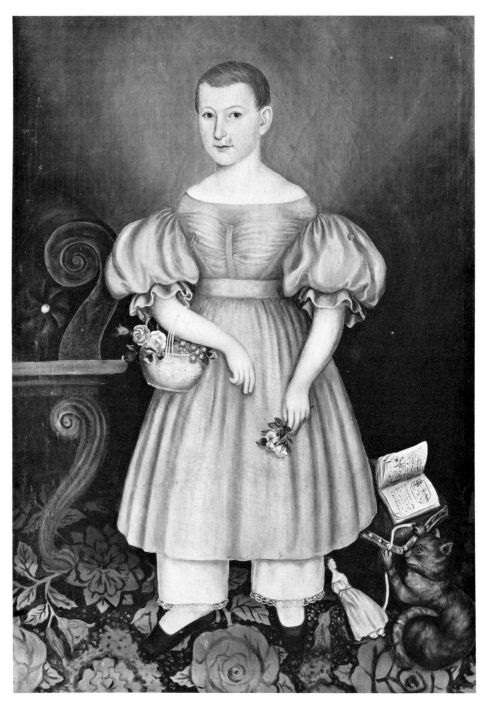

JOSEPH W. STOCK. *Portrait of Mary Amidon.* A typical and charming portrait by Stock. Oil on canvas, 48″ x 33″. (*Museum of Fine Arts, Springfield, Massachusetts*)

Joseph Whiting Stock (1815–55, active 1832–55)
Worked mostly in Springfield, Massachusetts, but also in New
Bedford; New Haven, Connecticut; and Warren, Bristol, and Prov-
idence, Rhode Island

Although he did a wide variety of other work as well, Joseph
Whiting Stock, the disabled artist from Springfield, is known today
for his large, fine, full-length portraits of children. In a typical
painting, such as the portrait of Mary Amidon, the child is shown
standing on a brightly patterned carpet with a cat or dog to which
the child points or which is otherwise prominent in the composition.
A few show the child outdoors fishing or engaged in some other
activity. The interior settings include dolls, flowers, or books in the
hand or close by. Furniture usually appears as part of the back-
ground. There is considerable distortion in perspective, particularly
with respect to the carpet and furnishings.

The body from the waist up is often shown in a seven-eighths
view. In a standing portrait the feet are prominent with the right
foot commonly turned at a forty-five-degree angle relative to the
left foot. Stock liked to surround the head with a subtly lightened
area of the background. Ears are prominent and hair close-cropped
and neat. Facial expressions are pleasant. Girls are clothed in bright,
colorful dresses with pantalets. In common with other limners of
the day, Stock used a flat style with little modeling of the features.
He signed some paintings on the back, but many others are un-
signed.

Joseph Stock was born January 30, 1815, in Springfield,
Massachusetts. At the age of eleven, he suffered a serious injury
when he was crushed under a falling oxcart and as a result was
confined to a wheelchair for the rest of his life. In 1832 he studied
painting under Francis White, a young pupil of Chester Harding,
and quickly developed into a fast artist. His diary or journal lists
938 paintings completed between 1832 and 1846. He lived and
worked mostly in Springfield and died there of tuberculosis when
he was only forty years old. Although disabled, he managed to
travel some and is known to have painted in New Bedford, New
Haven, Warren, Bristol, and Providence.

For a short period he was in partnership with a man named
Cooley and in 1846 this advertisement appeared which shows how

the portrait business was becoming dominated by the daguerreo-typists:

> Stock and Cooly. Portrait and Daguerrean Gallery. Opposite Chicopee Bank, Main St. Where the public are respectfully invited to call and examine their specimens of painting and superb colored daguerreotypes. Likenesses taken in a superior manner on large or small size plates and in groups of from two to seven persons. A perfect and satisfactory likeness guaranteed. Likenesses taken of deceased persons. Instructions carefully given, and pupils furnished with everything necessary for the business at prices ranging from $.75 to $1.50. Photographs put up in breast-pins, lockets, cases, frames from $2. *Portraits from $8 to $25.*
>
> To daguerreotype operators—German cameras, lockets, plates, cases, chemicals, polishing materials and all articles used in the business furnished to order.

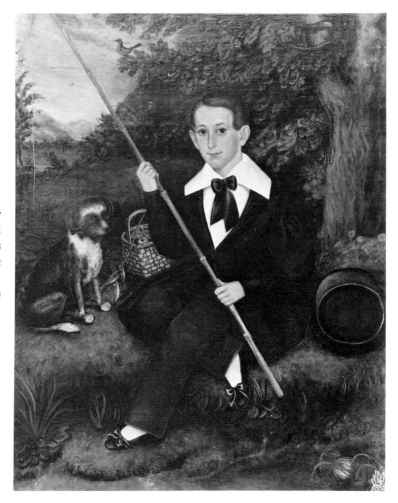

JOSEPH W. STOCK. *The Fisherman with His Dog.* Stock frequently painted pets in his portraits of children. (*Museum of Fine Arts, Springfield, Massachusetts*)

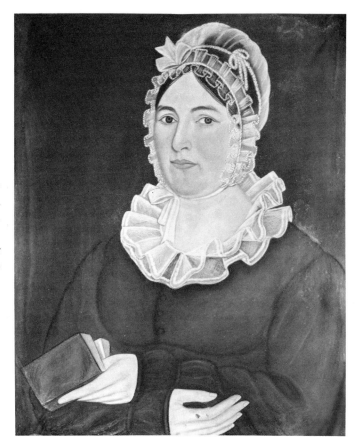

MICAH WILLIAMS. *Mrs. Henry Mundy* (Phoebe Ayres Mundy). Pastel on paper, 23¼″ x 19⅜″. (*New Jersey Historical Society, Newark, Photograph from Frick Art Reference Library*)

Micah Williams (1782–1837, active ca. 1815–ca. 1832)
 Worked in New Brunswick, Matawan, Freehold, and nearby towns in New Jersey; also possibly New York City from 1829 to 1832

"A Mysterious Pastellist Identified" is the title of Mr. Irwin F. Cortelyou's article in the August 1954 issue of *Antiques* magazine. Williams signed only a few of his pastels, and it was through persistent efforts on the part of Mr. Cortelyou together with help from other sources that this artist was finally identified and a pool of work ascribed to him based on his distinctive style. Almost all of his portraits are pastels, although he is known to have painted a few in oils including a signed example in the Abby Aldrich Rockefeller Folk Art Collection.

Most of his pastels are large, on paper about twenty-four by twenty inches in size. It was typical of him to line the pastel paper with a sheet of newspaper, then mount the two sheets on a wooden strainer, and afterwards seal the back with a second sheet of newspaper. His sitters, mostly of Dutch origin with names such as Vanderveer or Smock, are shown half-length, posed with the face

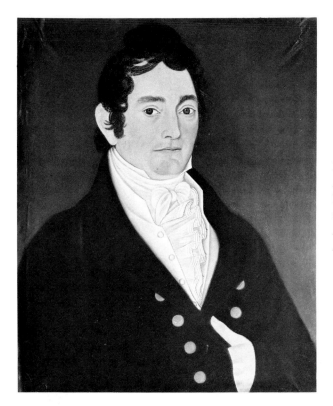

MICAH WILLIAMS. *Henry Mundy.*
A fine example of a pastel portrait
by Williams. Paper, 23½″ x 19⅜″.
(*New Jersey Historical Society, Newark,
Photograph from Frick Art Reference
Library*)

angled in a three-fourths view. The subjects are placed high on
the paper so that the top of the head is close to the upper edge.
A book or some other object is frequently in the sitter's hand, and
his arms are often crossed or tucked into his vest. The pictures are
clean, uncluttered, and well balanced. Facial features, eyes, mouth,
hair, are drawn with precision and delicacy. As Mr. Cortelyou
pointed out, the coloring is keyed in intensity and hue to the eyes
of the subject. A brown-eyed sitter, for instance, would most likely
have a background in shades of brown.

Details are sketchy about the life of Micah Williams. He was
born in New Jersey in 1782. On December 24, 1806, he married
Margaret H. Priestly and then lived in New Brunswick for most
of his life except for a few years spent in New York City, where
he was listed in the directories from 1829 to 1832. The couple had
five children. Micah Williams died November 21, 1837 and is
buried in New Brunswick.

Williams was a professional artist and according to the diary
of a sitter could complete a portrait in a day of work. In a review
of an art exhibition published in the April 16, 1823, issue of the
Paterson Chronicle and Essex and Bergen Advertiser, he received com-
mendation for the correctness of his design and execution. The
article mentions that he was self-taught.

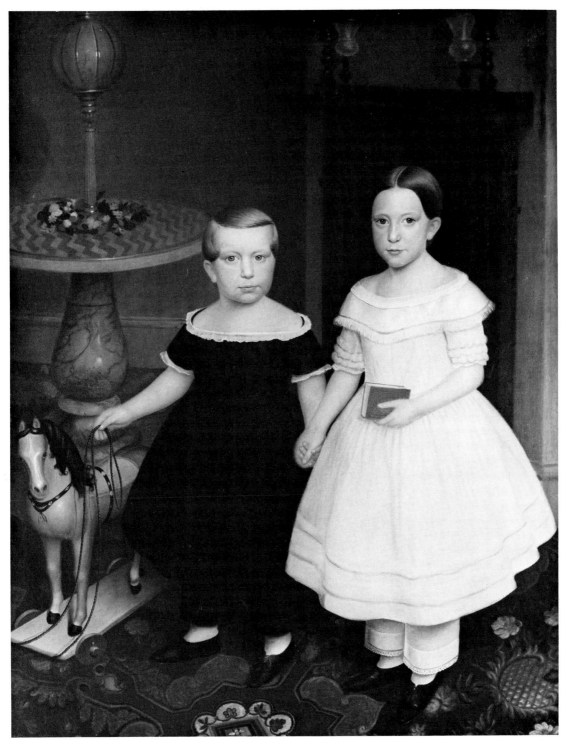

JAMES HARVEY YOUNG. *Charles L. Eaton and His Sister.* This portrait of two children
from Medford, Massachusetts, was painted in 1848 by a rather obscure artist, James
Harvey Young (1830–1918), in a style reminiscent of Joseph W. Stock. Oil on canvas,
53½″ x 41″. Signed on back. (*Fruitlands Museums*)

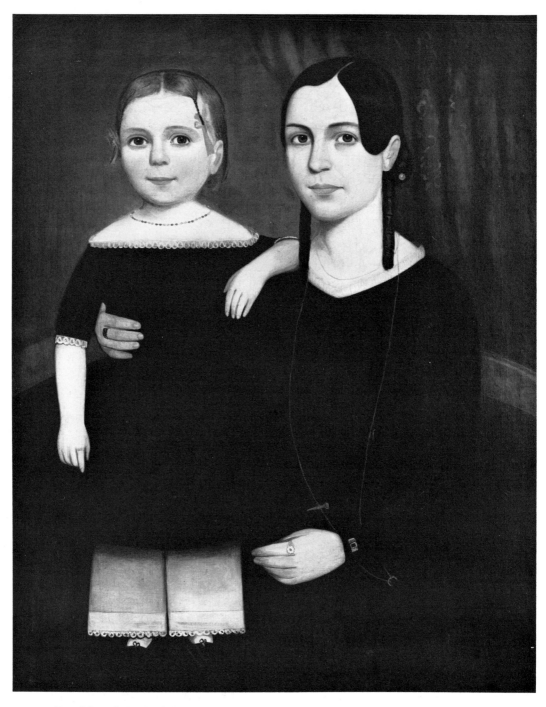

Lucy [Orcutt] Leeds of Pepperell, Massachusetts and Child. An appealing portrait painted ca. 1845 by an unknown artist. Oil on canvas, 35½″ x 28½″. (*Fruitlands Museums*)

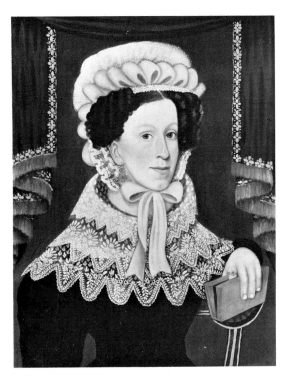

Lady Holding a Red Book. A stylized and detailed portrait in the best folk art tradition. Painted by an unknown artist in oil on wood panel, ca. 1825. 28″ x 21½″. (*Private collection, Photograph courtesy of Hirschl and Adler Galleries, New York*)

Gentleman Holding a Red Book. Probably the husband of the *Lady Holding a Red Book.* Oil on wood panel, 28″ x 21⅝″. (*Collection of Thomas Rizzo, Photograph courtesy of Hirschl and Adler Galleries, New York*)

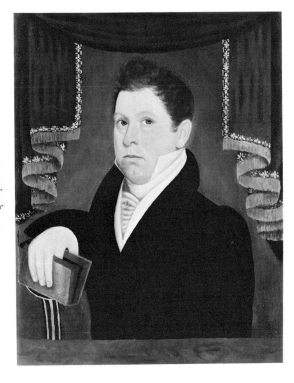

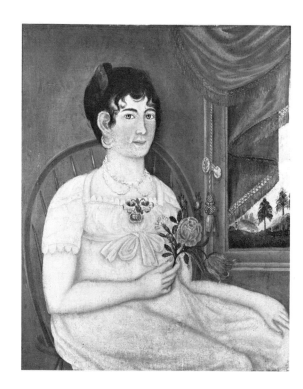

Mrs. Harrington. Artist
unknown. Painted ca.
1815 in oil on canvas,
31″ x 25½″. (*Lyman Allyn
Museum*)

Captain Harrington. Artist
unknown. Painted ca.
1815 in oil on canvas,
31″ x 25½″. (*Lyman Allyn
Museum*)

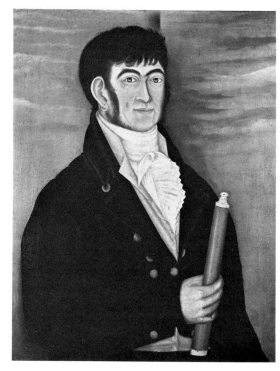

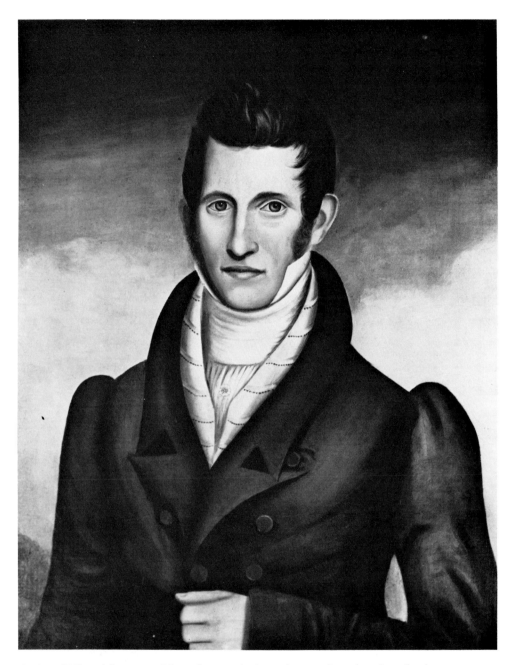

Andrew Fuller of Lancaster, Massachusetts. Artist unknown but dated on back
January 9, 1828. (*Fruitlands Museums*)

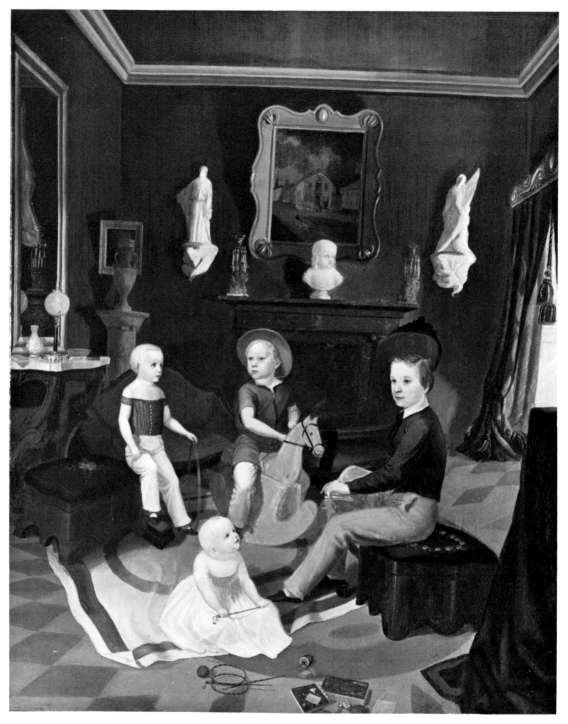

Carryl Children of Salisbury Center, New York. Artist unknown. An appealing group portrait which includes details of a Victorian living room. Oil on canvas, 47¼″ x 38″. (*Fruitlands Museums*)

CHAPTER FOUR Ship Portraits and Marine Paintings

A large group of both professional and amateur marine painters and painters of ship portraits are part of the American folk art tradition. Ship portraits came into fashion in the late eighteenth century and remained fashionable until about 1880—almost a century. The professional ship portrait painter who was commissioned to produce a "likeness" of a vessel was usually an artist who specialized in these, being familiar with the construction of ships and the ways of the sea. In this case it was the ships that traveled and not the artists. American vessels had their portraits done in harbors in Europe, the Mediterranean, the Far East, as well as on their native shores. These skillfully executed portraits are important records of the vessels as well as enormously attractive pictures. The foreign artists were in full gear producing ship portraits in large numbers long before their American counterparts started. Usually, the marine artist was a specialist; but a few diversified, academically trained artists also sought and executed ship portraits.

Many of these artists are impossible to categorize as either folk or academic. It was not unusual for a self-taught American artist to achieve a reputation as a "fine" one. Fitz Hugh Lane, rated by many as our finest marine painter, was largely self-taught, and his early works are distinctly primitive. A watercolor of 1830, *The Burning of the Packet Ship "Boston,"* exploits the swirling, rhythmic pattern of the waves as an

abstract design for its decorative effect. Lane later developed the sophisticated naturalistic style for which he is known. Some professional artists, self-trained or with only a small amount of instruction, were rather primitive in their early years but became more realistic later without ever becoming completely academic artists. The style of others, such as W. P. Stubbs, was inconsistent, with no steady progression from one style to another. In some cases flatly rendered schooners are dated later than ship pictures with considerable three-dimensional modeling. A possible explanation for this variability is that the artist executed a portrait for a price, and the additional time taken to render water, sails, vessel, and sky with more subtlety required a higher fee. Artists, professionals and amateurs, who used the pattern of waves for decorative effects, made abstract designs of unrealistic waves, stressed contour rather than depth and solidity, and brought the whole off with style and exuberance are more usually considered folk artists. Seascapes, harbor scenes, action-filled dramas of naval combat, storms at sea, and whaling episodes were favorite subjects for this group of painters.

Historical Background

The history of American marine painting extends as far back as the end of the seventeenth century when an occasional ship was shown in the background of a sea captain's portrait or in the foreground of city views. In the mid-eighteenth century, action-filled marine paintings became popular among the aristocratic classes in England and the rest of Europe. Some of this was transferred to American sails by Mediterranean and English artists who painted the naval engagements of the Revolution. An early instance was Joseph Roux in Marseilles who portrayed the *Engagement between Bon Homme Richard and Serapis* in 1781, a battle during which the *Serapis* was sunk and Captain John Paul Jones emerged the victor. In spite of their defeat, the British took pride in this encounter since the gallantry of the British seamen enabled the *Serapis* to achieve its purpose, which was to protect a convoy of merchantmen. This battle thus achieved the rare distinction of being popular with victor and vanquished, Americans and British, alike.

America, because of its geographic position, always had a segment of the population that had a romance with the sea. Soon after the Revolution, however, this became a partnership in marriage as the English restrictions were cast off and Americans became free to trade and travel. On September 3, 1783, the Treaty of Paris was signed to end the war, and less than six months later, on February 22, 1784, the *Empress of China* left for Macao to start the China trade. She was joined

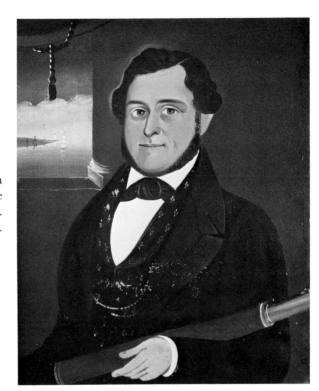

American Ship Captain. Painted in
the "flat" style of the
Prior-Hamblen group, ca. 1850.
Gouache on canvas, 20″ × 16½″.

by four other ships on the second venture late in 1785 and early in 1786. Three sailed out of New York, one from Salem, and one out of Philadelphia. These were followed in subsequent years by ships from Providence and Boston. After six years of trade, the Americans had sent twenty-eight ships to Canton; this trade amounted to one-seventh of all American imports.

Since England remained somewhat hostile and the rest of Europe cool to the new United States, the initial emphasis in the period after the war was placed on trade with China. But the interests of commerce soon prevailed, and other shipping ventures took our merchantmen to the Mediterranean for fruits and wine; to Africa for ivory, gold, hide, and dates; to the East Indies for spices; and to the Baltic for hemp, iron, and naval stores. The suddenly prosperous shipowners and shipmasters wanted portraits of their floating benefactors and had them done at home or in one of the many ports at which they called in the Mediterranean, the Baltic, or the Orient. The ship portrait demanded left little room for artistic license insofar as the vessel was concerned. Owners and masters required that the details of hull and rigging be carefully drawn as would be found in the meticulous delineation of the design on the drafting board. This was to be a permanent record of their ship as they knew it and saw it and not a romanticized work of art. The patrons were much less interested in the rendition of sea and sky.

The War of 1812 was a traumatic experience for the fledgling American merchant fleet. Some of the ships were converted into privateers, and the speed of the American-designed ships resulted in a creditable performance. Thomas Birch in Philadelphia was one of the leading artists to paint naval engagements in this largely naval war. Other American artists with a wide range of skills and styles such as Michele Cornè, Thomas Sully, Thomas Chambers, George Ropes, and George Thresher also portrayed actions at sea.

The merchant fleet recovered rapidly after the war. The economy demanded quick delivery of merchandise on a dependable schedule, and the packet companies met this demand. The packet period, until about 1850, saw the establishment of the Black Ball Line, the Red Star, Blue Swallowtail, Red Swallowtail, Dramatic, and the Black-X lines among others. As many as ten ships were operated at one time by the Black Ball Line. About 1850 the "Golden Age of Sail" began with the introduction of the long, narrow, and fast clipper ship. Nearly obsolete at the time of its appearance, the clipper ship and its era were short-lived, and by the 1860s steam had won the battle to carry cargoes quickly and on schedule.

European Port Painters

Although not American folk painters, of course, the professional foreign port painters worked for American patrons and to judge from their popularity must have pleased their American customers. Their paintings are so closely identified with American marine history and art that their omission would leave a gaping hole in the portrayal of American vessels. Soon after the Revolution, painters with the skill to render the precise detail sought by the Americans were available in the European ports where they traded, from the Germans and Danish in the Baltic to the French and Italians in the Mediterranean. Artists were supplying them for vessels of other nations and the American merchantmen became eager clients.

The usual medium for these European ship portraits was watercolor on paper, and sometimes gouache. They are very appealing pictures. Watercolor has a freshness and clarity not easily achieved in oils. The vessel is shown full broadside with the sails gently filled or with the lower ones furled the better to show the details of deck and rigging. Most often the setting is a port, frequently recognizable as Marseilles or some other by the buildings or terrain in the background. The rigging is drawn so that it is prominent and legible. Even with full sails there is very little evidence of rolling, pitching, or motion. The vessel is at rest,

suspended, floating lightly in a quiet pool with little ripply waves or other stylized depictions of the sea. The name and other information about the vessel are often lettered underneath.

The most famous supplier of these ship portraits was the Roux family of Marseilles, which was the principal center for this activity. Joseph Roux was born in 1725 and worked in the latter half of the eighteenth century as an instrument seller and painter. After his death in 1793, his family continued his artistic career until almost the end of the nineteenth century. His son, Joseph-Ange Antoine, developed a meticulous style of painting using ink and watercolor with delicate brushwork. In turn, his three sons, Mathieu Antoine, François Geoffroy, and Frédérick, continued the family tradition. One of Antoine Roux's

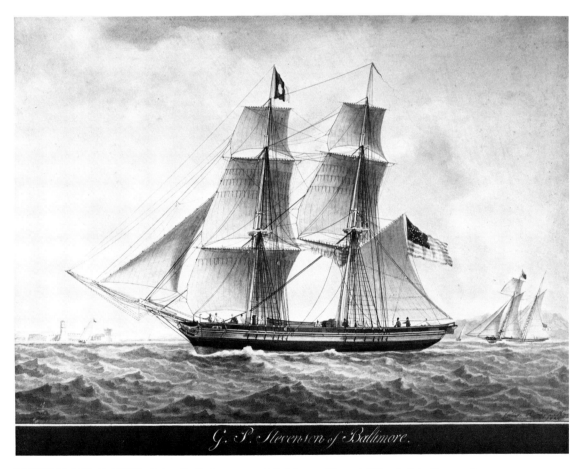

FREDERICK ROUX. *Brig. G. P. Stevenson of Baltimore.* Signed "Frederick Roux of Marseilles/1825." Watercolor. (*Marine Arts, Salem, Massachusetts*)

labels states that in addition to painting, "Antoine Roux Junior Makes & Sells Quadrants, Compasses and Ships Colours on the Quay near St. Jean Marseilles." Frédérick also worked in Havre from 1837 to 1852. None of the sons equaled their father in draftsmanship.

Artists were producing these watercolor ship portraits in many other ports besides Marseilles: all around the Mediterranean and in northern Europe and the Baltic. A list of a few of these and their ports follows:

Marseilles
 Joseph Roux (1725–93)
 Joseph-Ange Antoine Roux (Antoine Roux père, son of Joseph) (1765–1835)
 Mathieu Antoine Roux (Antoine Roux fils ainé, Antoine, Jr.) (1799–1872)
 François Geoffroy Roux (1811–82)
 Frédérick Roux (1805–70)
 Honoré Pellegrin (ca. 1800–ca. 1870)
 Nicolas Cammellieri (active 1798–1820)
 Marius Gasquy (ca. 1838)
 Louis Roux (another family) (1817–1903)
 Touzla (ca. 1800)
 Bernard Tibaud (ca. 1845)
Genoa
 Antoine Pittaluga (ca. 1830)
 Domenico Gavarrone (ca. 1848–ca. 1861)
Leghorn
 Guiseppi Fedi (ca. 1820)
 Pietro Mazzinghi (ca. 1830–ca. 1840)
 Luigi Renault (ca. 1853–ca. 1868)
Naples
 Michele Felice Cornè (active ca. 1799 and after that in the United States)
 De Simone (ca. 1866)
Palermo
 Guiseppi Monasteri (ca. 1880)
Venice
 Giovanni Luzro (ca. 1850–60)
Malta
 Nicholas S. Cammillieri (active ca. 1819–56)
 Ambrogio (ca. 1857)
 G. D'Esposito (ca. 1870–99)
Trieste
 Felice Polli (ca. 1835–ca. 1860)

Smyrna
 Raffael Corsini (ca. 1832–ca. 1880)
 Edmund Camellate (E. Camillati) (ca. 1830)
Havre
 Montardier (ca. 1820–ca. 1840)
 H. Cassinelli (ca. 1849–ca. 1854)
 Eugène Grandin (ca. 1857–ca. 1875)
Copenhagen
 Jacob Petersen (1774–1854)
Elsinore
 C. Clausen (active ca. 1837–ca. 1854)

Other ports around the world also had artists willing to oblige the visiting American ship. There were Pineda in Barcelona, John F. Loos (ca. 1860–70) in Antwerp, and George F. Gregory (1815–85) in Melbourne. A large group of paintings is unsigned so that neither the identity nor the nationality of the artist is known.

Toward the end of the nineteenth century, the American artist Edward J. Russell (1835–1905) did some work in the style of the Mediterranean artists and actually copied paintings by Roux and others.

Chinese Port Painters

The Chinese port painters form another important pool in which American shipowners and crew found their trophies. The stylized native Chinese school of painting favored flat renditions done with fine detail but using only elementary perspective. This approach, used on Western subjects for Westerners, allies these paintings closely with American folk paintings. Most of the Chinese artists also painted portraits, port scenes, and landscapes, copied prints, and did other artistic work for Americans besides painting portraits of their ships. It is difficult and sometimes impossible to identify positively some of the primitive-style portraits and other works now in America as Chinese, and some works previously considered to be American are now believed to have been executed in China. This confusion occurs far less often in the case of ship portraits since they are more distinctive and frequently include a Chinese port as background.

Americans and other Westerners were restricted by the Chinese to specified areas in China including Canton, Macao, Whampoa, Hong Kong, Shanghai, and Amoy. The artists occasionally signed their works on the front or back or stenciled the back of the canvas and, in some cases, glued labels to the frame or stretcher. Since the majority failed

to provide any identity, there is now a large group of paintings by unidentified Chinese artists. Two of the earliest to identify themselves are the artists Spoilum, who worked from 1785 to 1810, and Fatqua, who worked from 1805 to 1835, both in Canton; they are believed to have painted ship portraits. One of the earliest recorded ship portraits painted in China for Americans is dated 1812 and shows the ship *President Adams* wrecked in a storm. It is unsigned. A relatively large number of ship portraits were painted after 1830 until about the turn of the century. Artists such as Sunqua, Lai Sung, and Hing Qua are rather prominent since they signed their works. Some ran large studios with assistants who were trained to paint in the style of their master.

Most Chinese ship portraits are painted in oil on canvas, but a few are watercolor and gouache on Western paper or Chinese pith paper. The chronological list which follows includes the names of the major artists (not a complete list of Chinese port painters) who are known or believed to have painted ship portraits.

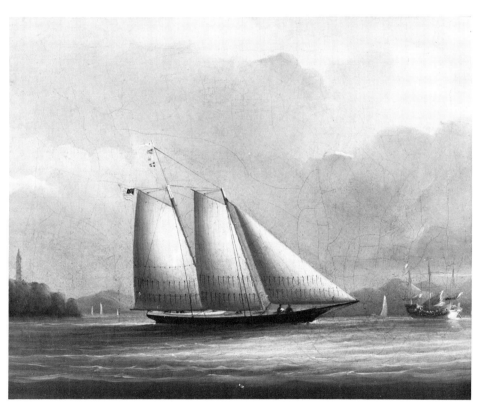

Yachting Scene with Junk. A China port painting of an American yacht in Chinese waters. Oil on canvas, 8½″ x 10½″. (*Marine Arts, Salem, Massachusetts*)

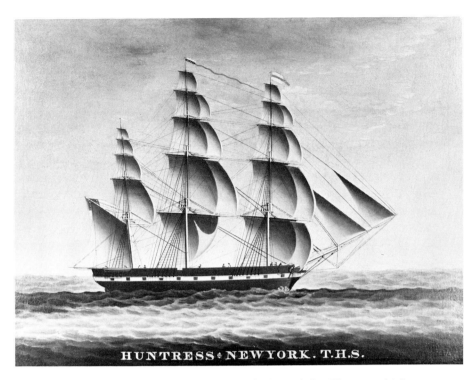

HUNTRESS♦NEWYORK. T.H.S.

Ship Huntress of New York. A China port painting of the *Huntress* which was built in Milton, Massachusetts. Oil on canvas, 27″ x 20″. (*Marine Arts, Salem, Massachusetts*)

NAME	WORKING DATES	PORT
Spoilum	1785–1810	Canton
Fatqua	1805–35	Canton
Sunqua	1830–70	Canton and Macao
Nam Cheong	1845–75	Whampoa and possibly Hong Kong
Yeuqua	1850–85	Hong Kong
Taicheong	1850–75	Hong Kong
W (?) E. Chung	ca. 1850–60	Hong Kong
Lai Sung	1850–85	Hong Kong
Lee Heng	ca. 1850–70	Hong Kong
Hing Qua	1850–80	Hong Kong
Woo Cheong	1860–80	Hong Kong
Chang Qua	ca. 1860	Hong Kong
Wing Chong	1860–80	Hong Kong
Hung Qua	1860–90	Hong Kong
Qua Sees	ca. 1880	Hong Kong
Pun Woo	ca. 1880	Hong Kong
Yat On	ca. 1880	Hong Kong
Lai Fong	ca. 1870–1900	Calcutta

**British
Influence
on Americans** In the late eighteenth and early nineteenth century, painters such as
Thomas Buttersworth, Thomas Whitcomb, Thomas Luny, and Robert
Salmon were executing ship portraits and other marine paintings in
England. Salmon's arrival in the United States in 1828 influenced
painters in the Boston area. Toward mid-century J. E. Buttersworth and
David McFarlane (active 1840–66) both had great impact on American
ship portraiture. Buttersworth came to America in the 1850s and
became a leading marine artist; and both he and McFarlane supplied
some of the ship portraits that were lithographed by Currier and Ives.
The Tudgay family of British marine painters who were active during
much of the nineteenth century were represented by F. Tudgay and
J. Tudgay, who painted American ships as well as those of many other
nations.

 Robert Salmon (ca. 1775–ca. 1845) was of Scottish descent, if not
birth, and worked in Liverpool, Greenoch (Scotland), and North Shields
between 1800 and 1828. In 1828 he emigrated to America where he
established himself as a marine painter in Boston until 1842 before
returning to Britain. In America he completed over four hundred oils
with the ripply little waves so characteristic of his work. During his
fourteen-year stay he set an example for Fitz Hugh Lane, William
Bradford, and Clement Drew, fledgling artists of the day. Lane and
Bradford later became important painters of the era.

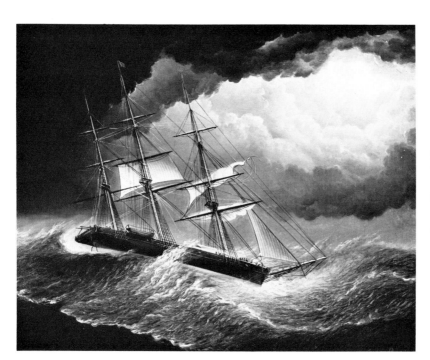

J. E.
BUTTERSWORTH.
The Storm. Signed lower
right. Oil on canvas,
16″ x 12″. (*Marine Arts,
Salem, Massachusetts*)

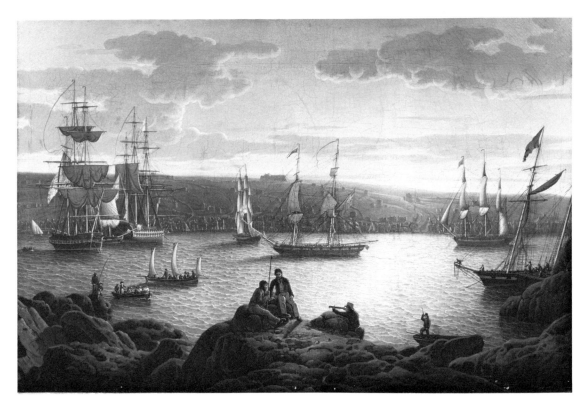

ROBERT SALMON. *Shipping at Pembroke.* A fine harbor scene. Oil on canvas, 27" x 41". *(Marine Arts, Salem, Massachusetts)*

J. E. Buttersworth (1817–94) was born on the Isle of Wight and came to America as a trained artist about 1850, settling in the New York area, and went on to become one of the best-known marine artists of the period. In his early career in America he painted many portraits of clipper ships but later switched to yachts and yachting.

American Port Painters

Only a very few remain of the small number of ship portraits that were painted in the United States before 1800. Ashley Bowen and John Phippen worked in the 1780s and 1790s and three or four of their watercolors are in the Peabody Museum. There are also a few surviving seascapes and harbor scenes, most in the form of crude overmantels, including an early one by Benjamin West.

Michele Felice Cornè, on his arrival in Salem from Naples in 1800, is generally credited with starting and popularizing ship portraiture in

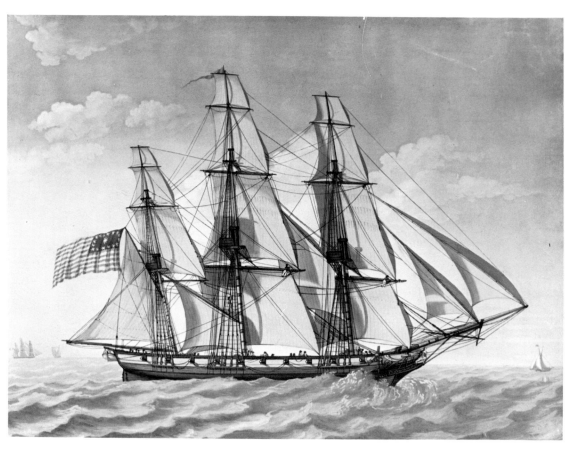

MICHELE FELICE CORNÈ. *Ship Hazard.* Signed: "Michele Cornè pinxit in Salem, 1802." Gouache, 13″ x 18″. (*Peabody Museum, Salem, Massachusetts*)

America. The Reverend William Bentley of Salem wrote: "Mr. Cornè continues to enjoy his reputation as a painter of Ships. In every house we see the ships of our harbour delineated for those who have navigated them. Painting before unknown, in its first efforts, is now common among our children." While in Salem, Cornè taught ship portraiture to George Ropes, a deaf and dumb sign and carriage painter. From 1807 until 1822 Cornè lived and painted in Boston doing ship portraits, marine and other paintings, and naval battle scenes during the War of 1812. Twenty-one paintings of these naval engagements were engraved and published by Abel Bowen in *The Naval Monument* in 1816. In 1822 Cornè moved to Newport where he continued his career until his death in 1845. Besides painting marine subjects, Cornè was a skillful portraitist and left a number of oils and watercolors of Salem residents.

In addition to Cornè, William Marsh and C. F. Dannenberg worked in the manner of the Mediterranean artists. Marsh painted in Boston

from about 1810 to 1860 and generally included Boston Harbor land-marks such as Boston Light or Fort Independence. Dannenberg worked in Boston and Newburyport from about 1805 to 1832.

During this early period George Thresher worked as a marine painter in New York City from 1806 to 1812, and in Philadelphia, Thomas Birch painted marine scenes and naval engagements of the War of 1812. Thomas Birch (1779–1851) is one of the more important painters who worked in America during the early part of the nineteenth century. He was born in England and came to Philadelphia with his father, William Russell Birch, in 1794. Their early work includes a series of views of Philadelphia designed, engraved, and published by father and son. The son, Thomas, painted in Philadelphia until his death and is noted for his marine and winter scenes as well as the naval battle scenes.

The next English infusion came with the arrival of Robert Salmon in 1828. During his fourteen-year stay he became known as the finest painter of the sea working in America, a mantle he passed on to Fitz Hugh Lane. These two went far beyond ship portraits to paint ambitious harbor scenes.

Fitz Hugh Lane (1804–65), always fascinated with the sea, might have become a sailor instead of an artist had he not become crippled in childhood. His first jobs as an artist were during his apprenticeship to the lithographer William S. Pendleton in Boston about 1832. He remained in Boston until about 1849 and then returned to his native Gloucester, where he spent the rest of his life. He passed the next sixteen years painting mostly in Gloucester, but he also painted during summer trips to Maine and possibly Puerto Rico. Today, Lane's paintings are among the most admired of American marine paintings. His oeuvre includes ship portraits, harbor scenes, dramatic battles between ships and the sea, and seascapes mostly done in a precise style with a masterly use of light that can hardly be considered primitive. In 1851 the *Gloucester Telegraph* said of him, "We have no one who can paint a ship and an ocean prospect like him."

William Bradford (1823–92) studied art in New Bedford under Albert Van Beest in 1857. Bradford painted fine ship portraits but is best known for his Arctic scenes, usually picturing a whaler caught in the ice or sailing between icebergs. Bradford turned from business to art in 1857 when he was thirty-four years old and must be viewed as an artist of the second half of the nineteenth century. He was an Associate of the National Academy (A.N.A.), and his output was in the academic tradition.

Three less documented artists who worked more in the folk art tradition are Clement Drew, Thomas Chambers, and Jurgan Frederick Huge.

Clement Drew (1806–89), a native of Kingston, Massachusetts, worked in Gloucester and Boston producing ship portraits, seascapes, views of lighthouses, and especially primitively dramatic pictures of ships at the mercy of the elements. The Boston directory lists him as a marine painter from 1838 to 1873. He was also the artist and publisher of lithographs, among which is the Bufford print *Missionary Packet Morning Star Passing Boston Light.*

Thomas Chambers (1815–after 1866) came to this country from England about 1832. From 1834 to 1866 he worked in New York City, Boston, and Albany painting marine and harbor scenes, naval battles, and landscapes. His listings include landscape painter, marine painter, artist, and portraitist. His paintings were executed in a highly individual and imaginative style with the use of broad, flat areas of bright, often harsh, colors. Ships, sails, clouds, and waves are treated as elements of flat design with sharp contrast of color, with light and dark patterns

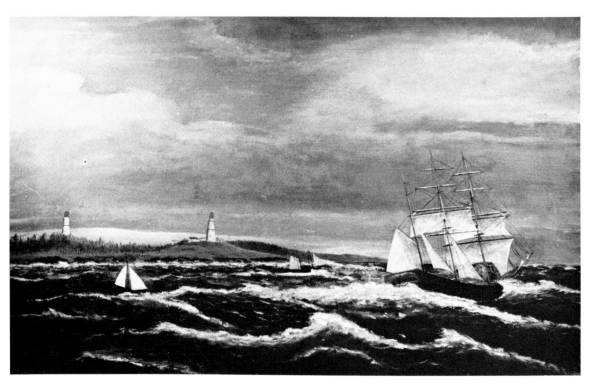

CLEMENT DREW. *Twin Lighthouses.* A seascape including the Thacher Island lighthouses on Cape Ann. Signed lower right: "C. Drew." Oil on canvas, 15″ x 24½″.

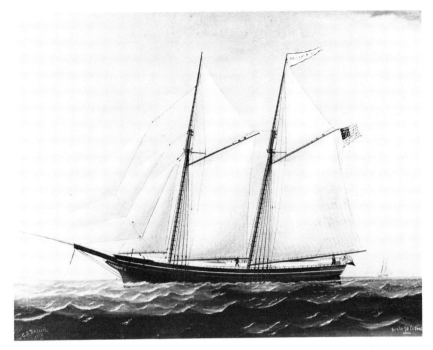

C. S. RALEIGH. *Western Star*. Signed: "C. S. Raleigh, 1878." A coastal ship painted in oil on canvas, 22″ x 30″. (*Marine Arts, Salem, Massachusetts*)

in sky and water. The edges of sails, crests of waves, and lines of the ship are highlighted with strokes of white. Many of his compositions were derived from prints. Very few of his works are signed.

Jurgan Frederick Huge (1809–78) was born in Germany, came to America at a young age, and settled in Bridgeport, Connecticut, where he was listed as a grocer and artist. As a marine painter he worked in Bridgeport and New York City painting harbor views as well as portraits of steamers and sailing vessels. He also painted residences and other buildings. Much of his work was done in watercolor but he also painted in oils. His known work is executed in a stylized way and is generally signed and dated between the years 1838 and 1878.

Others who worked mostly during the first half of the century but with less pronounced individual styles include Benjamin Franklin West (1818–54), who was a ship and marine painter in Salem, Massachusetts; William Henry Luscomb (1805–66), a native of Ballston, New York, who painted ship portraits in Salem, Massachusetts, during the 1840s and 1850s; and James Guy Evans (active 1838–62), who was a marine and historical painter in New Orleans.

In the second half of the nineteenth century, James E. Buttersworth was newly arrived from England and at work in the New York area. Joining him in supplying Currier and Ives with clipper ship paintings for lithographs were Joseph B. Smith and his son, William S. Smith, from Brooklyn. Charles S. Raleigh, also from England, ran away to

sea at the age of ten and after serving aboard ship in various capacities came to Bourne, Massachusetts, about 1870. He married and settled in New Bedford, working as a house painter and decorator. In 1877 he set up a studio to concentrate on painting ships and marine subjects, especially New Bedford whalers. He returned to Bourne in 1881.

The 1860s, 1870s, and 1880s saw William Formsby Halsall and William P. Stubbs at work in Boston. Stubbs was born in Bucksport, Maine, in 1842 and worked in Maine as well as Boston. Somewhat similar to the work of Stubbs was that of S. F. M. Badger in Boston in the 1890s. William Plummer, a rather elusive figure, left some fine seascapes and steamer portraits in a primitive style.

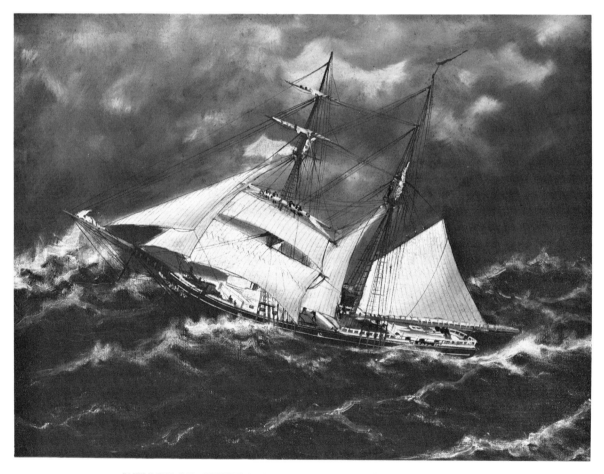

WILLIAM P. STUBBS. *Ship in Storm.* Signed: "W. P. Stubbs, 1901." Oil on canvas, 22" x 30". (*Marine Arts, Salem, Massachusetts*)

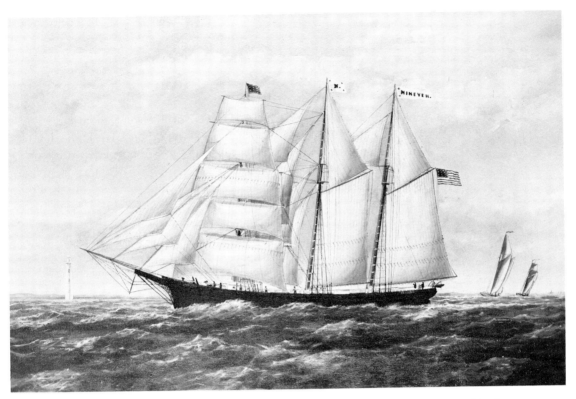

WILLIAM P. STUBBS. *Barkentine Nineveh Passing Minot's Light.* Signed: "W. P. Stubbs."
Oil on canvas, 24″ x 36″.

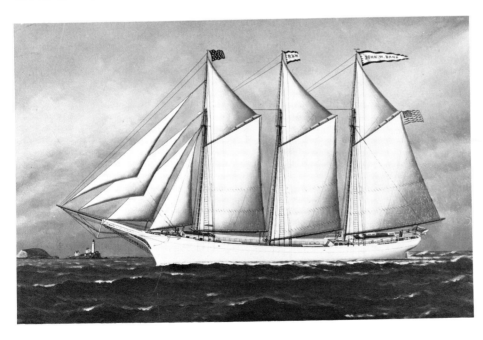

S. F. M. BADGER.
Schooner John W. Dana.
Oil on canvas,
24″ x 30″. (*Marine Arts,
Salem, Massachusetts*)

As the century wore on, sail diminished in importance for deep-sea travel and commerce as steam steadily forced out wind-driven vessels. Sail was significant for coastal commerce for a much longer period, and it was not until 1894 that steam tonnage surpassed sail tonnage in coastal shipping. Most of the late nineteenth-century coastal vessels were schooners that carried lumber, coal, ice, and other bulky commodities. Artists such as Stubbs and S. F. M. Badger painted many of these. In New York City Antonio Jacobsen started about 1870 and continued painting ships well into the first quarter of the twentieth century with pre–World War I ocean liners. He is known particularly for his early steamers showing the combination of steam and sail and his little harbor tugboats. A new wealthy class emerged after the Civil War which was able to afford the extravagant sport of yachting. Their graceful vessels were also captured on canvas by the marine artists of the era.

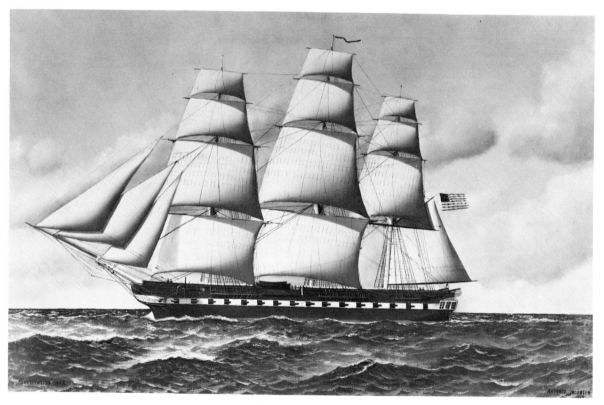

ANTONIO JACOBSEN. *U.S.S. Constitution, 1845.* Signed and dated: "Antonio Jacobsen, 1917." Oil on canvas, 21″ x 36″. (*Marine Arts, Salem, Massachusetts*)

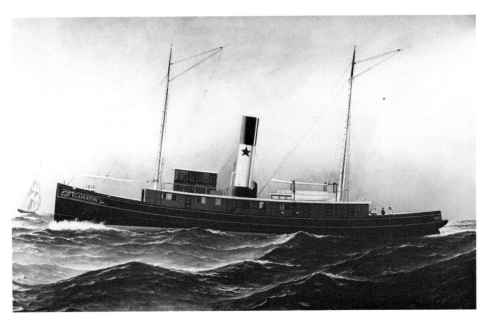

ANTONIO JACOBSEN. *Tug Gladiator.* Signed and dated:
"A. Jacobsen 188[9?]1." Oil on canvas, 21″ x 35″. (*Marine Arts, Salem, Massachusetts*)

Coastal, Sound, and River Steamers

"If you see a need, find out how to supply it" was Robert Fulton's motto. His steamship *Clermont* made the first successful trip by steam up the Hudson River to Albany on August 17, 1807. Within a month, regular passenger service was initiated which included meals and concern for the comfort of passengers. The venture was the successful start of what became a tremendously important mode of travel, but one that is now largely forgotten. Before long New York became a center for such boats with a network of routes to cities up the Hudson River; through Long Island Sound to points in Connecticut, Rhode Island, and Massachusetts; and south to points in New Jersey and later farther down the coast. Other lines were soon operating on Chesapeake Bay, along the Delaware River, on the Great Lakes, and, of great importance, along the Mississippi and connecting rivers. Millions found the service fast and inexpensive. At one point in mid-century the price of a ticket from New York City to Troy was as low as fifty cents. In the 1860s one could board a boat at the southern tip of Manhattan and, traveling at a speed of almost twenty miles an hour, arrive at Harlem in half an hour. Today, the same trip by subway is slower and less pleasant.

Commissions for portraits by the owners and captains of these small vessels were largely restricted to the New York area. The Chesapeake Bay and Mississippi boats are shown in lithographs and as incidental background in some paintings, but few actual painted portraits of specific vessels exist. The delineators of these "beautiful specimens of steam

vessel architecture" (from the obituary of James Bard in 1897) include most prominently the twin brothers James and John Bard. Also working to supply the demand in New York City were John V. Cornell (active ca. 1838–ca. 1849), Joseph B. Smith (1798–1876) of Brooklyn, Charles Parsons (1821–1910) of lithographic fame, and Antonio Jacobsen (1850–1921), a late painter. J. F. Huge (1809–78) worked in Bridgeport, Connecticut, and Fred Pansing did many portraits for the Fall River Line.

Over three hundred ship portraits by James and John Bard have been recorded, but it is estimated that their large output may have been five times that number. Starting about 1827, the twin brothers worked in close collaboration until John died in 1856. James continued working until about seven years before his death in 1897. His obituary states that during the sixty-three-year span of his career, he painted "almost every small steamer that was built at or around the port of New York." The Bard brothers painted the river steamers, excursion boats, tugboats, and other small vessels. Theirs was a specialty within a specialty, excluding ocean liners, clipper ships, large sailing vessels, and men-of-war.

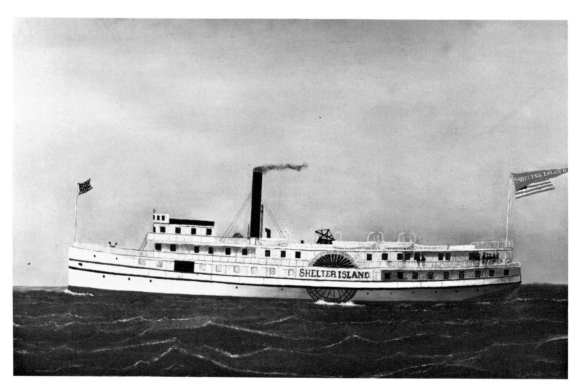

ANTONIO JACOBSEN. *Sidewheeler Shelter Island.* Signed and dated: "A. Jacobsen 1888." Oil on canvas, 22″ x 36″. (*Marine Arts, Salem, Massachusetts*)

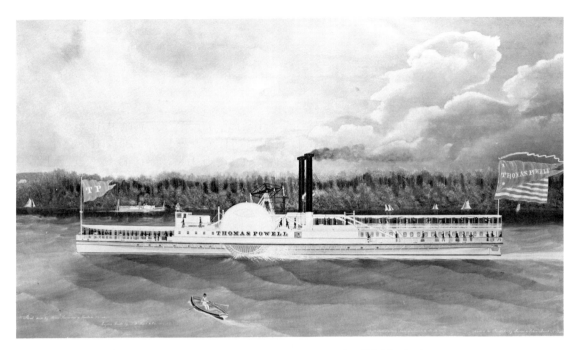

JAMES and JOHN BARD. *Thomas Powell,* with sidewheeler *Highlander* in
background. Signed and dated: "Drawn and Painted by James and John Bard
N.Y. 1846." Oil on canvas, 31″ x 55″. (*Collection of Howard A. Feldman*)

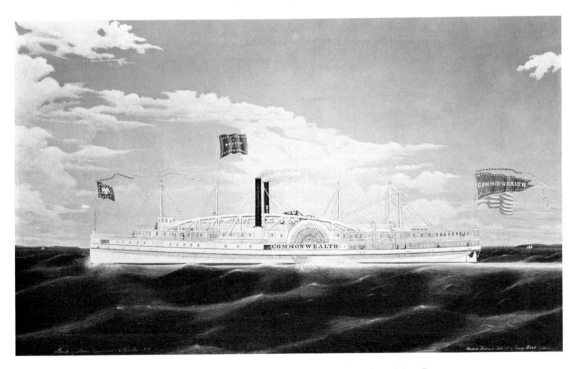

JAMES BARD. *Commonwealth.* Signed: "Picture Drawn and Painted by James
Bard, NY/162 Perry St." Oil on canvas, 36″ x 57″. (*Hirschl and Adler Galleries, New York*)

There is no evidence that either John or James, the senior painter of the partnership, had any formal training. Like most naive, untrained artists, James established a pattern for his paintings and clung to it. His boats are always shown broadside and in great detail, faithfully exhibiting correct scale and construction. All are shown going swiftly to their destinations and, with a few early exceptions, from right to left, usually with some typical Hudson River scenery in the background. They are never shown at anchor or at a wharf. There is a distinctive bubbly effervescence at the bow as it cuts through the water, a Bard hallmark. The soda-water bubbles also appear at the paddle wheel and at the stern in the case of a screw-propeller-driven boat. The gleaming white boat with its meticulous detail stands out sharply against the sketchily rendered landscape. Almost always there are tiny sailing craft near the shoreline and often small named steamboats in the distance. On the decks and in the cabin windows can be seen top-hatted men in black in stark profile, like identical little wooden figures. Later paintings show few figures, and occasionally a boat chugs eerily along without any human presence. A bright, fluttering, oversized banner gives the name of the boat. These paintings are usually large in size (thirty inches by fifty inches is typical) and are usually in oil on canvas, although some are watercolor and gouache on paper. Most are signed.

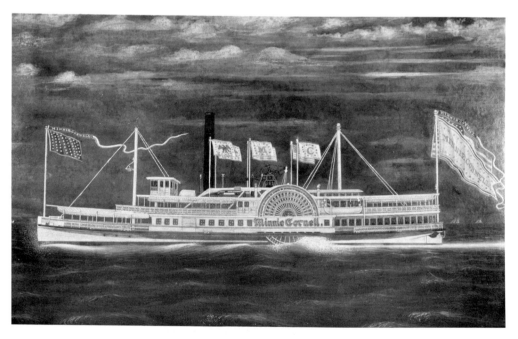

JAMES BARD. *Minnie Cornell.* Signed: "J. Bard 1870 [or 1879]." Oil and tempera on paper, 16½″ x 27¾″. (*Collection of Howard A. Feldman*)

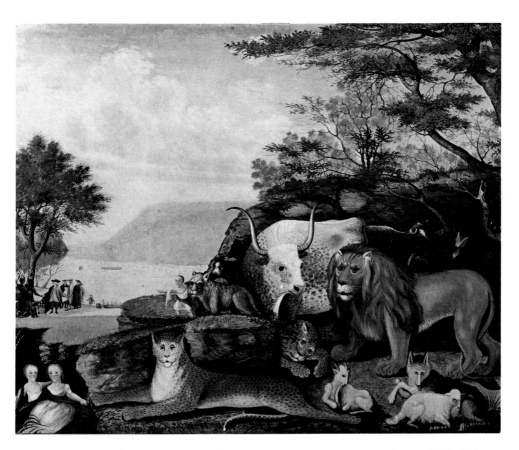

EDWARD HICKS. *Peaceable Kingdom*. One of the many versions of this folk
art classic painted by Hicks. Oil on canvas, 23⅞″ x 30″. (*Hirschl and Adler
Galleries, New York*)

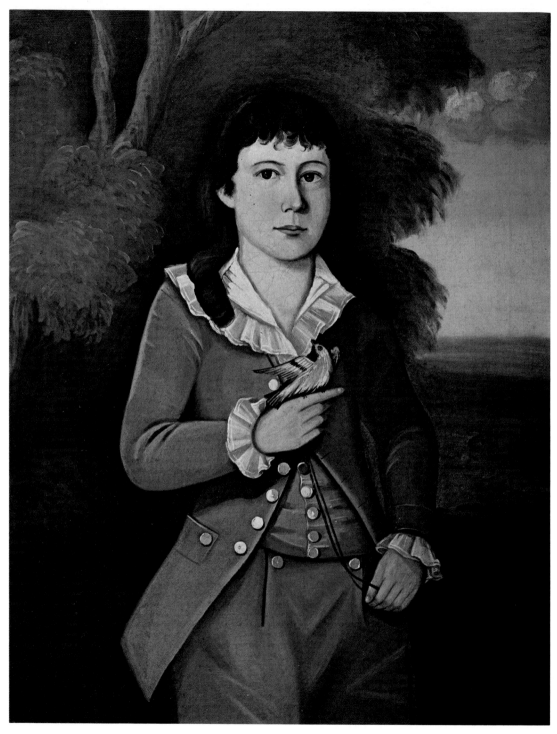

BEARDSLEY LIMNER. *Alexander Dix*. Dix lived in Watertown, Massachusetts, where this portrait was probably painted. Attributed to the Beardsley Limner and painted ca. 1785–90. Oil on canvas, 36″ x 28″. (*Hirschl and Adler Galleries, New York*)

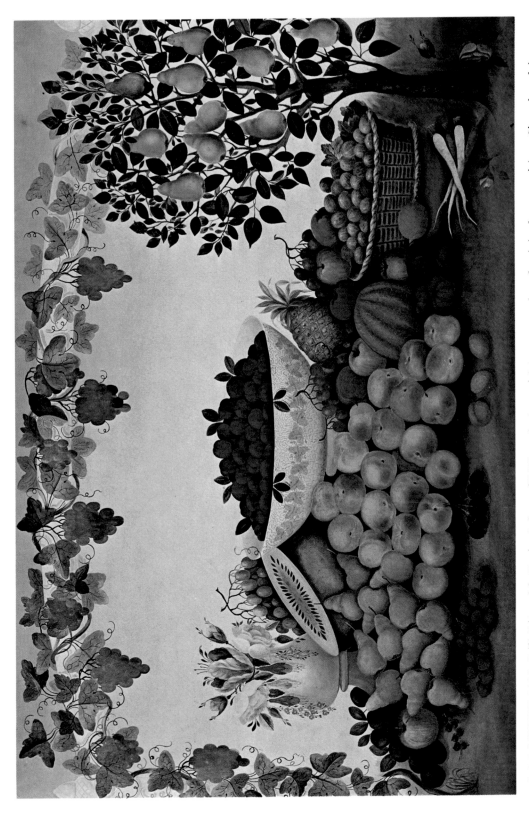

I. W. NUTTMAN. *Still Life with Fruit.* A fine still-life painting with an unusual and original composition. Signed and inscribed on back: "I. W. Nuttman. Painter/8 Coes Place." Painted ca. 1835. Oil on canvas, 40″ x 60″. (*Hirschl and Adler Galleries, New York*)

THOMAS CHAMBERS. *View from Mt. Holyoke.* Oil on canvas, 21¾″ x 29⅝″. *(Fruitlands Museums)*

American Greek Revival Interior. Painted about 1830 by an unknown artist, it is a rare example showing the appearance of an American parlor of the period. Possibly a memorial picture for the husband and father. Oil on canvas, 34″ x 44″. (*Hirschl and Adler Galleries, New York*)

Girl with a Rose. A very fine and colorful example of a portrait of a child by an unknown artist. Oil on canvas, 30½″ x 24¾″. (*Fruitlands Museums*)

Formal Vase of Flowers. An extremely elaborate and well-executed velvet painting highlighted with applied gold leaf and gold powder. The composition was probably inspired by French wallpaper or flower print. Boston, ca. 1815. Watercolor on velvet, 25″ x 22″.

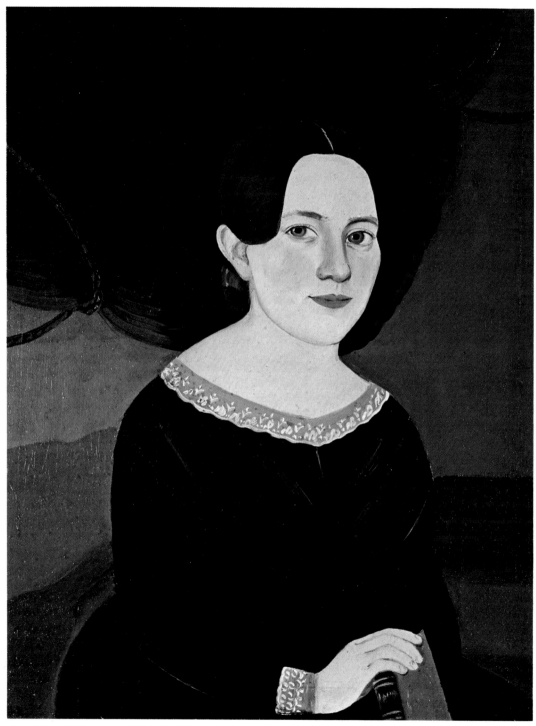

Abiah Tucker. A "flat" portrait of a young lady from Alexandria, New Hampshire. Painted by a member of the Prior-Hamblen group. Oil on canvas, 17″ x 14″. (*Collection of Howard A. Feldman*)

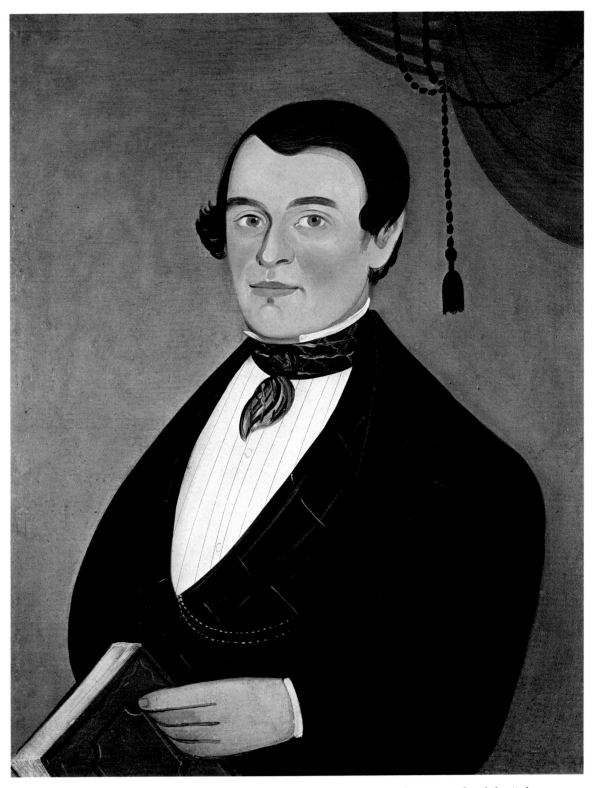

PRIOR-HAMBLEN GROUP. *Man with Red Book*. ca. 1850. A fine example of the "pigeon-breasted" style. Oil on canvas, 26½" x 21½". (*Collection of Howard A. Feldman*)

JAMES BARD. *The Isaac Smith.* A fine example of a Hudson River boat painted in 1861. Signed and dated at lower right. Oil on canvas, 30¼" x 51½". (*Collection of Howard A. Feldman. Photograph by John Kress Bachman*)

HORACE BUNDY. *Girl in Blue Dress.* Signed on back: "H. Bundy, painter, April 1850." Oil on canvas, 33" x 26". (*Heritage Plantation of Sandwich*)

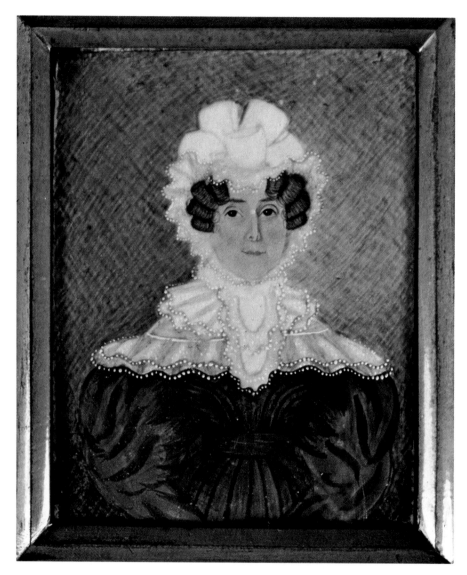

Grandmother in Her Finery. A miniature portrait inscribed on back: "Age—63—when likeness taken in 1832." Artist unknown. Found in New Hampshire. On ivory, 2¾″ x 2¼″.

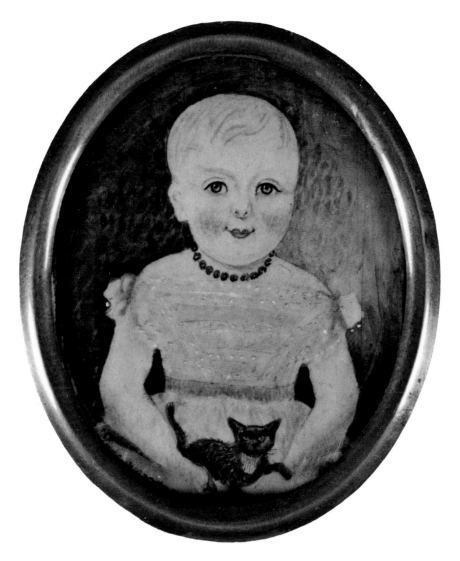

Child with Cat. A charming miniature by an unknown artist. Found in New Hampshire. On ivory in oval, 2⅛″ x 1¾″.

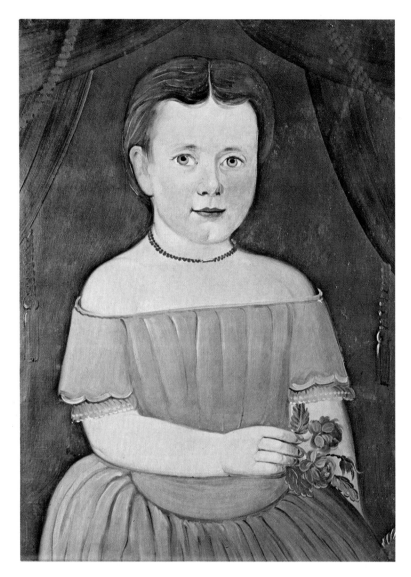

WILLIAM PRIOR. *Girl with Flowers*. Inscribed in contemporary hand on backboard: "Painted by Wm. M. Prior July 7, 1855, New Bedford. Painting $4.00, Frame $3.00." A rare example of a "flat" portrait with something more than an attribution to Prior. Oil on academy board, 17½" x 13¼".

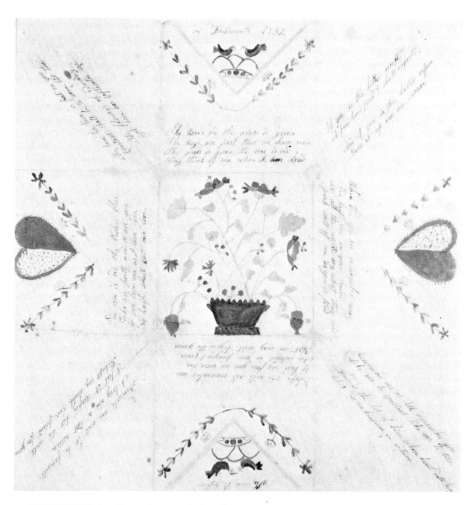

STEPHEN B. GIFFORD. *Valentine*. Drawn in 1832; the artist was from Dartmouth, Massachusetts. Ink, gouache, and watercolor on paper, 12½″ x 12½″.

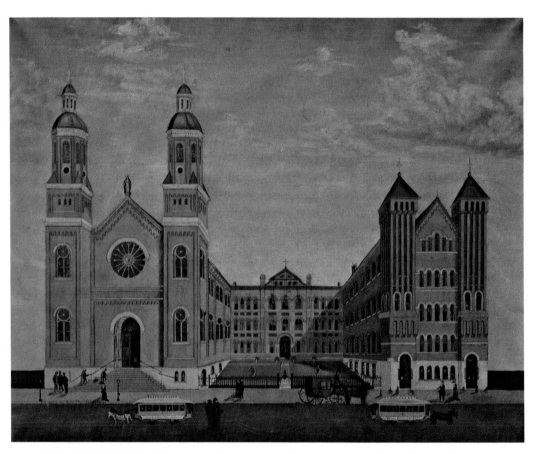

REV. GRAZIANI. *Church of the Assumption*, Syracuse, New York. Signed at lower left: "Painted by Rev. Dr. Graziani/1885." Oil on canvas, 41¼″ x 51¼″. (*Collection of Herbert W. Hemphill, Jr. Photograph by C. Michael DePunte, courtesy of Heritage Plantation of Sandwich*)

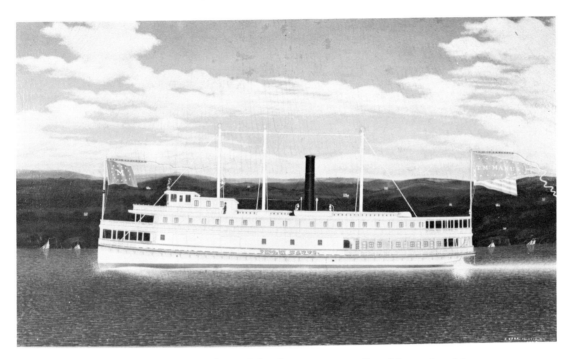

JAMES BARD. *Thomas McManus.* One of the few stern propeller ships painted by Bard. Signed: "J. Bard, Painter N.Y./1872.3." Oil on canvas, 30″ x 50¼″. (*Collection of Herbert W. Hemphill, Jr., Photograph courtesy of Heritage Plantation of Sandwich*)

Professionals vs. Amateurs

By a large majority, the surviving marine paintings are the works of professionals—men who made all or part of their living from their paintings. For the most part, ship portraits were executed by professionals with a considerable degree of proficiency. Native ship portrait painters had to compete with foreign painters by standards already established in foreign ports. Thus, most of these can be seen as only partly primitive, and then mostly in the sense that all else in the painting is subordinate to the ship, which is rendered as a beautiful and majestic object, and that standard formulas are followed in composition and in the profile presentation. In the case of the Bards, there was no foreign competition, so they were able to develop a distinctive and native style of painting their river and coastal boats. J. F. Huge is clearly a folk artist in that volumes such as water or smoke billowing from funnels posed a problem for him and resulted in stylized representation. About half his known output is in the marine category, and since he was otherwise employed as a grocer, for much of his career he was less dependent upon supplying ship portraits in the prevailing fashion.

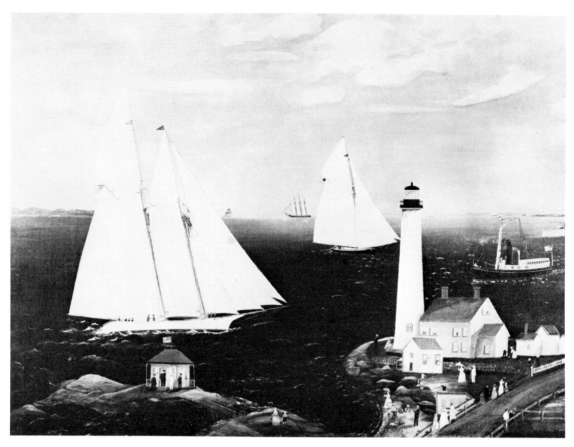

WILLIAM T. GOODING. *New London Light from the Northeast.* Painted ca. 1870. Oil on canvas, 24½″ x 34⅜″. (*Lyman Allyn Museum*)

J. H. WRIGHT (1813–83). *U.S. Ship Constellation.* Inscribed on border below: "U.S. Ship Constellation Capt. Reed [*sic*]. 16 Dec 1833. Painted by J. H. Wright." An early "primitive" work by an artist who later became an academic painter. Oil on canvas, 20″ x 30″. (*Museum of Fine Arts, Boston, M. and M. Karolik Collection*)

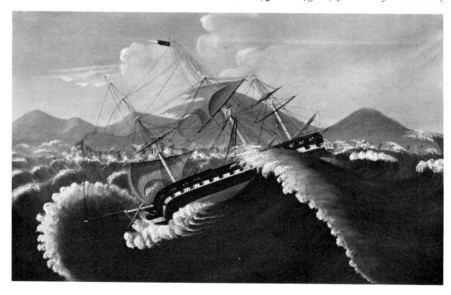

However, highly stylized waves, overly dramatic compositions, and excessively faulty perspective and proportion are more often the product of the amateur. Seamen, dock workers, and just interested land people form the cadre of the amateur marine painter. A talented amateur is frequently known from a single work with little or no information of his prior or subsequent development. Such a single work survives by sheer good fortune. At its best a painting of this nature is original and dramatic with an exuberance often lacking in the more restrained professional works. A fine example is the illustrated *Whaling Off the Coast of California,* which was crayoned aboard ship by a mate named Coleman.

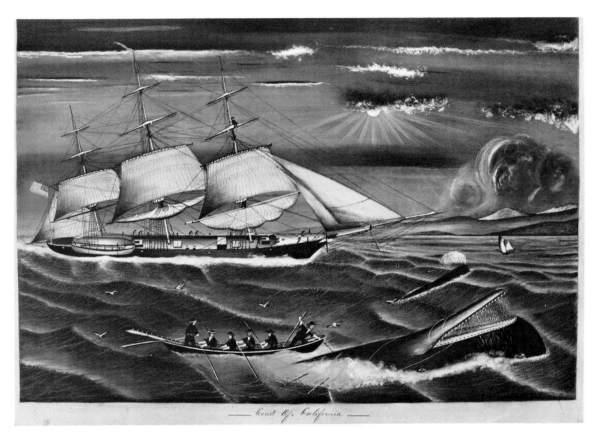

Whaling Off the Coast of California. A "sandpaper" drawing in black, white, and colored chalks by a mate named Coleman aboard the ship *Joseph Grinell.* On prepared board, 20″ x 29″. (*Museum of Fine Arts, Boston, M. and M. Karolik Collection*)

CHAPTER FIVE Other Jobs for the Professional

The religious, patriotic, and still-life paintings, the house portraits, signs, murals, and landscapes produced by the professional cadre were in many cases the same types of works produced by some of the amateurs. Distinction between works of the professional and those of the talented amateur is often unclear and in our time unimportant, since the significant issue is the quality of the product. Some artists straddled the divisions by following some unconnected occupation which supplied them with the major part of their income while carrying on some artistic pursuit that brought added income. Most folk paintings lack authorship identification, and this group is no exception; but a few personalities rise sufficiently above the background noise for us to recognize them and some of their works. Edward Hicks, Joseph Hidley, Thomas Chambers, Rufus Porter, and William Matthew Prior are the prominent names.

The professionals called themselves house and sign painter, coach painter, painter and stainer, fancy painter, painter and glazier, japanner, and, of course, artist and limner. Some lived and worked as craftsmen in a single community with a shop, advertisements in the local papers, and other physical signs of an entrepreneur. Others sought to sell their services over a wider area and became itinerant craftsmen. The services

provided varied widely and depended upon the talents of the individual and the market for them. Some painted signs; lettered and embellished coaches, drums, window shades, cornice boards; painted murals, fire-screens, overmantels, funeral hatchments, portraits, landscapes, still-life pictures, political banners, and the insides and outsides of houses. Some specialized in painting, graining, marbleizing, and stenciling furniture. Some stenciled only floors and walls and cut and installed glass in windows. Some painted clocks and mirrors or gilded frames. Some japanned tinware. Some taught drawing and painting. The eighteenth-

Civil War Drum. Painted on wood, 13″ high by 16½″ in diameter. (*Hirschl and Adler Galleries, New York*)

Birdsey Hall Tavern Sign, Goshen, Connecticut, ca. 1802. Painted on wood by an unidentified sign painter. Overall dimensions 53″ x 26″ x 2″. (*Collection of Herbert W. Hemphill, Jr., Photograph courtesy of Heritage Plantation of Sandwich*)

Fireboard with Newport Scenes. An elaborate and late fireboard painted by an unidentified artist ca. 1860. The scenes were copied from prints issued between 1831 and 1857. Oil paints and gold leaf on canvas, 28¼″ x 40½″. (*Hirschl and Adler Galleries, New York*)

and nineteenth-century painter did what he could to make a living, and versatility enlarged his potential, especially in small communities. The many decorated surfaces which must have existed can only be speculated upon today from a few scattered remnants and evidence of their existence as depicted in paintings.

Town Views

The production of town views reached high tide between 1840 and 1880 when a lithograph was made of just about every city and town in the United States. Making and selling these prints was an important part of the business of some lithographic firms. Most were bird's-eye views, but some were scenes within the city. Earlier, between 1800 and 1840, there had been some views which were engraved for books, such as those by John Warner Barber, as well as free prints. A few paintings were done on commission for a resident or businessman or sometimes for the enjoyment of the artist himself. Generally, the village green was the heart of these pictures, as well as of the village. Before 1800 almost no work of this type had been done except for a few views painted by William

Burgis and others to be made into engravings in England and Europe; but by the mid-nineteenth century the itinerant townscape artist was an established figure.

In 1800, in Philadelphia, William Birch and his son, Thomas, both recently emigrated from England, drew, engraved, and published twenty-eight views of *The City of Philadelphia*. This was followed by Joshua Shaw's *Picturesque Views of American Scenery* (Philadelphia, 1819–20), William Guy Wall's *Hudson River Portfolio* (New York, 1820–25), and W. J. Bennett's series of views in the 1830s. An immediate forerunner of the flood of town views were the sketches by W. H. Bartlett, which were published in London as engravings in 1840 in *American Scenery*. Individual city views, lithographed in the United States, were drawn by Fitz Hugh Lane, Edwin Whitefield, and dozens, perhaps hundreds, of other artists. Most of these views cannot be considered folk art and, in many cases, were only sketches used in the preparation of the lithograph and have since been destroyed.

The style and characteristics of the folk painter with the attention to detail, the crispness, and the inclusion of more than could be seen from any one vantage point satisfied the clientele who were seeking an accurate record of their homes or places of business rather than an academic work of art. Joseph Hidley (1830–72) spent his life in and

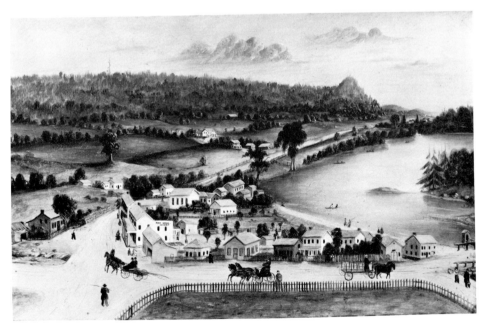

JOSEPH H. HIDLEY. *Glass House Lake.* Painted about 1860. Oil on canvas. (*Abby Aldrich Rockefeller Folk Art Collection*)

around Poestenkill and Troy, New York, where between about 1850 and 1870 he painted a series of remarkable townscapes depicting the neighboring towns nestled in the geography of their surroundings. He painted Poestenkill in the summer and again in the winter, as well as Glass House Lake, West Sand Lake, Fort Plain, and other towns, some of which have not been identified. His early style is distinctly primitive with little atmospheric haziness in the distant mountains and with abundant activity shown on the streets of the town. The buildings are emphasized but are an integral part of a neat and orderly mapping. His later paintings follow the academic tradition to a greater extent and consequently have less interest. They lose their naive charm without becoming first-rate traditional paintings. At least one of his paintings of Poestenkill in Rensselaer County, New York, was lithographed by G. W. Lewis in Albany about 1860. In addition to his views, which are oils on canvas or wood, he executed a few biblical scenes. It is believed that Hidley also worked as a cabinetmaker and taxidermist.

Henry Walton was another painter of townscapes active in upper New York State between about 1835 and 1850. His wide-angle views record such villages as Pickaway in Chemung County, Painted Post and Addison in Steuben County, and Ithaca. Walton was also the artist of many lithographs which he drew on the stone himself for the publishers and lithographers Pendleton, J. H. Bufford, G. W. Endicott, and Sarony. He painted a view of Athens, Pennsylvania, in 1851 and in 1857 the early mining town of Grass Valley, California. In addition to his activities as a lithographer and painter of town views, he painted portraits and miniatures of the country residents of the regions around Ithaca and Elmira, New York. His portraits vary in style and appeal with some of his small watercolors, ten by eight inches or less, faithfully representing his sitters in interiors with floor and wall decorations rendered in the decorative manner of the folk artist. His larger oil portraits are fewer in number and, although colorful, lack the grace of his best watercolor portraits. His style is uneven, with his primitive paintings intermingled with rather dull academic ones. He worked in both watercolor and oil and almost always signed his work on either the front or the reverse.

The time and place of Walton's birth are not known, but it is speculated that he was the son of Judge Henry Walton (1768–1844), a wealthy landowner in Saratoga Springs. In any case by 1836 he was established as an artist in the Finger Lakes region of New York, working in Ithaca until 1846 and then in Elmira, Big Flats, Painted Post, and Addison. He joined a Gold Rush party arriving in San Francisco aboard the steamer *Oregon* in September 1851. His view of Grass Valley was painted in 1857, and later that year he journeyed to Michigan. He died in Cassopolis, Michigan, in 1865.

House, homestead, and farm portraits are a more personal form of architectural painting than town views and were more often painted by less well-trained artists, sometimes by a member of the family living in the house. More have survived, perhaps because of the careful protection given them by the owners of the buildings. An early example, and one of the few eighteenth-century canvases to survive, is a naive view of the homestead of General Timothy Ruggles of Hardwick, Massachusetts, painted by Winthrop Chandler. This fully primitive picture shows flat houses without shadow rendered with faulty perspective and stylized trees in a composition framed by trees and hills on either side. The scene is enlivened with human and animal activity.

By 1800, Francis Guy, a former silk dyer and calenderer from London, had established himself as a landscape painter in Baltimore. His specialty was painting gentlemen's country seats in Maryland. Characteristically, these are rather distant views of a fine house in a landscape setting with Guy's inevitable hallmark of one or more pairs of small human figures in Empire dress used as accessories. After working twenty years or so in Baltimore, he moved to Brooklyn, New York, where he died in 1820.

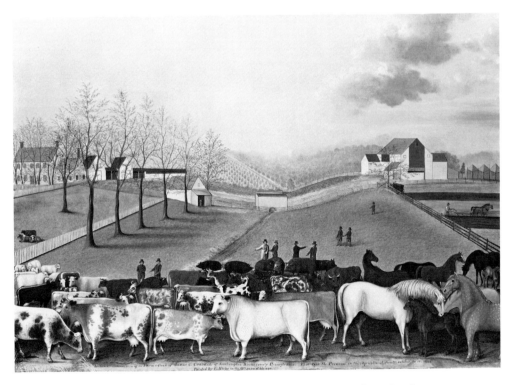

EDWARD HICKS. *The Cornell Farm.* Shows the buildings and stock of James C. Cornell and is signed: "Painted by E. Hicks in the 69th year of his age." Oil on canvas, 36¾" x 49". (*National Gallery of Art, Gift of Edgar William and Bernice Chrysler Garbisch*)

Although the Quaker Edward Hicks is best known for his many and varied versions of the *Peaceable Kingdom,* a sizable group considers the farm views to be his best work. The best known are *The Cornell Farm* (ca.1849) and *The Twining Farm* (ca. 1846). Also working in Pennsylvania was Charles C. Hofmann, who produced large landscapes from 1865 to 1881. His *View of Henry Z. Van Reed's Farm* was completed in 1872. Hofmann painted the almshouses of Berks, Schuylkill, and Montgomery counties apparently from intimate knowledge since he was in and out of them from 1872 on, because of his habit of intemperance. He died a pauper in 1882. Paul A. Siefert came to America from Germany in 1867 and painted large watercolors of Wisconsin farms from the late 1860s until about 1915. His main occupation was agriculture so that his activity as an itinerant farm painter was only a secondary source of income.

The grocer and artist Jurgan Frederick Huge, although mainly a painter of large watercolor marines, also painted portraits of houses and public buildings in and around Bridgeport, Connecticut. Fritz G. Vogt was active from about 1890 to 1900 in the area around Albany, New York, doing portraits of houses in pencil and crayon.

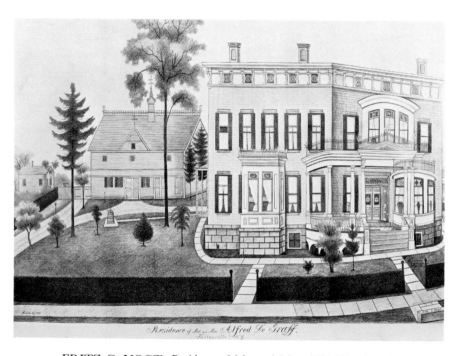

FRITZ G. VOGT. *Residence of Mr. and Mrs. Alfred De Graff/Fultonville, N.Y.* Signed: "Fritz G. Vogt—March 27, 1895." Crayon and pencil, 27⅞″ x 40″. (*Hirschl and Adler Galleries, New York*)

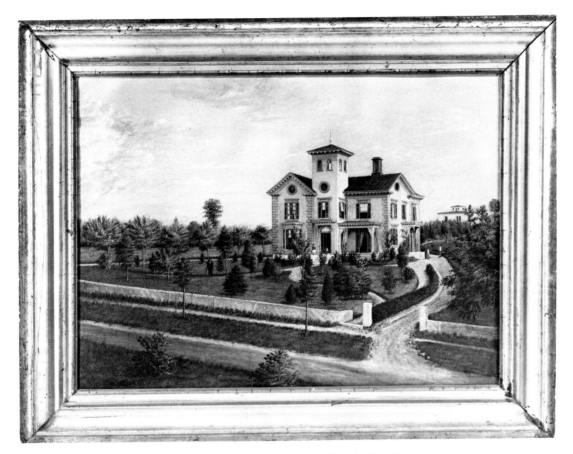

House in the Suburbs. Painted ca. 1852 by an unidentified artist in the Troy, New York, area. The proud owner and his two children are pictured on the walk and at the front door. Oil on canvas, 22″ x 30″. *(Formerly in the permanent collection of the Whitney Museum of American Art)*

Factory and Mill Views

An aquatint, *View of Pawtucket Bridge and Falls,* which was published in *The Polyanthos* (Boston, 1812) includes a view of Slater's Mill. This early illustration was followed by many other printed views of mills which appeared in books, magazines, and newspapers and as free prints as manufacturing increased in importance during and after the War of 1812. The early mills were often portrayed in village surroundings as part of a rural community, the later ones as part of a complex of industrial buildings. Many of the originals for the printed views have disappeared. After mid-century there was a tremendous growth of industrialization so that mill sites outgrew their status as villages and became urban centers. Paintings were commissioned to commemorate mergers, acquisitions, or a new building or plant site. These were used to decorate boardrooms or as sources for advertising posters and publicity. Few artists of the oil paintings, watercolors, and pen-and-ink drawings of the various types of industrial landscapes have been identified.

Portraits of public buildings that were sources of great civic pride, such as the Fairmount Water Works in Philadelphia, and those that were symbols of enlightened humanitarianism, such as hospitals, almshouses and insane asylums, were also in demand.

Still-Life and Landscape Pictures

These essentially nonpersonalized categories were painted simply for decoration. In seventeenth-century Holland, still-life paintings enjoyed great popularity; but the eighteenth-century French and English academicians held this form of painting in low esteem since it failed to express a grand or noble sentiment. According to the academic scale of values, lofty historical subjects rated first, followed by portraits, landscapes, genre, and the lowly still life.

Following this official line, the prominent painters in America avoided frivolous subjects for the most part except, perhaps, as background or accessory in the composition of a portrait. However, the house and furniture decorators were not bound by such conventions and painted vases of flowers on fireboards to shield the fireplace in summer instead of the vase of real flowers used by the wealthy. The fine shell and flower compositions with which John Penniman ornamented furniture for the Seymours and others may be viewed as still-life painting. In 1790, when only seventeen years old, Penniman painted a view of Meeting House Hill in Roxbury, Massachusetts. By 1804 he was employed by Aaron Willard in Boston as a dial painter, and he painted Willard's portrait the same year. He was also the teacher of Alvan Fisher, a well-known painter in the academic tradition who acquired a style from Penniman "which required years to shake off—I mean a mechanical ornamental touch, and manner of coloring."

Except for the furniture and decorative painters and the schoolgirls with their theorem paintings on velvet and paper, there were virtually no still-life paintings in America before about 1810. The Peale family and their sponsorship of the Columbianum or Academy of Fine Arts did much to change this. The first exhibit in 1795 in the Senate Chamber of the State House in Philadelphia included still-life pictures. Many members of the Peale family soon began painting such pictures as did other Academy members including Charles Bird King. Philadelphia remained a center for still-life paintings, and about mid-century both John Francis and Severin Roesen were at work there. Some of the paintings by the Peales and later by Francis and Roesen were used as models by the folk painters. Other sources of inspiration were prints, especially the lithographs of Currier and Ives.

Still Life with Watermelon. Probably an early work of Alexander Lawrie (or Lourie). Painted in a style popular in Philadelphia about 1850. Lawrie later became a professional artist and worked in the academic style of the time. Oil on canvas, 22" x 27".

The nonacademic professionals in their endeavors produced many attractive compositions for their clients, sometimes close approximations of the master from whom they copied. Occasionally, their shortcomings produced humorous but charming results. Schoolgirls and other amateurs, often not following the mainstream of American still-life painting, sometimes accomplished minor masterpieces which have no obvious antecedents.

Since landscapes suffered from some of the same bias that afflicted still lifes, few were painted in the eighteenth century and then usually as an overmantel decoration or on the summer fireboard. Most of these were copies of English and European prints. The landscape as an accepted form of hanging art had its heyday only after Alvan Fisher, Thomas Doughty, and Thomas Cole painted scenes from nature that initiated the acclaimed Hudson River school of painting about 1825–30. By then the European academicians had cast off some of their prejudices and were also painting landscapes.

THOMAS CHAMBERS. *View from Mount Holyoke.* Typical of Chambers's imaginative landscapes. Oil on canvas, 22″ x 30″. (*Fruitlands Museums*)

Most of the nineteenth-century American nonacademic artists continued to feel that painting was a craft, not an art, and that to copy a print only made good sense. Bartlett's engravings in *American Scenery,* 1840, and *Canadian Scenery,* 1842, provided many artists and lithographers with a ready source. Throughout much of the period the hand-colored lithographs by Currier and Ives and others were prime competition for the artist trying to sell landscape paintings. After the decline, about mid-century, in the demand for painted portraits, artists like William Prior felt pressured to sell landscapes to compensate for the loss of this other business.

Thomas Chambers was one of the most creative and prolific of the landscape artists. He painted in a highly stylized, primitive manner. His landscapes were often imaginary, including castles and ruins. Others were obviously taken directly from prints, but a few may have been observations directly from nature. The colors, techniques, and composi-

tions which he used give his work an artistic individuality which encourages quick attributions, a fortunate happenstance since few of his works are signed.

Very little is known of Chambers's life. He was born in England in 1815, came to America in 1832, and became a naturalized citizen. The New York City directories listed him as a "landscape" and later a "marine painter" from 1834 to 1840. He was then listed as "artist" in the Boston directories from 1843 to 1851. After that he appeared in Albany from 1852 to 1857 and finally in New York City again in 1858–59 and 1861–66. The time and place of his death are unknown.

The Quaker Edward Hicks also painted landscapes, especially of natural wonders like Niagara Falls and Natural Bridge in Virginia; but these generally have religious overtones.

THOMAS CHAMBERS. *Summer House in a River Landscape.* Oil on canvas, 14″ x 18″. (*Hirschl and Adler Galleries, New York*)

**Patriotic
and Religious
Paintings**

Nineteenth-century Americans faced life with religion and the further spiritual uplift of patriotism rather than today's burden of taxes. The United States had already won two wars against the awesome power of England. Given such circumstances many must have felt that the United States was just about invincible. The focus for this feeling was George Washington, and his image was incorporated into all kinds of prints and paintings. At the turn of the century, the historical painter Frederick Kemmelmeyer commemorated Washington with the iconography that was to become associated with him—eagle with shield, portrait in wreath, flags, trumpets, and a Masonic medal—in a painting called *The American Star.* When the old Washington family vault was replaced by a new one in 1837, the interest created a demand for prints and paintings on the subject. Prior painted numerous versions including a moonlight scene, and he also produced a number of views of Mount Vernon, Washington's home. Prior also had a thriving trade in portraits of Washington painted on glass.

The symbols associated with Washington were part of the artistic vocabulary of the sign painter. One of these, the Quaker preacher Edward Hicks, was trained in painting and lettering by a coach maker and then earned a living as a coach, sign, and ornamental painter. He

EDWARD HICKS. *Sign of the Newtown Library Company.* Painted in 1825, this sign includes a portrait of Benjamin Franklin, a fellow Pennsylvanian much admired by Hicks. (*Newtown Library Company, Newtown, Pennsylvania, Photograph from Frick Art Reference Library*)

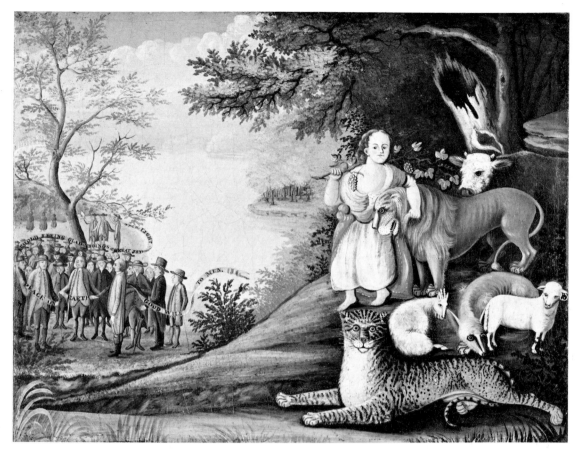

EDWARD HICKS. *Peaceable Kingdom.* A version painted by Hicks about 1832. Oil on canvas, 17⅝″ x 23⅝″. (*The Henry Francis du Pont Winterthur Museum*)

often included Washington on horseback in his neatly lettered signs. Penn's treaty with the Indians was another of Hicks's favorite subjects. But today he is best known for his irresistible *Peaceable Kingdom* paintings which were based on a verse from Isaiah:

> The wolf also shall dwell with the lamb,
> And the leopard shall lie down with the kid;
> And the calf and the young lion and the fatling together;
> And a little child shall lead them.

In Hicks's literal interpretation, the early versions have a small child with a lion as the central figures and usually a spotted leopard at the child's feet. Hicks sometimes paraphrased the quotation to include a section on the "illustrious Penn," a Quaker who is often shown signing the "lasting Treaty" with the Indians in the background. A printed card with the paraphrased verse was sometimes given along with the painting. Most were painted for friends as gifts, but some were sold for about

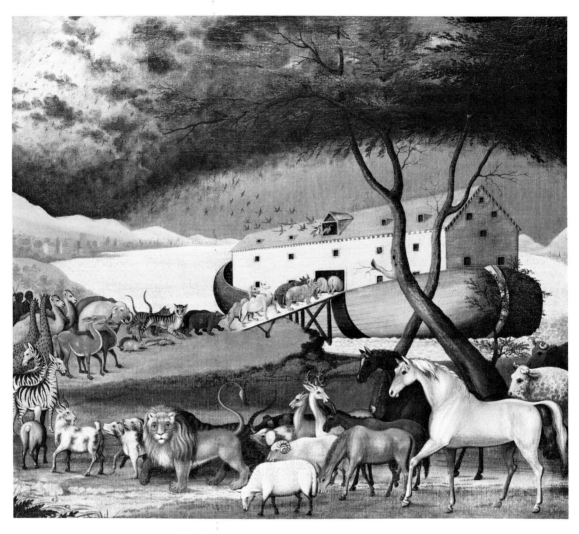

EDWARD HICKS. *Noah's Ark.* Painted by Hicks about 1848 using an N. Currier print as inspiration. Oil on canvas, 26½″ x 30½″. (*Philadelphia Museum of Art*)

fifty dollars each. It is estimated that between 1816 and 1849 Hicks completed nearly one hundred versions of the *Peaceable Kingdom*. Another subject from the Bible is the version of *Noah's Ark* which is closely based on the N. Currier lithograph. Hicks made generous use of all kinds of printed sources for his designs.

Edward Hicks was born in Attleborough (now Langhorne), Bucks County, Pennsylvania, on April 4, 1780. His parents, Hicks on both sides, were from an old New England Puritan family with Royalist leanings. After the revolutionary war the once-prosperous family fell upon hard times so that when young Edward's mother died in 1781, the father allowed his son to be reared in the household of the Twining family.

They were affluent Quakers and the source of Edward's religious con-
victions. At the age of thirteen he was apprenticed to a coach maker
where he learned to paint and letter. After a seven-year apprenticeship
young Hicks set up in business for himself as a coach and ornamental
painter.

He spent most of his life in Newtown, Pennsylvania, where he was
a prominent Quaker preacher and played an active role in church affairs.
Later in life he devoted much of his time to creative painting of which
the *Peaceable Kingdom* series, from 1816 on, is an example. He found art
of value in life, a belief that is not in the Quaker tradition and that
his peers found upsetting. Edward Hicks continued to paint almost until
his death in 1849.

Erastus Salisbury Field is another nineteenth-century professional
painter who devoted much time to patriotic and religious painting,
although he followed a far different route in a completely different
style from that of Hicks. Field studied very briefly under S. F. B. Morse,
the artist-inventor, in 1824–25 and then went on to a relatively successful
career as an itinerant portrait painter. In 1848, however, at the age of
forty-three, he began withdrawing from portrait painting to spend
considerable time painting subjects connected with American history,
biblical history, and mythology. His painting *Lincoln with Washington and
His Generals* is typical of his later portrait work and shows the in-

Noah's Ark. Hand-colored lithograph, 8″ x 12½″, published by
N. Currier. One of five versions published by him and later by the
partnership of Currier and Ives.

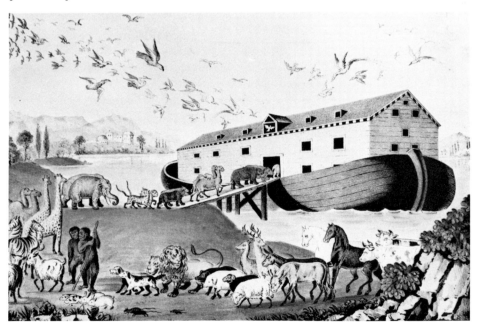

ERASTUS SALISBURY FIELD. *Lincoln with Washington and His Generals.*
Included in this daugerreotypelike composition are (left to right) Ambrose E.
Burnside, Lincoln, Washington, U. S. Grant, Rutherford B. Hayes, and
Chester A. Arthur. Oil on canvas, 32″ x 39″. (*Museum of Fine Arts, Springfield Massachusetts*)

fluence of the camera. His grandiose *Historical Monument of the American
Republic,* about nine by thirteen feet, was probably executed in response
to a competition announced in 1874 for the design of the central building
at the Philadelphia Centennial Exposition. It was never entered in
competition and in fact was not even completed until 1876, the year
of the exposition. The buildings are shown with hundreds of reliefs
depicting scenes from American history and life. Statues of America's
great are scattered over the buildings with a seated Lincoln, whom Field
venerated, shown in a front and center position halfway up the tower
on the main entrance. Field's religious works include *The Garden of Eden*
and *Death of the First Born.*

A few other painters such as Joseph Hidley painted religious subjects, but for the most part this was a limited category for the professional. The amateur painters, particularly schoolchildren, were active in depicting both patriotic and religious subjects. In any case American religious subjects were mainly confined to narratives from the Old Testament such as the story of the Prodigal Son, Moses in the bullrushes, and Naomi and Ruth. Versions of the events in the life of Christ such as the Crucifixion and the Last Supper were not often done.

HISTORICAL MONUMENT OF THE AMERICAN REPUBLIC.

ERASTUS SALISBURY FIELD. *Historical Monument of the American Republic.* Painted ca. 1876 in a monumental size, 9′3″ x 13′1″. (*Museum of Fine Arts, Springfield, Massachusetts*)

Murals and Other Household Decoration

"House and sign painter" was a dependable and respected trade but in rural communities often had to be combined with occupations like farming or schoolteaching as a seasonal filler. To broaden their base the more imaginative craftsmen also painted decorations on fire buckets, drums, flags and standards for the town militia, Masonic aprons, sleighs, coaches, and patterns on the walls and floors of village and farmhouses. A lack of money for carpets or fancy imported wallpaper created a demand for the services of a local painter who could provide a gay and colorful substitute using stencil decorations or, in some cases, freehand painting. A talented few even painted murals in imitation of French scenic wallpaper.

It was a boon to the rural painter when about 1800 wallpaper fashions turned to small, neat patterns which could be copied easily either freehand or with stencils. Many of the imported wallpapers were made using stencils so that a competent worker using stencils and painting directly on the walls achieved a close approximation to the desired effect. Geometric designs, flowers, and leaves with swags and other devices for borders were painted in bright colors on many country walls over the next fifty years. If there was no local painter with the skill, then itinerants such as Moses Eaton, Sr. (1753–1833), and Moses Eaton, Jr. (1796–1886), of Hancock and Dublin, New Hampshire, filled the void.

Scenic wallpapers became fashionable in France in the early nineteenth century, and by 1815 scenes showing parks, romantic landscapes, and cities appeared on the walls of prosperous families in America. Dufours of Paris and others exported the expensive mural papers with titles like "Monuments of Paris," "Bay of Naples," and "Incas in Peru." About 1834 Zuber and Company, in Rixheim, Alsace, printed a paper called "Scenic America" with large American views that were popular in Europe, including Niagara Falls, Natural Bridge in Virginia, Boston Harbor, and New York City. These views were based on engravings made in the 1820s.

In 1804, only a few years after Michele Felice Cornè arrived from Naples, he received commissions to paint fireboards and murals for the Salem East India Marine Society and fine Salem houses. The rooms in the East India Society were embellished with four historical subjects, among which were *The Landing of the Pilgrims* and *The Landing of Columbus.* Cornè decorated the Lindall-Barnard house in Salem by pasting heavy strips of paper on the walls and then painting them with a variety of pastoral landscapes, mountains, and hunting scenes. In 1810 he was awarded a contract to decorate seven rooms and the upper and lower entries of the Sullivan Dorr house in Providence, which he executed with an amazing variety of subjects, his most spectacular being a mural on a long wall of the parlor entitled *The Bay of Naples.*

RUFUS PORTER. *Wall Mural,* painted in a gray-green monochrome. From the Whitney house in Harvard, Massachusetts. (*Fruitlands Museums*)

Rural America followed the trends set in the fashion centers, and those who could afford it sometimes had original scenes painted on their walls by "tramp painters," or itinerants. The most prominent among the muralists was Rufus Porter who began painting murals about 1820. In addition to traveling and painting, he trained assistants who after their apprenticeships went out on their own. There were probably also followers who imitated him but whom he never actually trained. The majority of the scenes painted by these men are found in Massachusetts, Maine, Vermont, and New Hampshire. They are often signed.

Some painters of the Porter school are Stephen Twombly Porter, his son; Jonathan D. Poor, his nephew; Orison Wood; E. J. Gilbert; ? Paine; E. V. Bennett; and ? Swift. Poor was active in Maine and eastern Massachusetts. Orison Wood (1811–42) was an outstanding follower who worked in Maine in the 1830s, as did Gilbert, Bennett, and Paine.

A few of the murals were clearly inspired by prints but others seem to be original with the artist. Porter's book *A Select Collection of Valuable and Curious Arts,* published in 1825, gives complete details for painting murals including preparation of the paint, the colors to use for specific objects, techniques for applying paints, and even the size in inches that particular objects should be made in order to represent given distances from the viewer. A series of articles in *Scientific American* in 1846–47 also includes suggested compositions. Innumerable drawing books of the period offer compositions, and some of these may be as yet unidentified sources for murals still in existence.

Rufus Porter with his many facets is today, unfortunately, a little-known American. He was born at West Boxford, Massachusetts, in 1792. In 1801 his family moved to Maine and shortly after, in 1804, Rufus entered Fryeburg Academy. He remained there only six months, ending his formal education at the age of twelve. From 1807 until 1812 he lived in Portland earning a living first as a musician and then as a house and sign painter. His activities during the next few years were fluid and included brief service during the War of 1812 and marriage to Eunice Twombly in 1815. By 1816 he was in New Haven earning a living as a portrait painter and a dancing-school master. About 1818 he made a trip to Hawaii. Until 1824 he was an itinerant portrait painter and later a landscape painter working from Virginia to Maine. Some of his miniature watercolors have survived. About 1824 he switched to mural painting, presumably because he saw it as a better opportunity, and worked at it throughout New England until about 1845.

His interest in writing and science was apparent in the publication of his *Valuable and Curious Arts* in 1825. The book was a compendium with additions of practical receipts gathered from many earlier "how to" books. The 102 pages and 115 items include simple, well-written, brief instructions on, among other things, graining, marbleizing, etching and engraving, painting floor coverings, and, of course, mural painting. The volume was popular and widely used.

In the 1830s Porter began patenting and also publishing some of his inventions in magazines such as *American Mechanic* and *New York Mechanic*. In 1840 he bought an interest in the *New York Mechanic* and until 1842, when he sold out, he was its editor and publisher. By 1845 he had given up mural painting for his new career in science and invention, and on August 28, 1845, the first issue of *Scientific American* appeared, founded and edited by Porter. It became one of the most important scientific journals of the period. Porter had a distinguished publishing and scientific career until he was overtaken by old age; he died at the age of ninety-two in 1884, forgotten and lonely.

CHAPTER SIX Works of the Amateur—Painting and Calligraphy

A majority of the paintings and pastels encountered today were the work of a large corps of amateur artists. Most numerous in this group were members of the wealthier families of the northeastern part of the United States who prospered from the trade and commerce that gained great momentum after the Revolution. This earlier "affluent society" included leisured married women, gentlemen dilettantes, and the girls from the private schools or academies who were taught music, dancing, painting, drawing, sewing, and embroidery in addition to some academic subjects. As Thomas Jefferson wrote, "The ornament too and the amusements of life, are entitled to their proportion of attention. These, for a female, are dancing, drawing, and music." The successful works were framed and hung in the home to be admired by members of the household and guests. In 1813 the Russian visitor Paul Svinin noted, "Already Mothers boast of their daughter's talent for drawing and show the products of their brushes to each other." The ex-actress Susanna Rowson operated a popular and successful academy in the Boston area which observed an annual Public Day or Exhibition at which "very beautiful specimens of Embroidery, Paintings and Drawings in watercolours, Maps . . ." were displayed.

By the middle of the nineteenth century, the flow of female semi-nary works had diminished partly because of the competition from readily available landscapes painted by professionals and the cheap, plentiful colored lithographs of Currier and Ives and other publishers. Another factor in the decline was the recognition of the contributing role that women could play as teachers, and at the lower social end,

LUCINDA DANA. A typical needlework picture executed by Lucinda Dana (1792–1826) of Princeton, Massachusetts. Needlework and gouache on silk in an oval, 9¾″ x 7½″. (*Fruitlands Museums*)

Girl and Harbor. A watercolor scene, ca. 1815, with possibly Boston harbor in the background. A work of average competence typical of the output of the amateur painters of the day. Watercolor, gouache, and pencil on paper, 8″ x 10″.

as part of the factory labor force. The seriousness with which women began to see themselves is reflected in the monthly periodicals for women. The *Ladies' Repository* of 1854 observed: "Woman's rights has become one of the prominent themes of the age. Every-where is it discussed. Some of the Sex have arisen, and made an effort to throw off the shackles which they assert have so long prevented woman from taking that active part in the drama of life which the Creator designed she should." With the founding of women's colleges and the admission of women to existing ones in the 1830s, pressure was put on the preparatory schools for a more serious curriculum with less emphasis on genteel aristocratic skills and accomplishments.

While this artistic fervor lasted, it was supported by an army of instructors and by a library of books giving detailed instructions on drawing and painting and the correct "receipt" to use in the preparation of the paint and other materials. By 1824 little watercolor cakes that were ready to use were made in Philadelphia. Many of the instruction books for use by those who wished to teach themselves were imported from England, but even as early as 1787 there were some American drawing books. An increasing number were published in America during the first half of the nineteenth century. Engravings or lithographs of landscapes and still-life compositions were often part of the home-study books, and, in the prevailing nineteenth-century attitude, the student was encouraged to copy them. Painting and drawing from nature were considered less desirable than following a print made by a professional artist; a library of prints was thus an important part of the supplies of a school or teacher of art.

Although some of the instructors were staff members in the larger academies, many were itinerant or professional artists with a class or two on the side to help support themselves until their art was recognized. An early advertisement for students for an art class was put in the *Maryland Journal* (Baltimore) by Frederick Kemmelmeyer on January 3, 1792. Kemmelmeyer, active as a professional painter from 1788 to 1805, painted signs, portraits, and historical and patriotic works. One of his best-known paintings is *Washington Reviewing the Western Army at Fort Cumberland, Maryland.* This must have been a popular subject since several versions are known. His advertisement read:

Kemmelmeyer, Frederick
Has opened a Drawing School, for Young Ladies at his Home, in Market-Street, the Corner of St. Paul's Lane, where he teaches that polite art every Day in the Week, (Sunday, excluded) from Two to Four o'clock, P.M. Price Seventeen Shillings and Six-Pence per Month. Limning in Oil, Crayons, and Water-Colours. Also Sign-Painting done on moderate Terms.

Most of the amateurs turned out only a few works but some became dedicated artists.

Sarah E. Harvey (1835–1924) executed her first oil painting as a student at Charlottesville Seminary in New York. In the ensuing years she painted over one thousand pictures, most of which she gave away. Another amateur was Eunice Pinney, who after her second marriage in 1798 indulged in her hobby of painting. Over fifty of her watercolors have survived.

Still Life and Paintings on Velvet

Baskets of flowers or fruits, watermelon and other fruit on a table, and vases of flowers were frequently painted subjects during the first half of the nineteenth century. These still lifes were executed in pastels on prepared paper, watercolor on paper, oil on canvas, and particularly in oil or watercolor on velvet. The vogue for painting on velvet lasted from about 1800 to 1840 with a peak during the 1820s. Maria Turner wrote in *The Young Ladies' Assistant in Drawing and Painting* in 1833 (Cincinnati): "Velvet Painting was a few years ago a very fashionable study for young ladies. . . . We now scarcely hear it mentioned, or see any traces of it, except when we travel through the country where painting has not made great progress." Now, whether or not Miss Turner classified Washington, D.C., as a rural backwater, a contemporary account in the diary of a dilettante, the son of a well-known shipbuilder, shows that velvet painting was alive and well there.

> Georgetown, D.C. April 21, 1832
> Verry warm and pleasant today, at about ten o'clock today the Miss Steward came to our house from Alexandria and brot an eminent lady with her, she teaches painting on velvit and musik on most any instrument what ever, they stoped at our house till about one o'clock and then they returned to Alexandria.

> April 22, 1832
> Verry pleasant and warm. I went down to Alexandria to take a lesson on painting on velvit and finished two pieces and it was said to be the handsomest . . . in Georgetown.

> January 25, 1833
> Last night I painted a piece of fruit on velvit and completed it, and think to paint a gar of flowers tonight, they are about $\frac{1}{2}$ yard square

> January 26, 1833
> No news to write today it is pleasant, I have been painting this evening on the piece of velvit that completes the two pieces and another pair which I think to have framed and sent to my mother as a present.

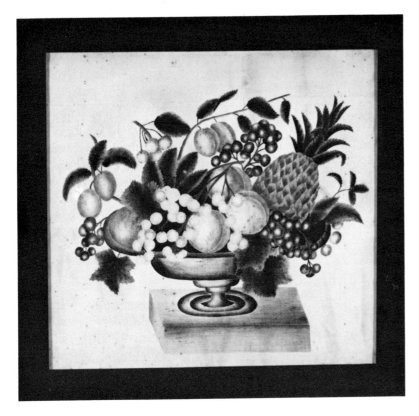

ELIZABETH W. CAPRON. *Still Life Theorem.* ca. 1840. Oil on velvet, 17⅛″ x 18⅜″. (*Collection of Herbert W. Hemphill, Jr., Photograph courtesy of Heritage Plantation of Sandwich*)

Still Life. A stylized composition of fruit and flowers. Watercolor on paper, 15¾″ x 19½″. (*Heritage Plantation of Sandwich*)

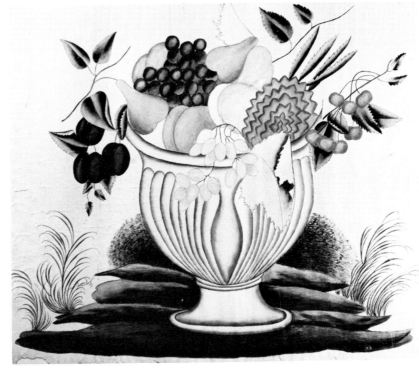

Although Miss Turner felt that in 1833 velvet painting had "ingloriously fallen into disrepute," she gave directions for it in her *Young Ladies' Assistant:*

> Flowers and fruit are certainly the most appropriate subjects for the velvet-scrub; but landscapes and figures may be executed with success. . . . You must choose velvet of a thick texture, and a short and even nap. Pin it over the design, and trace it on the window; and if you are to paint a landscape, dilute the liquids which you intend for the sky, and put them on with a sponge on the wrong side of the velvet; then strain it over a board and begin to paint, first laying on the light colors, and afterwards shading with the darker, as you do in mezzotinto, but without the theorem. Fruit and flowers are done in the same manner, except that you do not color the velvet on the wrong side, unless you wish to have a ground-wash.

These instructions were for a traced design, but in many cases the compositions were done with theorems or stencils. A quasi-mathematical definition of a theorem is an idea or statement derived from the application and combination of individual elements. If fruits and flowers are considered elements, then a still life built up of these individual parts may be called a theorem. In practice this combination was achieved either by painting the individual pieces freehand or by the use of stencils. The stencils were made of heavy paper treated with alternate coats of shellac and oil which rendered it stiff, strong, and waterproof. Cutouts representing elements of the design were made which were then used as guides in coloring the composition. As Miss Turner described it:

> Lay the hornpaper on the design you wish to copy, and trace with a sharp-pointed steel pen, the outlines of one petal. At some distance from this petal, trace another and as many as you afterwards can shade without the brush touching at the same time more than one. The stems and some of the leaves may also be traced before the hornpaper is removed. Then cut out those parts which are contained within the outline and lay the hornpaper which now receives the appellation of formulus, or *theorem*, over the bristol-board. . . .

These instructions were for a floral design on paper. Theorems were used for watercolors on paper as well as on velvet. The separation of the elements, such as individual grapes in a bunch of grapes, is generally characteristic of the use of stencils since the cutouts prevented them from blending. The painting was not a simple matter of filling in the cut-out section but was artfully shaded along the edges. The resulting compositions frequently acquired a gravity-defying look with pineapples or other fruits hovering precariously on top of a filled bowl or wicker basket.

There are so many velvets with identical compositions that there must have been a common source for the designs, but as yet the specific

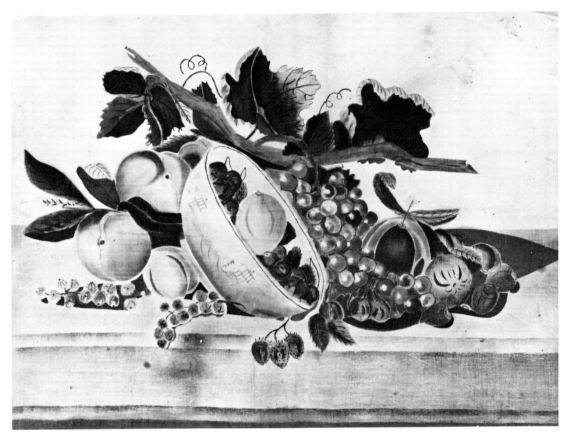

The Tipped Bowl. The tipped bowl is one of the standard designs with many variations often used by the nineteenth-century theorem painter. Stencil and watercolor on velvet, 19⅛″ x 26″. (*Museum of Fine Arts, Boston, M. and M. Karolik Collection*)

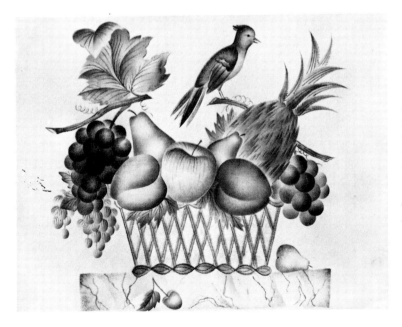

Basket of Fruit with Bird. An imaginative and well-executed theorem using stencil and watercolor on velvet, 13¼″ x 18″. (*Museum of Fine Arts, Boston, M. and M. Karolik Collection*)

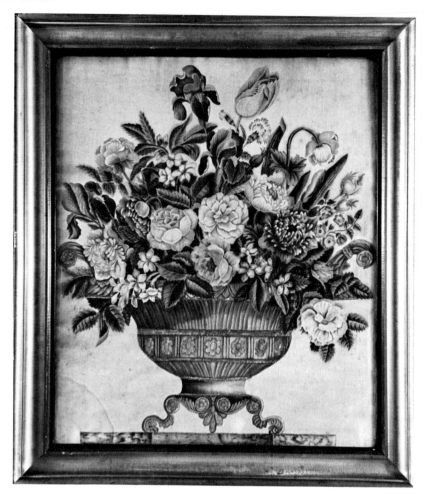

Formal Vase of Flowers. An extremely elaborate and well-executed velvet painting highlighted with applied gold leaf and gold powder. The composition was probably inspired by French wallpaper or flower print. Boston, ca. 1815. Watercolor on velvet, 25″ x 22″.

Three Part Stencil. A set of three stencils used to produce a basket of fruit composition. The large stencil on the bottom is on paper, 11″ x 19″.

prints have not been uncovered. The basket of flowers was a popular decorative device on furniture brasses, on silverware handles, and, of course, on the furniture of the Salem carver Samuel McIntyre from the late 1780s until his death in 1811. The basket of flowers occurs frequently on New England velvets. Possible sources of inspiration were the imported wallpapers, especially those from France. The rather lavish arrangement of flowers in the fancy bowl which is illustrated here bears a striking resemblance to some of the designs on the wallpapers of the period. The sizes would have been about right for tracing. The watermelon compositions on marble tables were probably inspired by the Peales.

It is likely that the design and the stencils were supplied by a school instructor or sold in a kit. The planning, drawing, and cutting of a moderately complicated design required more skill and patience than would probably be needed to paint it freehand in the first place. An instructor could have prepared the stencils or theorems for the use of his pupils. This theory is supported by the fact that a set of stencils in the collection of the Society for the Preservation of New England Antiquities, one of the few complete sets in existence, appears to have been used many times. Landscapes, biblical, mythological, and romantic subjects, and memorials were also painted on velvet but not with the happy result achieved in the still lifes.

Some fine stylized watercolors exist, both theorems and freehand, which are stylistically similar to the velvet paintings. Oil paintings tend to be more complex and ambitious, imitating the Peales or Severin Roesen. Occasionally a masterpiece of design and originality is achieved in this medium also using the stencil technique.

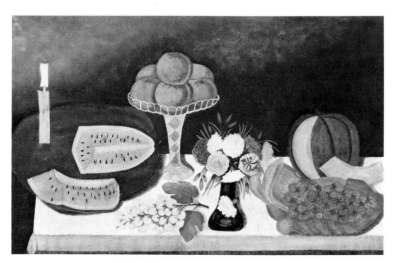

Tomatoes, Fruit and Flowers. A fine amateur still-life painting, ca. 1840–50. Oil on canvas, 20″ x 31½″. (Museum of Fine Arts, Boston, M. and M. Karolik Collection)

The Claremont Hotel, New York. A spirited genre picture by a talented amateur. Oil on canvas, 26″ x 35″. (*Metropolitan Museum of Art, The Edward W. C. Arnold Collection of New York Prints, Maps and Pictures; Bequest of E. W. C. Arnold, 1954*)

Landscape and Genre

The popularity of landscapes increased after about 1830, led in part by the newly emerging Hudson River school. While these painters went out to paint the American landscape, the amateur followed suit, but usually by copying a print. The medium for these paintings and drawings often reflected the character of the artist. Messy oils were typically reserved for men while pastels, charcoals, and watercolors were usually used by women and children. Oils, by tradition, were used mostly on canvas although sometimes on wood boards or cardboard. Sheets of drawing paper, frequently made and watermarked by J. Whatman of England, were used for watercolors. Pastels and charcoals were usually on "sandpaper," a thick paper coated with a glue and then dusted with marble chips. The rough surface of these sandpaper sheets was ideal for holding the dusty stroke of the pastel crayon or the charcoal stick.

Inspiration for the painting or drawing came from many sources. The drawing books gave instructions in composition, perspective, colors to be used, as well as illustrations to copy and instructions on enlarging or diminishing a print when transforming it into a painting. High on the list of favorite views to be copied were the 119 engraved views from drawings by W. H. Bartlett which were published in London in 1840 in *American Scenery* and a similar volume published in 1842, *Canadian Scenery*. In fact, some of the parts in which the original subscribers' copies were issued bear advertisements on the back cover for *The Youth's New London Self-Instructing Drawing Book*. In addition to the various books and portfolios of engraved views, the popular lithographs and new illustrated weeklies which appeared in the 1850s served as source material.

Harpers Ferry, West Va. A composition probably inspired by a Currier and Ives print published ca. 1858. Charcoal and white chalk on sandpaper, 20¾″ x 27½″. (*Hirschl and Adler Galleries, New York*)

For the most part these prints were slavishly copied, but for a few they served as a springboard for new and imaginative compositions. Some of the artists embellished their landscapes with castles and other items drawn from the imagination in the manner of Thomas Chambers. The addition of horses and wagons in some and people at work in others enriches the pictures with elements of genre. Biblical figures, angels, or characters from mythology inhabit other scenes. There were, of course, a few who decided upon an original composition without the crutch of a print, portraying scenes in their village or town or their homes with family members scattered about the composition. On the seas, the diaries and sketchbooks of sailors, especially whalers, offer dramatic views of life on shipboard and of ports of call. Pioneer life and mining scenes must be included as Americans struggled west.

Over the years the folk paintings from the northeastern part of the United States have been well researched and catalogued. Much less study has gone into the works produced in the South and West. In part this is the result of the relative wealth of material in one area and its scarcity in the others. It was not until later in the nineteenth century

JONATHAN FISHER. *View Along the Maine Coast.* Typical of the work of this minister and artist from Blue Hill, Maine. Oil on canvas, 26½″ x 46½″. (*Hirschl and Adler Galleries, New York*)

MRS. FOLSOM. *Conway Castle.* A finely detailed charcoal drawing, 22″ x 28″. (*Hirschl and Adler Galleries, New York*)

California Mission. An extremely flat painting by an amateur of an unusual subject. Painted ca. 1850. Oil on canvas, 20½″ x 24″. (*Collection of Herbert W. Hemphill, Jr., Photograph courtesy of Heritage Plantation of Sandwich*)

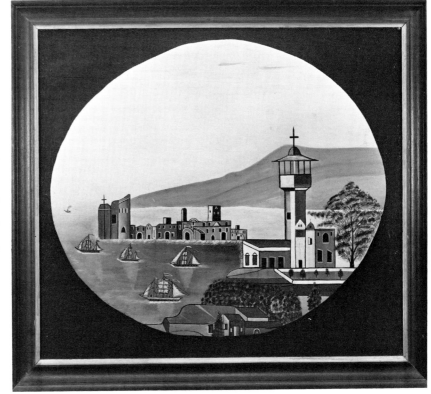

that Chicago and San Francisco could boast of the leisured class that existed in Salem at the beginning of the century. The relative stability of New England family life was conducive to the preservation and passing on of family possessions from one generation to the next. New England was also spared the destructive forces of war inflicted on the South.

Both the Civil War and the opening of the West were covered by a small army of amateur and professional sketchers and adventurers who drew and painted battle scenes, scenes of army life, scenes on the prairie and of Indian life, mining operations, and street scenes in western towns. The illustrated weeklies sent artist-correspondents across the country wherever there was a story. Some of the resulting sketches are distinctly naive while others are sophisticated. Many of the expeditions to the West for surveys or other purposes included professional and amateur artists.

Memorials and Family Records

Memorials became a fashion late in the eighteenth century and the vogue lasted for about fifty years. Mourning pictures appeared in a variety of media beginning with finely wrought embroidery on silk which was gradually encroached upon by watercolors for the sky, then the faces, hands, and other fine details, background scenery, and buildings until the whole picture was done in watercolor on paper. Sometimes funeral cards, faces, or parts of clothing were pasted on the picture instead of being painted. Mourning pictures were also painted on velvet and glass and, rarely, in oil on canvas. Associated with these were other accessories such as rings, lockets, and miniatures for friends and family members of the deceased and china and engravings for the public in the wake of the death of a public figure such as George Washington.

Mourning pictures were usually executed by the girls and women in the family to commemorate the death of a family member, either for someone who had died recently or many years before, or in anticipation of some future contingency. Sometimes they were made for the artist herself or for a relative she had never known. Occasionally, schoolteachers like William Saville executed memorial pictures in watercolor on paper as an adjunct to their occupation.

Despite the subject, the mourning pictures are not depressing. They have bright blue skies, lively green landscapes, blue lakes and streams, white houses, angels, or doves. Death is represented with stock symbols which became conventionalized. Chief among these are the graceful weeping willow, the classical funeral urn with the epitaph below giving the name and age of the deceased, a tomb, a church or churchyard,

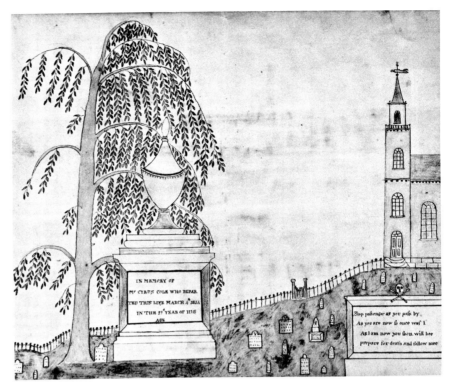

Cole Memorial. Memorial for Cyrus Cole, New England, ca. 1815. Ink and watercolor on handmade laid paper, 12½″ x 15″. (*Fruitlands Museums*)

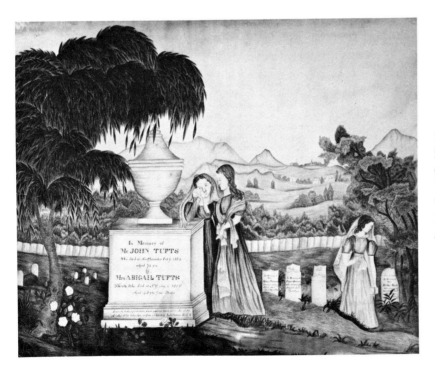

Tufts Memorial. Memorial for John and Abigail Tufts of New Gloucester, ca. 1825. Pencil, ink, and watercolor on paper, 13½″ x 17¼″. (*Fruitlands Museums*)

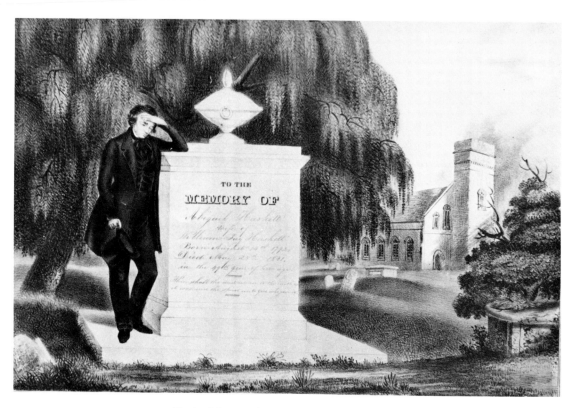

To the Memory of . . . Lithographed and hand-colored memorial by N. Currier, ca. 1845. $8\frac{3}{4}$″ x $12\frac{3}{4}$″.

and the figures of the bereaved. An amazing variety was achieved in the execution and addition of other elements such as villages, seascapes, boats, and animals. The lingering tradition of needlework was imitated by pinpricking the paper to give the texture of cloth and by using short-hatch brush strokes to imitate stitches.

The death of George Washington in 1799 inspired many memorials which included national emblems and a portrait of him. Many are so similar in design that they are presumed to have a common origin, either a print or the product of a female seminary. One favorite contains the portrait of George Washington on a funeral urn on a tomb which bears the epitaph "Sacred to the Memory of the Illustrious Washington." Also featured are the ubiquitous weeping willow, Columbia as a mourner with a liberty cap on a pole, a soldier turned away with his gun resting on the ground, and a symbol to represent the Society of the Cincinnati.

In the 1840s and 1850s the lithographic houses including N. Currier and the Kelloggs issued blank hand-colored prints to be filled in by the family. Few original pieces were made after the introduction of these twenty-five-cent prints.

In contrast to the memorials which were mostly executed by the females, family records or genealogies were made by both sexes in the family and sometimes by a professional outside the family. Most were drawn with pen and ink on paper with the addition of watercolor to the design. They list the births, marriages, and deaths of members of a family, usually starting with a mother and father and going through the statistics regarding their children. Notations often appear in different handwriting as changes took place over the years.

One of the standard patterns for such pieces was the family tree with children shown as fruits on the tree. The Gloucester, Massachusetts, schoolteacher William Saville (1770–1853) made these professionally at the end of the eighteenth and the beginning of the nineteenth century. Saville inscribed the parents' names in inverted hearts at the base of the tree, together with the date of their marriage. The children's names and birth dates are inscribed on the fruit of the tree. He frequently added a little house and some other decorative element at the foot of the tree.

Another standard design is a simple list of names with the dates of births, marriages, and deaths, the entire list framed by classical columns connected by an arch at the top. Variations have angels, garlands of flowers, weeping willows, or vignettes of houses as embellishments. In other cases strict geometric layouts and designs were used. As in the case of the memorials, such hand-drawn records were not commonly made after the popular lithographs became readily available. N. Currier and the later partnership of Currier and Ives issued at least fifteen different designs between 1845 and 1874, including one in German, one for blacks, and one with spaces reserved for parental photographs.

Shaker Art

It is an anomaly that the Shakers, a religious community of celibates who led a life of disciplined simplicity in austere surroundings devoid of ornamentation, should have developed a singular art form in their spirit drawings. Aside from utilitarian works such as maps and plans, the Shaker drawings were private, even secret, expressions of religious feeling. Since it was against the rules of the community to display such things, these works of art were hidden away.

The period of the spirit drawings began about 1842 and ended before the Civil War. In 1842 eighteen communities existed: New Lebanon, Watervliet, and Groveland in New York; Hancock, West Pittsfield, Tryingham, Harvard, and Shirley in Massachusetts; Enfield in Connecticut; Canterbury and Enfield, New Hampshire; Alfred and Sab-

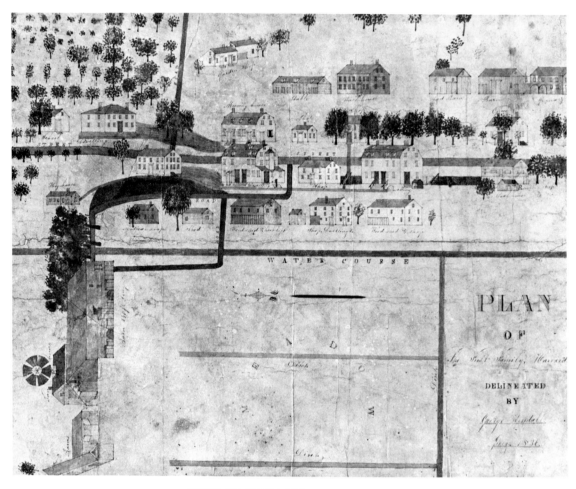

GEORGE KINDALL. *Plan of the First Family of Harvard.* Map of the
Shaker community at Harvard, Massachusetts, July 1836. Ink and
watercolor on paper, 12½″ x 16″. (*Fruitlands Museums*)

bathday Lake, Maine; Union Village, North Union, Whitewater, and
Watervliet in Ohio; and South Union and Pleasant Hill, Kentucky. The
early works were simple types. The sacred sheets of 1842–44 were pen-
and-ink drawings composed of little marks and cryptic symbols arranged
in geometrical plans. Sometimes messages were included in a neat,
simple script without flourishes. Following the sacred sheets were mes-
sages which were enclosed in a geometrical figure such as the outlines
of a triangle, square, circle, or heart. Small pictures sometimes illustrate
the text. Another phase was that of the leaf-and-heart rewards which
were presented by members of the sect to one another as tokens of esteem
and affection. The leaves and hearts, or other shapes like fans, were
drawn on rectangular paper or cut out and ornamented.

The sacred sheets and leaf-and-heart rewards were the prelude to the major inspirational drawings that began about 1845. One type was the tree-of-life painting and the associated floral and arboreal themes. The tree-of-life drawings which used variations of the tree as a religious and mystical symbol were frequently painted with watercolors and achieved a high degree of abstraction. They are some of the finest folk art designs extant.

The second major type consists of the distinctive, elaborate spirit drawings which are usually in pen and ink, sometimes colored. The drawing generally consists of a neatly written inspirational text which is associated with many pictorial symbols having religious and mystical significance such as angels, trumpets, doves, swords, crowns, and harps,

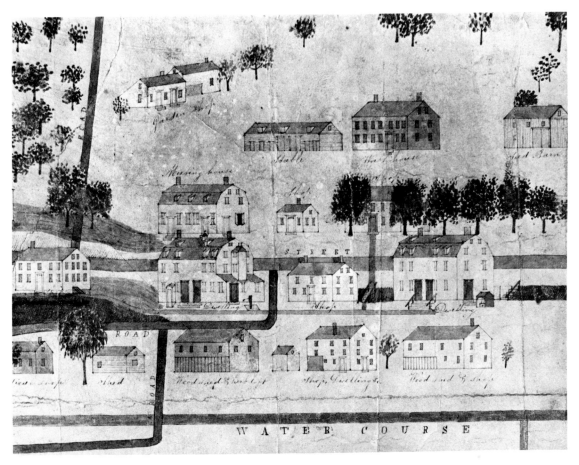

Detail of Shaker map, *Plan of the First Family of Harvard.*

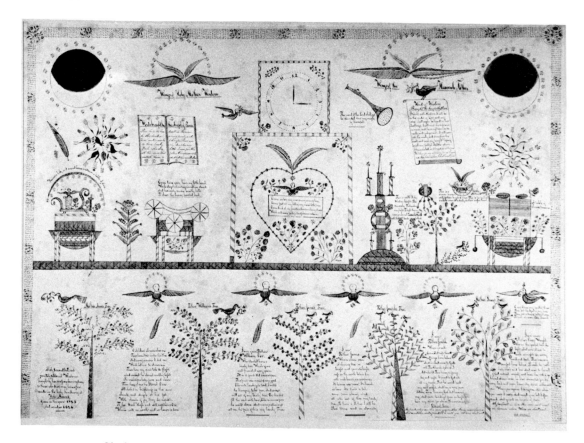

Shaker spirit drawing, *Wings of Holy Mother Wisdom. Wings of the Heavenly Father.* An elaborate drawing that includes messages in script and symbolic figures. The message was given in 1845 and copied in 1846. Place unknown. Blue ink on paper (with blue tint), 18⅝″ x 27¾″. *(Fruitlands Museums)*

all of which are part of a large detailed design. The patterns are more or less symmetrically balanced. The pictorial figures are usually simplifications of natural forms with little attempt at three-dimensional illusionism. The compass and straightedge were employed in the geometrical and orderly designs. Solidity was indicated by dividing an area into small triangles which were then filled in with fine parallel lines. This outburst of paintings and drawings coincided with a religious revival among the Shakers and subsided with it.

Other Paintings

The more ambitious amateurs tried to paint portraits of family members or their pets. Although most of these were not successful, in some cases a charming and well-executed example resulted. Some of the portraits of the pet cat, dog, or favorite horse project the strong bond between

the animal and the artist. Any painting that carries this message to the viewer today has at least one of the requirements of art, sometimes overriding the other shortcomings.

Maps of the world or of the United States, drawn in ink and colored with watercolor, are not infrequently found. Such items were probably done by schoolchildren as a teaching exercise. In the same vein, water-colors of national heroes such as George Washington or episodes of history were most likely the work of students. Battle scenes, in oil or watercolor, were probably executed by participants or someone with a special interest in the subject.

Allegorical and mythical subjects and melancholy romantic hero-ines such as Maria from Sterne's *Sentimental Journey* were especially popular with the schoolgirl. Venus and other Greek deities and heroes were often portrayed. The religious subjects were based on narratives from the Old Testament but a few stories from the New Testament, such as that of Christ and the woman of Samaria, also had appeal. Many of these were painted on velvet.

EDMUND J. BAKER. *Map of the United States, 1821.* Made by the artist, probably a student, in January 1821. Ink with outlines in watercolor on paper, 20″ x 24″.

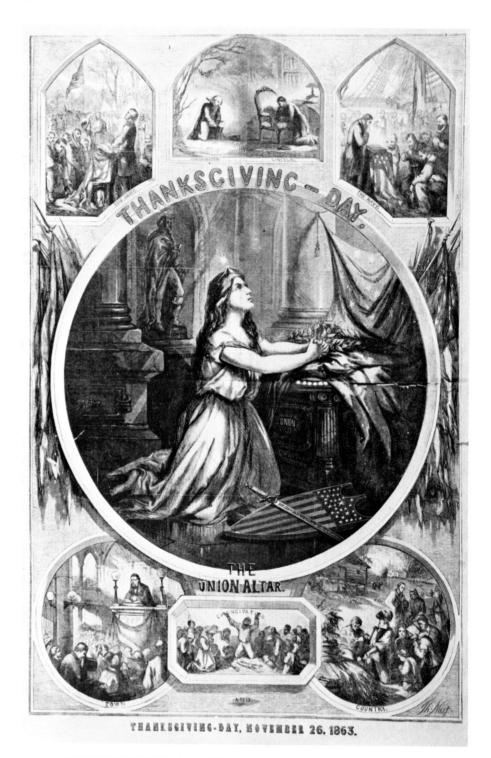

THOMAS NAST. A double-page spread, *Thanksgiving Day, November 26, 1863,* which appeared in *Harper's Weekly.*

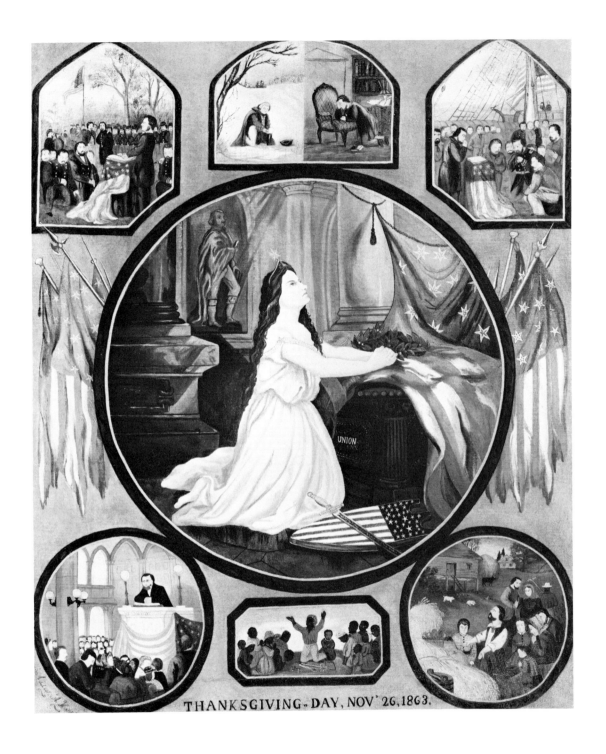

THANKSGIVING-DAY, NOV 26,1863.

ADDIE A. HARRINGTON. *Thanksgiving Day, 1863.* A Civil War
painting with a patriotic theme copied from *Harper's Weekly* (opposite).
Oil on canvas, 27½" x 22½". (*Hirschl and Adler Galleries, New York*)

STEPHEN B. GIFFORD. *Valentine.* Drawn in 1832. The artist was from Dartmouth, Massachusetts. Ink, gouache, and watercolor on paper, 12½″ x 12½″.

Valentines and greeting cards were also the objects of the folk artists' attention. Frequently these were embellished with intricate cut-out designs as well as colored drawings. Many other incidental pictures of various subjects were painted which defy classification.

Calligraphy

Calligraphic drawings and ornamental writing were by-products of the writing masters, writing schools, and the teaching of writing as a regular subject in the public schools, all of which proliferated in the nineteenth century. The eighteenth-century writing master was concerned with writing not only as a utilitarian skill but also as an art, a talent to be developed. Increasingly in the nineteenth century the needs of commerce required only a neat and legible script, but the enormous emphasis on the subject left room for a large amount of "flourishing."

Writing schools were established in the major cities with the most accomplished teachers settling in such important literary and cultural centers as Boston. Younger men not yet established, part-timers who supplemented their income with the teaching of writing, and second-stringers who lacked the skill of the city masters taught in the villages and hamlets and became itinerants. They came to a town and advertised for students in the local press or distributed broadsides. Exhibits were sometimes held of their own work or that of their students in rented quarters such as a room in the local hotel. Even those who were hired by established schools moved about as contracts were terminated or in search of a better position.

The advertisements of the writing schools in the press offered something for everyone: mercantile hand for business, ledger hand for bookkeeping, ornamental penmanship, running hand, and "elegant epistolary handwriting" for the ladies. The hours of the writing classes were arranged to accommodate everyone. Classes sometimes began at 5 A.M. and others ended at midnight. Courses were often scheduled from 5 A.M. to 7 A.M. with others in the late evening so as not to interfere with the working day. The courses varied in length and consisted of perhaps six, ten, twelve, or eighteen lessons. In Belfast, Maine, Freeman Page

Leaping Deer. Steel pen drawing on paper, 21⅞" x 29", executed ca. 1840. (*Abby Aldrich Rockefeller Folk Art Collection*)

rented the front room of Colonel Cunningham's Hotel where he offered twelve lessons for three dollars including stationery. Lessons began at 2 P.M. and a second class at 7. Mr. Page, in announcing his series in the *Hancock Gazette and Penobscot Patriot* in 1821, backed up his advertised claims by holding an exhibit of writing samples by persons from eight to forty years of age whose works were executed under his tutelage.

The demonstration pieces and proposal sheets were elaborately flourished by the instructors to be as impressive as possible. Such items as well as the pupils' best efforts may be included in the folk art category. It seems unlikely that for most pupils ten or twelve lessons in ornamental writing would result in the smooth, flowing intricacies of some of the accompanying illustrations. Elaborate pen drawings were also used by teachers at the entrance to their shops.

Writing masters often taught additional subjects such as bookkeeping, accounting, drawing, and painting and were to be found at a wide range of institutions from Foster's Commercial School in Boston to the Albany Female Academy. Accomplished penmen also wrote cards and invitations and engrossed documents. Penmanship exhibits and contests were held at fairs. The First Exhibition and Fair of the Massachusetts and Charitable Mechanic Association was held at Faneuil and Quincy halls, Boston, in 1837. Several pages of the ensuing report were devoted to judging penmanship. Large calligraphic drawings which have been found in their original frames were often entries in such contests. A kind of vogue existed for such work which was met by Currier and Ives, who issued lithographs with calligraphic embellishment, and by Endicott, who did a portrait of Jenny Lind in calligraphic drawing.

Perhaps the major source of inspiration for calligraphic works were the instruction books published during the nineteenth century. They were written by teachers, often self-styled professors, who used them as textbooks and to enhance their reputations, especially as the inventors of some new system of penmanship. Often, the newness of the system resided mainly in the title. Such books were used by an upwardly mobile population for self-instruction as well as for textbooks in schools. Thus, a young man on the frontier could teach himself to be a writing master without attending classes or serving as an apprentice. At first books were based upon earlier English models, later, upon earlier American ones. Ray Nash in his bibliography of American writing books lists about 375 published between 1800 and 1850.

The first American writing treatise was published by John Jenkins (ca. 1755–1822) at Boston in 1791. Jenkins was a district schoolmaster whose lack of skill in writing led him to analyze letters so as to reduce the alphabet to a composite of a half-dozen principal strokes that could be learned by mechanical drills copied from his copybook. Jenkins and

his "plain and easy" system were followed by others who promoted their own systems. The American spirit of "anyone can" was part of their success. According to the circumstances and time, these books were illustrated with copperplate or steel engravings, wood engravings, or lithographs. Often there was a title page ornately flourished with swans, eagles, birds of unrecognizable species, feathers or quills, cherubs' heads, and swirls and curlicues. *Shepherd's American Geographical Copies* which was engraved by Peter Maverick in 1801 has on its title page a large flourished bird holding a banderole in its beak placed above a feather made of loops. Rembrandt Peale entered the arena with his *Graphics, a Manual of Drawing and Writing for the Use of Schools and Families,* which was published in 1835. "Try" was the encouraging message under his name on the title page. These copybooks abounded with exercises with uplifting messages and warnings against evil thoughts and bad habits. In Pennsylvania a German and English copybook by C. F. Egelmann was published in 1829 and in two subsequent editions. Spanish writing books appeared in New York in 1838. There were books especially for ladies, children, or aspiring businessmen. Some of these books contained pen drawings which were copied. *Dean's Universal Penman,* published in New York in 1808, has illustrations of flourished birds, a fierce-looking fish, a knight on horseback piercing a dragon with his lance, an eagle sitting atop a globe, angels blowing horns, and a fanciful sea monster or dragon.

Goldsmith's Gems of Penmanship Containing Various Examples of the Calligraphic Art (1845), in addition to swans and borders, displays such gems as a fish executed "quickly with a metallic pen in 10 minutes,"

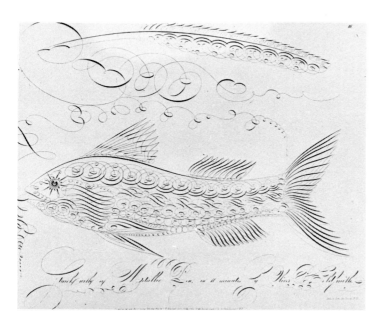

Fish. A lithographed plate from *Gems of Penmanship* by Oliver B. Goldsmith, 1845. This example was drawn by the author in ten minutes and was intended to be used as an example for the students to copy. Lithograph by Endicott on paper, 9½″ x 12″.

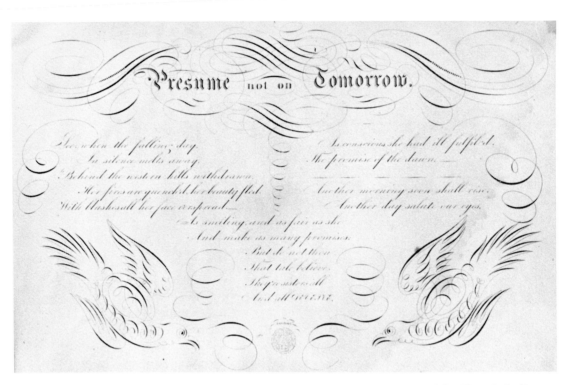

Presume Not on Tomorrow. A plate from *Beauties of Writing* published by French in Boston in 1843. This engraved plate on paper, 8¾″ x 10½″, was copied or borrowed from earlier writing books. (*Fruitlands Museums*)

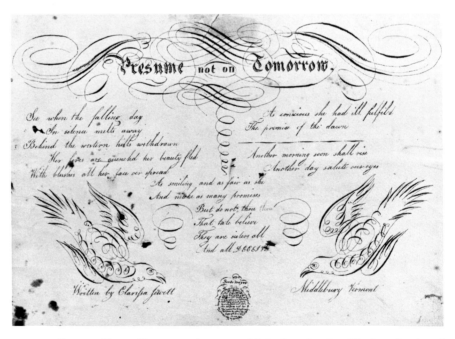

Presume Not on Tomorrow. A pen-and-ink drawing by Clarissa Jewitt of Middlebury, Vermont, included in a drawing book made by her in 1830. It is clearly a copy of the plate with the same title which appeared in *Beauties of Writing.* (*Shelburne Museum, John M. Miller, photographer*)

two birds with crests sitting on branches "after J. J. Audubon, Executed with Bagley's Gold Pen in 30 Minutes." A much later book is *Real Pen Work* published by Knowles and Maxim at one dollar per copy in 1881. Illustrated were a "real penwork" horse, lion, eagle, deer, and other subjects which could be copied using the "transfer process." A transfer of the design was made by tracing it on a thin sheet of translucent paper. The back of this paper was then blackened with a lead pencil to transform it into a version of today's carbon paper. The design was "transferred" by placing the blackened paper on a clean sheet of paper and then tracing over the design on the face with a pencil. The transferred image on the clean sheet was then finished, using a steel pen and ink to darken the lines.

Some families built chains of schools promoting their system. In the 1830s the Dolbeares in their New York and New Orleans writing academies trained teachers and agents for their "science of practical

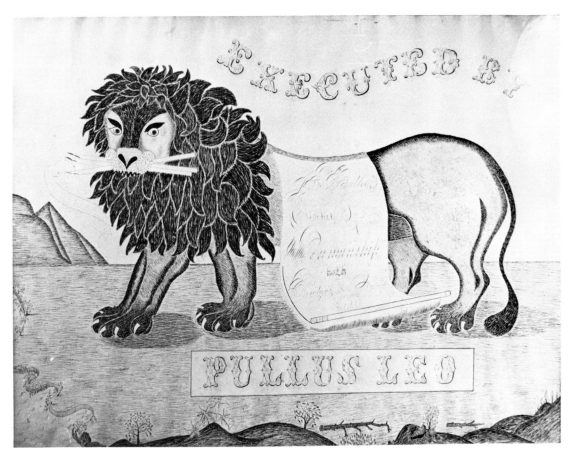

Pullus Leo. A pen-and-ink drawing by J. B. Butler, 1855. Brown ink on paper, 14″ x 19″. (*Lyman Allyn Museum*)

Lion and Chariot. A pen-and-ink drawing with watercolor accents. Drawn by C. W. Cummings on Whatman paper, 21½″ x 34½″.

penmanship." But the Spencers were the empire builders. Platt Rogers Spencer (1800–1864) was a publisher of copyslips in partnership with Victor Moreau Rice (1818–69) who organized business colleges and normal schools in New York State starting in 1848. A series of copybooks was turned out by Spencer during the 1850s. Numerous Spencer family members were teachers and agents. The business connection with Rice, Superintendent of Public Instruction of the State of New York, was probably the key element in their great success.

The invention of the steel pen aided the development of uniform and controllable systems of penmanship. An eighteenth-century master devoted considerable time to teaching the preparation of a proper quill, paring it down with a penknife so that it provided elasticity for writing and shading. It was difficult to make two quills so much alike that the difference in handwriting was unnoticeable. Although metallic pens had long been known, they were not highly regarded at first. Improved metallic pens were made by the Shakers in New Lebanon, New York, in 1819. While working as a jeweler in Baltimore, Peregrine Williamson

reportedly invented a steel pen with flexibility by cutting an extra slit on either side of the main one, which invention was then appropriated by the English. Another story is that the steel nib was invented by the Englishman James Perry in 1823. In any case, James Perry and John Mitchell were the first to mass-produce steel pens. They were imported from England, then later manufactured here, and they came into wide use. Most of the nineteenth-century calligraphic pictures were executed with these highly flexible, sharp-pointed steel pens.

Many of the calligraphic drawings are examples of flourishing produced by writing masters and are based upon images that became conventional for this type of work such as the leaping deer, fish, lion, riderless horse, birds, eagles, swans, and feathers. Sometimes these are

REAL PEN-WORK LION.
Full instructions for making this Lion given in the Transfer Process. Copyrighted 1882, by KNOWLES & MAXIM, Publishers, Pittsfield, Mass.

Plates from *Real Pen Work*, published by Knowles and Maxim, Pittsfield, Massachusetts, in 1881. Page size, 9″ x 11″. (See next page.)

embellished with red or colored inks and sometimes tinted with water-color paints. There are also some that are combinations of penmanship flourishing and pen-and-ink drawing. Sometimes flourishing is used only for a border. At the other end of the spectrum are ornamental writing pieces consisting of fancy penmanship or lettering with an ornamental border or title. These range from the professional products of an engrosser to the products of a proud schoolgirl.

REAL PEN-WORK HORSE.
Full instructions for making this Horse given in the Transfer Process. Copyrighted 1882, by KNOWLES & MAXIM, Publishers, Pittsfield, Mass.

Full instructions for making this Eagle and Snake given in the Transfer Process.

More plates from *Real Pen Work*.

REAL PEN-WORK DEER.

Full instructions for making this Deer given in the Transfer Process. Copyrighted 1882, by KNOWLES & MAXIM, Publishers, Pittsfield, Mass.

Beauties of the Mind. A penmanship display written by Suky Nixon of Framingham, Massachusetts, in 1816. Ink, with watercolor accents in the decoration, on paper, 11½″ x 7½″.

CHAPTER SEVEN Pennsylvania Frakturs

The cultural distaste of the Quakers and the plain Pennsylvania Germans for self-glorification kept them from participating in the portrait vogue that developed in New England early in the nineteenth century. The few portraits by Jacob Maentel and a handful of others represent the highlights of the genre there. However, the Pennsylvania Germans provided us with quantities of colorful art in their frakturs. The folk art of the Pennsylvania Germans is almost the only true folk art practiced in America as defined in the European sense, meaning a residual of some earlier art movement which has filtered into the provinces and which there becomes standardized so that it is essentially a decorative scheme. Their decorated documents, illuminated paper sheets called frakturs, were based on traditional forms and decorations native to the sections of Europe from which they came. As time passed, there was an infusion of American motifs and ideas.

Even today, some of the Pennsylvania Germans have a strong tendency to maintain their own culture, especially sects such as the Amish. Although they shared a tradition of plainness with the mostly English-speaking Quakers, the language barrier helped to maintain a

separateness in their own towns and sections of the country. Most of the Pennsylvania Germans spoke *Deutsch* ("German") and by corruption of this word became known as the Pennsylvania Dutch.

The vast majority of the European immigrants to this area were Protestant and deeply religious. Although much of their art has religious associations, the cross and other symbols dominant in Roman Catholicism are generally avoided. The first arrivals came late in the seventeenth century, mostly from the territories bordering the Rhine. Others came from Switzerland and the surrounding regions. A few were trained as teachers, scholars, or ministers but most were farmers. Most immigrants, regardless of where they landed, gravitated toward Pennsylvania where their first settlement was established in 1683—appropriately, at Germantown. William Penn extended the initial invitation, and later commercially aggressive English shipping agents operating on the Rhine and letters from earlier settlers praising the rich land encouraged more of these Germans to flock to Pennsylvania. But other sections of America also had settlements and by the middle of the eighteenth century, the Moravians, members of a sect centered in Bethlehem, Pennsylvania, had churches located in eight states: Maine, Connecticut, Rhode Island, New York, New Jersey, Pennsylvania, Maryland, and North Carolina.

German law required that the vital statistics of births, baptisms, and marriages be recorded on certificates which were often made by the minister. The style of the lettering on these certificates was called *Fraktur* in Germany and was similar to what was called Gothic in England. Its remote ancestor was a medieval style of manuscript lettering. A style of script writing called *Frakturschrift* was also used. At first, the decoration was only incidental to the document but eventually grew to overpower it. As in Europe, fraktur lettering was used only for important papers and usually those with religious connotations. Some of the sects had been denied the use of print in Europe so that hand-executed documents were the only means of making permanent records of vital statistics. Dr. Henry C. Mercer in a pioneering work in 1897 called the certificates of the Pennsylvania Germans "frakturs," and by extension the word now includes drawings using stylized decorative symbols even in the absence of writing. Some have even extended the definition of the word further to include illuminated documents that were occasionally made in other sections of the country even though they are written in English, use English-style lettering, and lack the traditional Pennsylvania German decorations. Frakturs were made from about 1750 until 1850, with a high point between 1800 and 1835 during which some of the finest pieces were produced. The Pennsylvania fraktur decorators developed a new and original style of beauty. Frakturs became so popular that by the mid-nineteenth century they were mass-produced.

Writing Sampler (Vorschrift). This fraktur includes two stanzas of an Amish hymn, the alphabet in lowercase, numerals, and the alphabet in capitals. Dated 1825 but not signed. Pen and black ink and watercolor on paper, 7⅝″ x 12⅞″. (*Museum of Fine Arts, Boston, M. and M. Karolik Collection*)

A wide range of illuminated certificates and related items were executed in Pennsylvania, among which are birth, baptismal, and wedding certificates, bookplates, bookmarks, house blessings, family registers, rewards of merit, specimens of handwriting, valentines, sheets of music, puzzles and mazes, and New Year's and baptismal wishes. It is helpful to know some of the German words used to describe these frakturs.

BELOHNUNG Reward of merit, usually executed by the teacher to be given to a student for good work.

BUCHERZEICHEN Bookplate, to be used in front of books such as the Bible, psalm books, hymnals, or school books. It usually includes the owner's name and some pious or practical comment.

DISTELFINK Goldfinch, a bird frequently used in designs. Also used to illustrate the letter *D* in school books.

FAMILIEN REGISTER Family register.

House Blessing (Haussegen). "People often build themselves houses and palaces." Pen and colored ink and watercolor on paper, 12⅛″ x 15⁵⁄₁₆″. (*Museum of Fine Arts, Boston, M. and M. Karolik Collection*)

GEBURTSSCHEIN Birth certificate, often combined with the baptismal certificate, *Taufschein.* The combination is the most common type of fraktur. It includes vital statistics of the child and his family with names, dates, and often township and county, which is important genealogical information.

GULDENE ABC Primer.

HAUSSEGEN House blessing. Includes pious sayings or mottoes. Intended to be hung on the wall.

IRRGARTEN Mystical maze of passages from the Bible.

LESEZEICHEN Bookmark.

TAUFSCHEIN Baptismal certificate. See *Geburtsschein.*

TRAUSCHEIN Wedding certificate, a rare form. Some say they were buried with the wife. Sometimes later notations about marriage or death were written on the reverse or at the bottom of birth and baptismal certificates.

VORSCHRIFT Specimen of penmanship and calligraphy often prepared by the teacher and copied by the pupil in order to learn to write. Commonly includes alphabets, numerals, and usually a sentence or two.

The certificates of birth and baptism were the most widely produced of the illuminated documents, although not all of the certificates were so embellished. The baptismal certificates invariably include birth data and were used only by those groups which practiced infant baptism. A typical birth and baptismal certificate includes a section such as the following (translated):

To both husband and wife, namely _____ and his legal wife _____ who was born _____ was born a son (daughter) named _____. He (she) was born in the year of our Lord _____, the _____ day of _____ at _____ o'clock of that day, under the sign of _____ and since has joined the state of grace through baptism by Pastor _____, preacher and servant of the word of God on the _____ day of _____. The son (daughter) was born in America, in the province of Pennsylvania, in _____ County, _____ Township. The godparents are _____ and _____.

Each pastor used his own wording, but the contents are similar. In fact, it was easy to standardize the format sufficiently to produce preprinted certificates. (Johann) Henrich Otto printed these as well as other types of frakturs in the 1780s using the press at Ephrata, and he sometimes then used wood blocks to print the decoration. The forms were later filled in and in many cases decorated further by hand. About 1789 a new variant appeared when the text was printed within a heart-shaped border instead of the usual rectangle; this went on to become the most popular printed type. Thus, the birth and baptismal certificates which were first lettered and decorated by hand were replaced gradually by those with a combination of printed text and hand decoration and, finally, with entirely printed ones. The dates of birth and baptism are not reliable indicators of the time when the fraktur was made since they were frequently executed months, or even years, after the event.

Those sects which practiced adult baptism recorded only the birth of the child so that the certificate supplied only that information. The verse from a hymn or psalm usually present in the combination birth and baptismal certificate was omitted.

The early Pennsylvania schoolmaster lacking printed textbooks or primers for the teaching of writing made his own patterns or *Vorschriften.* Preachers soon used them as vehicles to spread their spiritual messages. From these teaching services, the *Vorschrift* was extended to secular

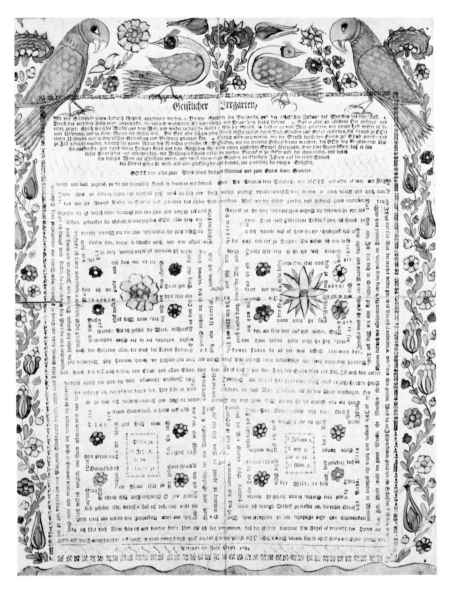

Spiritual Garden-Maze (*Geistlicher Irrgarten*). The printed message deals with the weakness of man and his final redemption through faith. Attributed to (Johann) Henrich Otto, dated 1784. Pen and ink and watercolor on paper, 20⅞" x 16½". (*Henry Francis du Pont Winterthur Museum*)

employment as a sort of writing sampler to show proficiency and to preserve poetry and other comments, usually moral and uplifting ones. *Vorschriften* were made from about 1765 to 1830. *The Golden ABC for Everyone* was the Pennsylvania German version of the New England primer which as a printed text and in illuminated versions served as a source for much fraktur writing.

The house blessing was a version of a "God Bless Our Home" picture intended to be hung on the wall. Its central theme is a prayer for the protection of the home and family. Associated with it are usually meditations for the twelve hours of the day and a heart clock. This popular form was also made with decoration and text completely printed in the nineteenth century.

Among the uncommon kinds of frakturs is the spiritual garden maze, *Geistlicher Irrgarten.* This was an eighteenth-century form in which a religious verse, such as the story of the Fall of man, is written in a labyrinth so that the paper must be turned as it is read. In the nineteenth century the labyrinth developed into the true lover's knot, a form of valentine. Similar to the valentines were the love letters (*Liebesbriefe*)

Birth and Baptismal Certificate (Taufschein). A hand-lettered, hand-drawn, and hand-painted fraktur signed boldly at the bottom: "H. Seiler." ca 1795–1815. Pen and ink and watercolor on paper, 13" x 15¾". (*Henry Francis du Pont Winterthur Museum*)

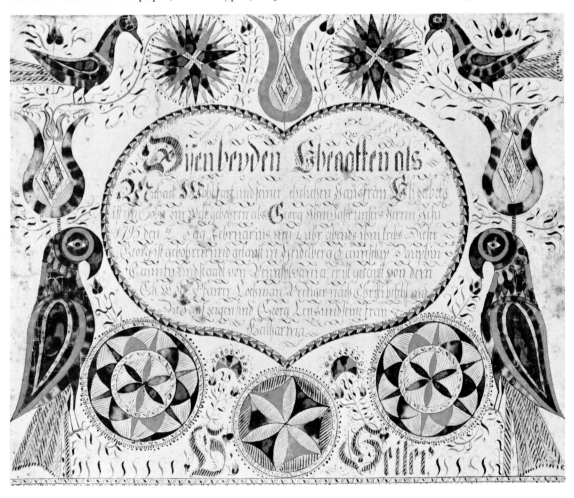

which were folded and cut and then decorated. The generally circular form contained eight or sixteen hearts around a central motif and was often mounted on a colored background to highlight the cutouts. Fold-up valentines were also made. Other forms of greetings such as New Year's wishes and baptismal wishes are quite rare.

Paintings using fraktur motifs were in some cases made without the accompanying text, sometimes as an all-over abstract design, sometimes as portrayals of religious, folkloric, historical, architectural, still-life, portrait, or genre subjects.

The Artists

Early fraktur as a stylized art form was a transplant from Europe, and some of the artists may actually have brought certificates with them ready to fill out with names and dates. In any case the artist continued to use the same style of decoration he had used in Europe. An original and personal style was cherished and respected, and copying the work of another was frowned upon. However, having established a style and forms of decoration, there was a strong tendency for the artist to cling to it. The certificates were prized by the Pennsylvania Germans, who either framed and hung them as colorful accessories or carefully stored them between the pages of their Bibles.

The earliest American fraktur manuscripts were produced in the Ephrata Cloister around 1745. During the next one hundred years, until about 1850, large numbers were made by various sects and then later by commercial printing houses, both kinds coexisting for several decades. The designs produced by the Mennonites, Amish, Lutherans, Dunkers, Moravians, Schenkfeldians, and other sects often display characteristic motifs reflecting the origins and religious beliefs of the group. Conrad Beissel left the Dunkers and founded the Ephrata Cloisters in Lancaster County in about 1730. This self-sustaining community of men and women stressed hard work, religion, and celibacy; all wore hooded white robes and wooden sandals. At one time this monastic community had about three hundred members, some of whom prepared illuminated songbooks, operated a writing school, copied books by hand, and executed large numbers of frakturs carrying biblical texts which they hung on the walls. Their decoration developed into a delicate style using soft colors.

The designs and letters of the early frakturs were outlined in ink and then brightly colored with watercolor or gouache washes. In most

communities the artist was the local minister or schoolteacher. Frakturs such as *Vorschriften* were occasionally copied by children as a learning exercise or a display of accomplishment in writing skills, and some other types were done by family members or other amateurs. But for the most part frakturs were made by professionals, either as a primary or an auxiliary occupation. Later in the eighteenth century, itinerant artists became the major producers, particularly of birth and baptismal records. Traveling from community to community seeking commissions, an inquiry of the local minister could quickly pinpoint the recent births and baptisms. Acting on this information, the artist called at the homes of those likely to find his services useful.

In the 1780s, in order to save time, itinerant artist (Johann) Henrich Otto began using carved wood blocks to stamp some of the standard decorative motifs. Another economy of the itinerant was the use of preprinted blank certificates with uncolored printed decoration which he colored and filled in with the appropriate facts. The fraktur artist Friedrich Krebs bought thousands of printed birth and baptismal forms of various styles. Later printing houses went even further by issuing already-colored printed certificates which could be filled in by a member of the family. Probably the last blow to individuality came when Currier and Ives published a *Geburts und Taufschein*, number 2227 in Frederick A. Conningham's checklist of Currier and Ives prints. Two *Familien Register* prints, number 1833 and number 1834, were published in 1846 and 1869.

The prime period of fraktur production falls between 1780 and 1850 with the high point between 1800 and 1835. Only small numbers were produced before the Revolution and mostly printed ones were used after about 1850. Throughout the entire period of handmade frakturs, only a very small percentage were signed by the artist in some way on the composition. An exception is the Evangelical Lutheran pastor Daniel Schumacher, who usually signed his birth and baptismal certificates. Moreover, his dates of baptism, unlike those of the itinerants, indicate when the fraktur was made since he executed the document at the time of the baptism. Schumacher was active in Berks, Lehigh, Northampton, and Schuylkill counties from about 1754 until his death in 1787. His balanced compositions are colored in pastel shades to which his fine penwork adds a look of delicacy.

Johann Henrich Otto's colorful and highly decorative frakturs inspired numerous followers who imitated his techniques and copied his motifs, especially his parrot. Other birds and flowers connected by meandering vines were designs he employed frequently, but his vocabulary included, in addition, exotica such as unicorns, lions, pelicans, mermaids, and sea horses. A feature that often appears is a wavy line

at the bottom of the fraktur. His hallmark, not characteristic of his followers, is his remarkably fine lettering. He worked from about 1772 to 1788.

Friederich Krebs (active 1780s–1815) and (Georg) Friederich Speyer (active 1785–1800) imitated many of Otto's designs but added motifs and touches of their own. Speyer's lettering was not comparable to Otto's, nor were his works so brightly colored. The heaviness of his vines distinguish them from Otto's more delicate ones. Original with him are pairs of women wearing bonnets and pairs of angels bearing flowers in one hand and palms in the other. He decorated many printed forms as well as hand-drawn frakturs. Krebs was the most prolific of the fraktur decorators and his early work was mostly in decorating printed forms. A feature of his hand-drawn frakturs is a heart with a scalloped border. Besides certificate illuminating, Krebs drew versions of scenes from folk tales and the Bible, such as the story of the Prodigal Son.

When not signed, the work of an artist may be identified by his style of decoration, the motifs used, the style and execution of the

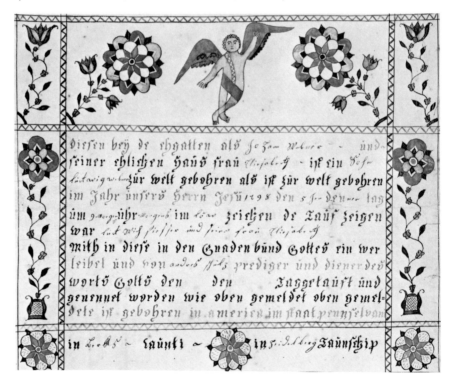

Birth and Baptismal Certificate (Taufschein). A certificate attributed to the Cross-Legged Angel artist showing the debonair character at the top of the sheet. Dated 1798. Pen and ink and watercolor on paper, 12½″ x 15¼″. (*Henry Francis du Pont Winterthur Museum*)

lettering, and the coloring, among other characteristics. Sometimes, the identity of the artist remains elusive although a solid body of work testifies to his having existed. One such is the Cross-legged Angel artist named for his use of a characteristic debonair angel with crossed legs and ribbon drape which appears in the center of the top border. The design is neat and orderly and includes floral motifs which give the effect of having been drawn with a compass and straightedge. A similar angel was used by Friederich Speyer in some of his frakturs. The Sussel-Washington artist is noted for his individualistic style and the use of human figures in highly patterned dress. A drawing of a man and woman, "exselenc georg general Washington" and "Ledy Washington," which belonged to the late collector Arthur J. Sussel, was the picture which drew attention to the artist and inspired his appellation. This picture is now in the Abby Aldrich Rockefeller Folk Art Collection.

Following is a list of fraktur illuminators who have been identified by name, mostly from signed pieces. The dates are working dates unless otherwise indicated. When only one date is given, it is usually the date of the only work or works known to have been executed by that artist.

Ache, H. M.
Anders, Abraham (1805)
Anders, Andrew (1787)
Anders, Judith (1807)
Andreas, Jacob
Anson, James (1804–9, New Jersey)

Bachman, Christian (1798)
Bandel, Frederick (1809–18, Ohio)
Bard, Johannes (1824–32)
Bart, Daniel (1797)
Bart, Susanna (1793)
Bauer, Andeas B. (1832)
Bauman, August (ca. 1900)
Becker, J. M. (1829)
Beidler, C. Y. (1847)
Bergey, Joseph K. (1803)
Bernhardt, Peter (1814, Virginia)
Bicksler, Jacob S. (1829)
Bixler, David (1828–48, 1862)
Brechall, Martin (1783–1823)

Brubacher, Abraham (1795–1806)
Brubacher, Hans Jacob (HIBB) (1789–1801)
Brubacher, Johannes (1795)
Busgaeger, J. George (1815–26)

Cassell, Christian (1771–72)
Cassell, Huppert (1763–73)
Cassell, Joel D. (1841–46)
Clemens, Johannes (1816)
Cordier, David (1815)
Crecelius, Ludwig (1830)

Denlinger, David (1830)
Detweiler, John H.
Detweiler, Martin M. (1765)
Dirdorff, Abraham (1780–81)
Ditmars, Peter (1838)
Dock, Christopher (d. 1771)
Dressler, S. O. (1852)
Dulheuer, Henrich (1773–86)
Dutye, Henre (1784)

Egelmann, Carl Friederich
 (1821–31)
Eisenhauer, Jacob

Faber, Wilhelmus Antonius
 (1811–18)
Fieter, Michael (1760)
Forrer, Johann
Fries, Isaac (1825)
Fromfield, William (1821)

Gahman, John (1806)
Geistweite, Rev. George (1801)
Gerhardt, George (1818)
Gise, Henry (1846)
Godshalk, Enos (1820)
Godshall, M. (1835)
Grimes, William
Gross, Isaac (1830)
Gross, Jacob

Hammen, Elias (1806, Virginia)
Hartman, Christian B. (1846)
Hartzel, John, Jr. (1815)
Heebner, David (1817–18)
Heebner, John (1831)
Heebner, Maria (1842–43)
Herr, Anna (1828)
Herr, David
Heydrich, Balzer (b. ca. 1762,
 active 1784, 1845)
Hill, Henry
Hillegas, Jacob (1811)
Hoffman, Johannes (1811)
Horn, Daniel Stephen (1839)
Huebner, Abraham (1772–1818)
Huebner, Henrich (1843)
Huebner, Susanna (1806–10,
 1828)
Huth, Abraham (1829–40)

Jaeckel, Christoph (1772)
Jamison, J. S. (1843)

Kassel, Georg (1800)
Kauffman, Daniel (1825)
Kauffman, Samuel (1825)
Keeper, Heinrich
Kehm, Anthony (1824)
Kiehn, David (1847)
Kinsey, Abraham K. (1864)
Klenk, Ferdinand (1875)
Krauss, Johannes (b. 1770,
 active 1786)
Krauss, Regina (1815)
Krebs, Friedrich (1780s–d. 1815)
Kriebel, David (1803–5)
Kriebel, Hanna
Kriebel, Job (1825)
Kriebel, Maria (1843)
Kriebel, Sara (1842–45)
Krieble, Abraham (1782)

Landes, Rudolph (1814–16)
Landis, Catherine L. (1846–50)
Landis, John (1826–29)
Landis, John A. (1852)
Lapp, Christian (1819)
Lapp, Henry (1822–1913)
Lehn, Henry (1843)
Levan, Francis D. (1820–50)
Limbach, Christian (1795)
Lueckin, C. (1772)

Maentel, Jacob (b. 1763, d.
 1863)
Magdelena (1815–25)
Margaretha (late eighteenth
 century)
Meyer, Elizabeth (1818)
Meyer, Martin J. (1835)
Miesse, Gabriel (1807–86)
Miller, Jacob (1821)
Miller, John G. (1831)
Moffly, Samuel (1805)
Mosteller, Johannes (1820)
Moyer, Martin (1835)

Muench, Karl C. (1795–1825)
Murray, William (1806–19,
 New York)

Neff, Elizabeth (1801)

Oberholzer, Jacob (1773–1810)
Otto, (Johann) Henrich
 (1772–88)
Otto, Wilhelm (1834)

Peterman, Daniel (1809–57)
Peters, Christian (1777)
Pile, John (1853)
Plank, J. L. (1883)
Portzline, Elizabeth (1834)
Portzline, Francis (b. 1771,
 active 1801–55)
Puwelle, Arnold

Reich, Elizabeth (1821)
Reinwald, Sarah (1787)
Renninger, Johannes (1841–47)
Rigel, Maria Magdalena (1838)
Romer (1831)
Rudy, Durs (1804–42)

Schantz, Rev. Joseph
Schenef, Friederich (1783)
Scherg, Jacob (1811)
Scherich, C. (1851)
Schneider, Christian (1784)
Schuller, Johann Valentin, Sr.
 or Jr. (1795–1815) (Johann,
 Sr., d. 1812)
Schultz, Barbara (1806)
Schultz, Lidia (1826)
Schultz, Regina (1806, 1848)
Schultz, Salamon (1836)
Schultz, Sara (1827)
Schultze, C. (nineteenth
 century)
Schumacher, Rev. Daniel
 (1754–d. 1787)

Seibert, Henry (1813)
Seiler, H. (1794–1815)
Seuter, John
Seybert, Abraham (1812)
Seybold, Carl F. (1843)
Shindel, J. P. (1855)
Siegfried, Samuel (1810)
Spangenberger, Johannes Ernst
 (Easton Bible artist)
 (1789–d. 1814)
Spangler, Samuel (1828–31)
Speyer, (Georg) Friederich
 (1785–1800)
Spiller, Johan Valentin (1809)
Stahr, John F. W. (1835)
Stober, John (1852)
Strenge, Christian (1794–1814)
Strickler, Jacob (b. 1770–94,
 Virginia)

Taylor, Alexander (1829, Ohio)
Teibel, (Johann) Georg
 (Weak artist) (1763–79)
Thompson, M. (nineteenth
 century)
Trevits, Johann Conrad
 (1790–1820)

Van Minian, John (1823–42)

Weaver, Carolina (nineteenth
 century)
Weber, Isaac (1822)
Weidner, Heinrich (1832)
Weiss, Anna (1793)
Weiss, Henrich (1791–96)
Weyzundt (nineteenth century)

Young, H. (1820–38)
Young, Rev. (1845–50)

Zinck, John (1834)
Zornfall, Martin (1812)
Zug, Johan (1788)

In addition, there are artists known only by their initials: J. B., C. F., A. K., B. H. I., E. M. M., J. S., L. T., A. W., and I. T. W. Other artists whose names are still unknown have various works grouped together as the work of one person and designated by some descriptive feature such as the Flying Angel artist or the Ehre Vater artist.

Design Motifs

A large number of design motifs were used by the Pennsylvania Germans and the sprinkling of others of their background in New York, Ohio, Virginia, and other sections of the United States. Although a few of the designs may have iconographic meanings from the Old World, their extent and interpretation is highly questionable. Some of the later frakturs include new elements such as the American eagle which is clearly not a carry-over from European culture. The motifs are a mixture of religious, secular, medieval, and heraldic elements which most likely were part of the vocabulary of the folk artist and were used over and over without much attention to their significance. Often, the design is schematic rather than an attempt to represent a realistic form. Hearts, tulips, birds, flowers, and geometric designs are those most frequently drawn from the design pool and are the ones that give frakturs a distinctive and recognizable character.

The heart, symbol of love and affection, shares honors with the tulip as the most widely used of motifs. More often its meaning is directed along religious rather than domestic lines. The distinctive Pennsylvania heart is constructed of two intersecting circles which are tied together at the bottom by lines forming a concave point, resulting in a heart with a roundish character. Inner construction lines are seldom shown. This form of heart was not universally used, but it is the one most characteristic of the Pennsylvania German folk artist. Hearts are most frequently used as frames for spiritual or other text, but occasionally they are used as pure ornament.

After tulips were introduced from Asia Minor about the middle of the sixteenth century, Germany shared in the tulip mania with most of Europe. Special colors and forms were sought and there was a wild surge of speculation in bulbs with prices reaching extravagant levels. This undoubtedly left its mark on the peasants who incorporated a stylized tulip into their folk designs. Curiously, it never attained in Germany the great popularity as a design motif which it achieved in Pennsylvania. Some scholars feel that the tulip symbolizes life, love, and immortality; others, the holy lily. When drawn in a form in which the

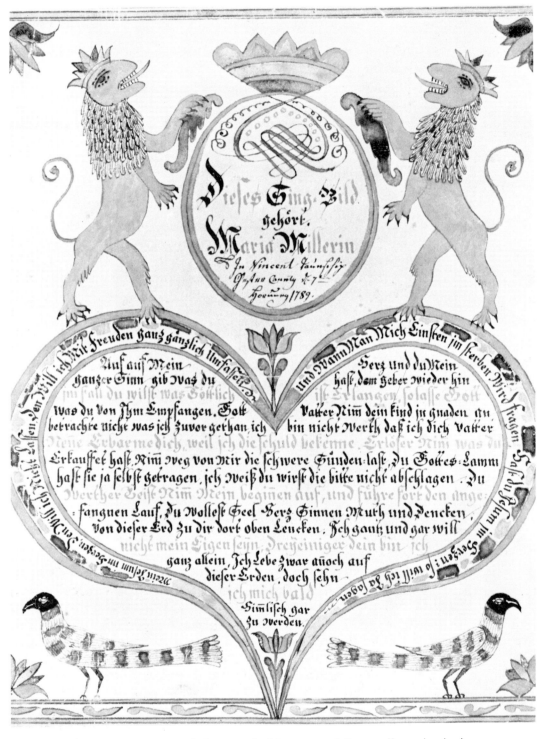

Singing Picture (*Singbild*). A rare fraktur, probably a reward for excellence in singing.
The heraldic lions are European in source. Attributed to Jacob Oberholtzer and dated
1789. Pen and ink and watercolor on paper, 7⅞″ x 6½″. (*Henry Francis du Pont Winterthur Museum*)

petals make three points, it is suggested that it represents the Trinity. No doubt the easily recognizable shape of the tulip and its bright colors were in a large measure responsible for its popularity, regardless of its meaning.

Fruits and other flowers were frequently used in addition to the tulip such as the forget-me-not, violet, rose, fuchsia, lily, grape, and pomegranate among others. In Germany, the fuchsia was regarded as a sacred plant since it was one of the first signs of life in the spring. Lilies have many Christian associations and were a favorite motif in the cloister at Ephrata. Many of the flower designs are conventions and sometimes do not even portray a specific kind of flower. The flowers may be strung together on vines, on upright stalks, or have the head only used as a design element.

Closely rivaling flowers as a motif are birds, among which are the *Distelfink* (goldfinch), parrot, peacock, pelican, eagle, dove, scarlet tanager, and rooster. The *Distelfink* was often used to illustrate the letter *D* in the elementary ABC school books so that its use on frakturs is not unexpected. But the widespread use of the parrot after its introduction as a fraktur design by Henrich Otto is somewhat surprising. At one time the Carolina parrot (paroquet), presumably the inspiration for this colorful image, was abundant in Pennsylvania, but as J. J. Audubon said, "an unwelcome visitor to the planter, the farmer, or the gardener." In 1839 Audubon remarked that their numbers were diminishing, but he could not foresee that they would soon be extinct. In September 1914, the last surviving Carolina paroquet died in the Cincinnati Zoological Gardens. The enthusiasm with which the parrot was adopted as a design motif in frakturs would indicate that its main appeal was decorative since it was generally regarded as a pest by farmers.

More significance can be read into some of the other bird designs such as the peacock, which by tradition symbolizes immortality since according to folklore its flesh does not decay. Pelicans in old German manuscripts represent maternal devotion. Single-headed eagles drawn in the American spirit are the birds of freedom whereas double-headed ones come from the old Hapsburg emblem. In any case, the artist took designs which appealed to him and incorporated them into a form of decoration that became a unique Pennsylvania idiom.

Animals of various types, domestic, foreign, and mythological, were also incorporated into the fraktur designs. Deer, horses, dogs, and occasionally snakes were used. The snake, of course, has his role in the Garden of Eden to recommend him. The unicorn, guardian of medieval maidenhood, symbol of the Virgin Mary, is used in some frakturs with striking effect. The unicorn is also paired with the lion, a combination inspired by the Great Seal of England.

Geometric figures of all types were great favorites. Neat, well-drawn motifs were easily made with a compass and straightedge. In addition to the principal design elements, there were frequently sawtooth and checkered borders made of geometrical elements. Similar abstract circular geometric designs were used to decorate the barns of the Pennsylvania Germans. In contrast with the strict orderliness of geometric figures, the human figure was used in various ways. Nonearthly forms such as angels, sometimes looking like plump German housewives, fly about or pose serenely in the composition. Mermaids also appear now and then. The most interesting are the humans who appear in contemporary dress, and particularly so when a house or contemporary setting is also pictured, as occasionally happens.

The folk artist included narrative pictures in his output, the subjects mostly from folktales or the Bible, but they were sometimes historical. His main occupation was making the required documents in the prevailing cultural context. The art and decoration was actually peripheral to the purpose but the colorful and richly ornamented frakturs must have struck a responsive note for the rural residents of Pennsylvania as they do for us today. The lavish use of hot colors like yellow and red, the fanciful designs, and the wedding of words and images are quite unlike most other folk art produced in this country.

Baptismal Wish (Taufwunsch). An unusual fraktur showing the human figure in contemporary costume. Attributed to the Sussel-Washington artist and dated 1771. Pen and ink and watercolor on paper, 7⅜″ x 9½″. (*Henry Francis du Pont Winterthur Museum*)

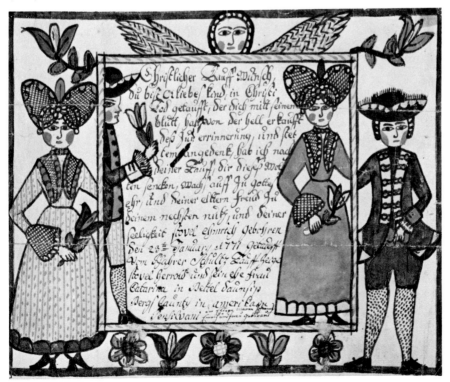

CHAPTER EIGHT Conservation,
Restoration,
and Care

Most of the American folk paintings discussed in this book
are from one to two hundred years old. Understandably, after that length
of time even the most carefully executed and well-cared-for academic
painting requires cleaning and other attention. But the materials, paints,
and techniques used by most folk artists often fell far short of the best
available. When combined with general neglect and abandonment
during the late nineteenth and early twentieth centuries, many of these
paintings were and still are found in deplorable condition. Until the
merits of these folk paintings were appreciated anew, they were consid-
ered simply not worth the cost of conservation and restoration, and in
the case of works of slight value, that is still true.

There is considerable difference of opinion among collectors, re-
storers, and dealers as to the desirability of extensive restoration. When-
ever additions have been made to a painting, some of the originality
of the work of art is obscured. Future scholars or art historians may have
difficulty making attributions to a particular artist or may be led astray
by repainted brush strokes or details. It is good practice to photograph

the back and front of a painting in its as-found state before any restoration is begun. By comparison with this photograph, later study will be aided by showing which areas were missing and repainted. Any writing on the back of the canvas will be recorded as well as the type of stretcher.

Although opinions vary about restoring a painting to nearly new condition or keeping as much of the patina (or ravages, depending upon your point of view) of age, there is a consensus that there is a need for measures to prevent the further deterioration of a painting from which paint is chipping or peeling, whose canvas is rotting, or whose paper is mildewed. Steps must be taken to conserve that which still exists from crumbling altogether. The services of an expert restorer who will render an opinion on the condition and possible remedies are often required.

Occasionally oil paintings were done on wood panels, but those most frequently encountered were done on canvas or other heavy cloth. The life of the picture on the support is limited by, among other things, exposure to temperature and humidity changes. The concomitant expansion and contraction of the fabric eventually causes flaking of the paint surface. When the fabric is in weakened condition, there is little option but to have it backed or lined with a new canvas, an aluminum panel, a sheet of fiber glass, Masonite, or similar material. This may be done more than once in the life of a painting so that paintings are lined and relined. In general usage, all linings, even the first, are called "relinings." Relining is an important procedure to extend the life of a painting and should be relegated to the professional restorer who has the equipment and skill. Basically, what he will do is to fasten the back of the weak canvas to a new support which is selected for its dimensional stability and other suitable properties. An important consideration is that materials used for the backing and adhesive be chemically inert. Equally important is that the process be reversible at some future time so that the painting can be removed and remounted if better materials are developed or a need arises to remove the old backing. It is good restoration and conservation practice to do only those things that can be undone. Most conservators use a thermoplastic adhesive such as a wax and resin mixture. This mixture is formulated to have good adhesive properties as well as a melting point low enough so that the painting is not damaged by the heat necessary to fix it to its new support, yet high enough so that it will not come off in a warm room. Some restorers have hot vacuum tables which apply equal pressure over the whole

Oil Paintings on Canvas

surface of a picture to cause it to lie flat on its new backing. Others are skilled in the use of a warm clothes iron. If this process is properly done, the relined painting has a new lease on life; the flaking paint surface is secured and protected from injury due to tears and other defects of the canvas.

With time the vibrant colors and subtle shadings of a painting become obscured by layers of dust and grime and by the discoloration of the varnish coat. Although some prefer the mellow look of an un-cleaned painting, for many others cleaning is a revelation of the artist's true intent. Cleaning has earned a bad reputation since much damage has been caused by inept workers who "skin" or overclean, thereby removing part of the surface of the painting. Often a superficial cleaning suffices, but sometimes the varnish coating has darkened so with age that its removal and a revarnishing are necessary to brighten the picture. The response of various types of varnishes to solvents varies widely, so the method of removal should be left to the specialist. The varnish coat serves as a protection for the surface of the painting. Many itinerants, in their haste to move on, neglected this application; as a result, dust and dirt have become embedded directly in the painted surface, posing special problems in conservation. However, a drab, chalky painting can be improved dramatically in competent hands.

One of the procedures followed by the conscientious restorer is the removal of old overpainting. Inpainting is the retouching of areas where the paint is missing, and overpainting is going beyond this to cover sound areas of the painting as well. Overpainting avoids the great difficulty of matching the retouch with the old painted area by blending it in generously with its surroundings. On occasion, overpainting has been carried out to make a picture more pleasing to a previous owner. Re-moval of the old overpainting may reveal a rather different version of an ancestor whose gray hair was later darkened or a dour expression transformed into a more cheerful one. The degree to which inpainting should be used depends upon various opinions.

Purists feel that any addition to a painting is a violation of the artist's intent and spoils the integrity of the picture. They feel that viewers should recognize that a picture is old and that age cracks and missing paint are to be expected. A middle group accepts painting in cracks and missing areas if this cosmetic treatment is not hidden from those who look closely. They feel that a missing area detracts from the artist's intent and distracts the viewer so that he does not see the painting as a whole. The third group believes that filling cracks and voids flush with the original paint surface and then recoloring the missing areas

to be as inconspicuous as possible are procedures that bring the painting as close to the artist's original work as possible.

Undertaking the restoration of a painting involves a discussion of the desired results. The point of view of the restorer must be compatible with that of the owner of the painting, or disappointment may be the result. The attitude toward conservation and restoration of works of art has undergone radical changes over the years.

The value of an oil painting is greatly reduced if there has been major restoration to the painted surface or if there have been modern additions made to improve the appeal of the picture. Major restoration is the repainting of a substantial or important area of the picture. Cleaning and touching-in cracks and small areas of missing paint are considered minor restorations and are admissible. But obviously, if modern re-touching alters the intent of the artist, the picture can no longer be considered a completely original creation by that artist.

Detection of Major Restoration and Alterations

Unfortunately, alterations to oil paintings are difficult to detect. A skilled artist can add a background scene to a simple portrait or change the color of the sitter's dress and most viewers would not suspect that anything had been changed. The same artist can also paint in half of the sitter's face if the original paint has flaked off.

Technicians in museum laboratories can examine the surface of a painting with a binocular microscope, make microspectrographic analyses of the paint, take infrared photographs, X rays, and ultraviolet photographs as part of their battery of sophisticated techniques for gaining information about a painting. Such resources are rarely available to the collector who must rely upon examination under differing light sources including ultraviolet light. Inspecting the surface at an angle almost parallel to the surface or with a raking source of light will often help locate changes in paint thickness or changes in the pattern of the brush marks. This is a good first step and any irregularities in the surface detected by this examination should be further scrutinized. It is of fundamental importance in any worthwhile examination that the observer be as critical and alert as possible so as not to dismiss lightly any unusual area without a logical explanation.

Another useful check is the inspection of the painting under as many light sources as possible. Often the color of a patch will match perfectly under incandescent illumination but will stand out when

viewed in sunlight or fluorescent light. Paint pigments are usually composed of a large number of different colors which reflect color back to the eye according to the light in which they are seen. Red, for example, will not seem as bright under fluorescent light as under incandescent since there is little red in the former illumination. In general, incandescent light is strong in the red wavelengths but weak in the blue parts of the spectrum, whereas fluorescent light has the reverse spectrum and is brightest in the blue components. Sunlight has a uniform spectrum over the visible range.

In addition to visible light, both sunlight and fluorescent light contain ultraviolet components consisting of short-wave radiation beyond the violet of visible light. Many pigments and binders in paint are fluorescent when irradiated by ultraviolet light, and this can greatly change the visible impact of a modern patch in a painting causing it to stand out from the surrounding areas. Fluorescence is the capacity of certain materials to absorb ultraviolet radiation which is not visible and then to transform this energy into light frequencies that the eye can see. Not all materials fluoresce when exposed to ultraviolet radiation, which is sometimes called black light. Some materials will not fluoresce when irradiated by long-wave ultraviolet, that which is closest to the visible light, but are activated by short-wave ultraviolet. Some materials also require long exposure to black light before there is any visible radiation.

Many collectors own ultraviolet lamps and make it a practice to examine all paintings under such light before they are bought. Such light sources are relatively inexpensive and come with short-wave bulbs or long-wave bulbs and some with both. Black light examination is now a standard technique and is extremely valuable. However, it must be strongly emphasized and clearly understood that what is seen requires interpretation and that the conclusions are not foolproof.

Usually, little interpretation is needed when examining an old unvarnished painting that has only one or two recent small touch-up spots. The examination is conducted in a dark room with the black light directed at the picture. The picture can generally be clearly seen as a result of mild fluorescence and some leakage of visible light from the ultraviolet bulbs. The few spots recently touched up will usually not fluoresce and will show up as dark spots. Touch-ups made many years ago, however, will show some fluorescence and with time will blend into the rest of the picture until only an expert can detect them. The old varnish on a painting usually fluoresces as a yellowish green. If the varnish is not too thick, repainted areas underneath are revealed as a

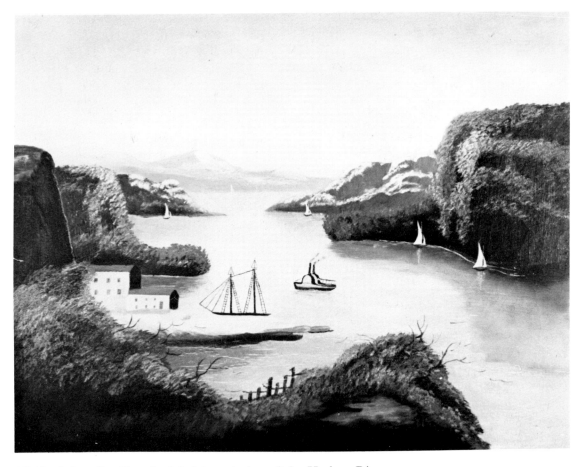

Highlands from Poughkeepsie. A bright painting of the Hudson River
copied by an amateur from a print. Dated 1886 but not signed. Oil on
canvas, 24″ x 32″.

dark purple tone, but old repainting under a thick and strongly fluores-
cent coat of varnish cannot be distinguished.

Unfortunately, those who engage in deception rise to meet the
challenge of current detection methods when the game is worth the prize.
Modern fluorescent materials and dyes are incorporated into touch-ups
or are used to cover them with a fluorescent film which the unwary
accept as good and solid proof of virginity. Most collectors should feel
safe when using the combination of visible and ultraviolet examination.
It is better, though, to obtain the paintings from a reliable, experienced,
and qualified source.

Detail of *Highlands from Poughkeepsie*, photographed using an incandescent electric light bulb as a source of light. The same detail is shown below, but photographed using ultraviolet light. Note the dark areas in the sky where paint was recently added to replace the old paint that had chipped off.

The weaknesses of paper as a support medium are many; some are well known but others are not. With proper restoration and conservation, however, a badly deteriorated folk painting can be made reasonably presentable and can continue to provide enjoyment for many more years.

Unfortunately, many of the causes of the deterioration of paper were imparted to the sheet at the time of manufacture. Paper is a felted sheet of vegetable fibers which for centuries was made from cotton or linen cloth macerated by soaking and beating. A screen was dipped into a slurry of this matter, scooping up a layer of matted fibers which when dry became a sheet of paper. A sizing of animal gelatin or some chemical was then applied to the surface in order to reduce the blotterlike absorbency of the crude sheet. Most papers were also hammered or rolled to harden and smooth the surface.

Very early papers were made using only natural materials, and these papers have lasted very well. As early as the mid-seventeenth century an "improvement" was made when alum (potassium aluminum sulfate) was added to the gelatin size as a preservative and hardener. Then about 1790 chlorine was used as a bleach so that off-white and colored rags could be used to make white paper. About 1850 an alum and resin size was substituted for the earlier gelatin size. In the 1860s wood pulp was introduced as a substitute for rags and the permanence of such papers is still being studied. Most of the chemicals that were added proved to be the seeds of destruction. In time they react and create sulfuric acid and other harmful by-products which yellow the paper and make it brittle and weak.

Even when the folk artists used high-quality papers, as many did, the paintings were exposed to a set of environmental hazards. Many were framed with a pine board as a backing. With time, the resins in the board, particularly at knots, leached through to the paper, staining the picture. If the painting hung during the gaslight and coal-burning era, the sulfur dioxide in the air became an acid of sulfur on the back of the painting between the backboards creating the yellow-brown streaks called board marks. If the painting hung in a light room, the sunlight almost certainly caused a permanent fading of the colors and weakening of the paper fibers. If the painting was stored in a dark area it may have fared no better since silverfish probably ate the sizing on the paper and some of the paint along with it. If the painting was stored in a damp location, mildew and foxing likely developed. If the painting was framed, condensation usually occurred inside the glass, leaving unsightly stains. If the painting was not framed, tears, creases, and surface abrasions were hazards.

Watercolor Paintings on Paper

Faced with the full range of problems the restorer has a formidable but usually not impossible task. Loose dirt is removed. If the paper is very yellow, water-stained, or foxed it can often be bleached using a chlorine gas chamber or similar process. If the paper is weak or badly torn, it can be mounted on a new piece of acid-free paper or mat board. Tears and insect holes can be repaired and the acid in the paper can be neutralized. The success of all these procedures depends upon the fragility of the colors and inks; with some the restorer has more latitude than with others.

The restoration of works of art on paper requires skill and experience and is best left to a professional paper restorer, a technician whose methods are quite different from those of the restorer of oil on canvas paintings. Even the removal of surface dirt must be carried out with caution. A wipe with a cloth can spread and embed grime so that it is very difficult to remove. Such dust can be removed with the shake bags of cleaning powder sold for use by draftsmen and architects. Pressure-sensitive tapes such as Scotch brand cellophane tape should never be used even for temporary repairs or for fastening to a mat or backboard. Such tapes can leave permanent, ugly stains.

Most delicate of all are pastels on paper. These are subject to a mold which feeds on the binder in the chalk stick. Such mold should be removed and the paper fumigated.

Care of Paintings

The best and safest way to frame a work of art on paper is in an acid-free mat with a similar backing which is then enclosed in a frame. The mat serves an important function in that it keeps the picture separated from the glass. The space reduces the chance of water staining if there is condensation inside the glass and also keeps the picture from adhering to the glass. The picture should never be mounted on cardboard for the sake of a smooth, flat appearance. The rippling and buckling of the paper is a result of expansion and contraction due to atmospheric changes and should be tolerated. When poor-quality board is used, it can have a devastating effect on the painting. Most collectors, however, object to the appearance of mats and feel they are not necessary in today's centrally heated homes. A compromise can be achieved by using a hidden space maker which acts as a mat but does not protrude above the inside edge of the frame. The back of the frame should be sealed to keep out dirt and insects. The picture should not be hung above a radiator or in another location where it is in the path of moving, dirt-

carrying, and heated air. The ultraviolet in sunlight and fluorescent light is very damaging, and direct and reflected light of this type should be avoided. A special plastic that filters out some of these harmful components is available. Pastels present a special problem and should never be framed with a plastic sheet instead of glass. The static electrical properties of plastic can attract particles of the pastel to the inside surface of the plastic.

As with a work of art on paper, an oil painting on canvas should be located away from heat vents and radiators. The frame should be well balanced and firmly attached to the wires and hooks that support it. These and the wall supports should be checked periodically. The stretchers should hold the canvas taut enough so that there is no sagging or wrinkling. Usually, there are keys in the back which can be adjusted. Little clumps of wire should not be tucked inside the stretcher for with time they will stretch the canvas and mar it. It is better to take the trouble to cut off the excess.

APPENDIX Selected List of American Folk Painters

BADGER, JOSEPH (1708–65), *Boston area*. Badger was the principal portrait painter in Boston after the deaths of Smibert, Pelham, and Feke. In his essentially primitive style he painted members of prominent Massachusetts families as well as people of lesser stations. By trade he was a house painter, glazier, and sign painter.

BADGER, S. F. M. (active 1890s), *Boston area*. Marine artist; painted ship portraits in the Boston area in the 1890s.

BARD, JAMES (1815–97), BARD, JOHN (1815–56), *New York City and Hudson River area*. Marine artists; these twin brothers worked in close collaboration until John died in 1856. James continued painting until about 1890. They are best known for portraits of the steamboats and small vessels in New York City harbor and on the Hudson River. Most paintings were large, in oil on canvas, but some were done in watercolor.

BARTOLL, WILLIAM THOMPSON (1817–59), *Marblehead, Massachusetts*. Portrait, landscape, house, and sign painter whose works include many portraits of local people.

BASCOM, RUTH HENSHAW (1772–1848 active ca. 1819–ca. 1837), *north central Massachusetts and lower New Hampshire*. The wife of a minister, Mrs. Bascom is known for her full-size or nearly full-size profiles on paper, colored with pastel crayons. On some she cut the profile and then pasted the portrait to a colored sheet. Rev. Bascom's pastorate changed several times during his service so, like an itinerant, Mrs. Bascom's portraits are found over a wide area.

BEARDSLEY LIMNER (active ca. 1785–ca. 1805), *from lower Connecticut to Boston along the Boston Post Road*. An unidentified artist named after portraits made by him of Hezekiah and Elizabeth Beardsley. Paintings attributed to him were mostly done in the New

205

Haven area but others are of sitters in Hartford, Worcester, Watertown, Boston, and other communities along the Boston Post Road.

BELKNAP, ZEDEKIAH (or ZEBAKIAH) (1781–1858, active 1810–ca. 1840), *throughout New England.* An 1807 graduate of Dartmouth College, Belknap became a prolific itinerant portrait artist. Although he often painted on canvas, he favored using wooden panels which he first scored with a rowel (a wheel with sharp points or spurs). This treatment produced a textured surface on the painting.

BLUNT, JOHN S. (1798–1835), *Portsmouth, New Hampshire, and probably Boston (ca. 1830).* Blunt, a landscape, marine, portrait, and miniature painter, was listed in the Portsmouth directory of 1821 as an ornamental and portrait painter. He exhibited at the Boston Athenaeum in 1829 and 1831.

BRADLEY, JOHN (active ca. 1832–ca. 1847), *New York City, Staten Island, and surrounding areas.* Bradley, listed as a portrait and miniature painter in the New York City directories, signed his work with the archaic *I.* for *J.* until he switched in 1836. Little is known about him. All paintings convincingly attributed to him are signed, and one is signed "I. Bradley from Great Britton."

BREWSTER, JOHN, JR. (1766–1854, active 1795–1832), *Connecticut, Maine, and Massachusetts.* After the painter-preacher the Rev. Joseph Stewart taught him to paint, Brewster, a deaf-mute from birth, was somehow able to function as an itinerant artist. His paintings include both the eighteenth-century full-length portrait style and later the smaller bust portraits more typical of the itinerant. Many of his paintings after about 1805 are signed on the stretcher.

BROWN, J. (active 1802–35), *Massachusetts.* Possibly several artists with this name. There was a J. Brown, a profilist in Salem in 1802; a watercolor portrait painter, also in Salem, in 1810; and a miniaturist at Lowell in 1835.

BROWN, URIAH (or URIEL) (active ca. 1803–08), *Salem, Massachusetts (1805), and New York City (1808).* An itinerant portrait and miniature painter who advertised in Salem in 1805. Listed as a portrait and miniature painter in the New York City directory of 1808.

BUNDY, HORACE (1814–83, active ca. 1837–ca. 1859), *Vermont, New Hampshire, and early in Boston.* Bundy painted landscapes, signs, sleighs, and oil portraits. Almost all of his portraits are signed in large script on the back, often with the sitter's name and the date. A high percentage of the portraits are in ovals, often with a bevel painted on the inner edge. Landscapes and other backgrounds were frequently used. His best portraits were painted in the 1840s, before he painted from daguerreotypes.

BUTTERSWORTH, JAMES E. (1817–94), *New York City.* Buttersworth, a marine, landscape, and portrait painter, was of English birth. He became one of the best-known painters of ship portraits after his emigration to America about 1850. Some of his paintings were lithographed by Currier and Ives.

CHAMBERS, THOMAS (1815–after 1866, active ca. 1833–ca. 1866), *New York City, Boston, and Albany.* Painting in a high primitive style, Chambers was one of the most creative and prolific landscape and marine painters of his era. Born in England, he came to America in 1832. He worked in New York City (1834–40), Boston (1843–51), Albany (1852–57), and again in New York (1858–66).

CHANDLER, JOSEPH GOODHUE (1813–84), *Massachusetts.* Chandler, an itinerant portrait painter, studied under William Collins of Albany, New York, from about 1827 to the early 1830s. His itinerant portrait period extended from about 1837 to about 1852,

when he moved to Boston where he stayed from 1852 to 1860. His wife was also a painter and a drawing teacher. Most of his portraits are in oil on canvas.

CHANDLER, WINTHROP (1747–90, active 1770–90), *in and around Woodstock, Connecticut, and Worcester, Massachusetts.* One of the few eighteenth-century American folk portraitists, Chandler worked in oils; his portraits were mostly of friends and relatives. His primary occupation apparently was house and sign painter. He also painted landscapes, mostly on overmantel panels and fireboards.

COATES, E. C. (active 1837–57), *New York City and Canada.* Landscape, marine, and historical painter who, like Chambers, worked after prints as well as originated his own compositions. Many of his landscapes were of Italian and New York State scenes. He also painted marine scenes with ships.

COFFIN, WILLIAM H. (active ca. 1837–ca. 1846 and later), *probably Massachusetts.* Marine artist working in oil and in watercolors.

CORNÈ, MICHELE FELICE (1752–1845), *Naples, Salem, Boston, and Newport.* Cornè, a marine, landscape, and portrait painter, was born on the island of Elba and worked as a port painter in Naples before coming to Salem in 1800. He was one of the first to practice ship portraiture in America. He worked in Salem until 1806, then in Boston from 1807 to 1822, and finally in Newport, 1822–45. His paintings of naval engagements during the War of 1812 were engraved by Abel Bowen and published in *The Naval Monument* in 1816.

CORNELL, JOHN V. (active ca. 1838–ca. 1849), *New York City area.* Principally a landscape and panorama painter, although he did some paintings of Hudson River steamers.

DAVIS, J. A. (active ca. 1838–54), *New Hampshire as well as Rhode Island and adjacent parts of Connecticut.* Painter of miniature watercolor portraits. Most are full face and bust length, often with a calligraphic script at the bottom of the picture identifying the sitter.

DAVIS, JOSEPH H. (active 1832–37), *southeastern New Hampshire and adjacent Maine.* Davis, a watercolor profilist, emphasized style and detail of clothes, painted furniture, and patterned floor covering. He carefully drew the profile in pencil and, presumably because he was left-handed, drew single portraits with the profile facing to the right. A decorative calligraphy on the paper below the picture gives the subject's name, age, and date. Few of his watercolors are signed. Little is known of his life.

DREW, CLEMENT (ca. 1808–ca. 1889, active ca. 1838–ca. 1886), *principally Boston area and Maine.* Marine artist, figurehead carver, publisher, photographer, and art dealer working in the Boston/Gloucester area from about 1838 until about 1886. He was a native of Kingston, Massachusetts, and was listed as a marine painter in Boston directories from 1838 to 1873. Artist and publisher of Bufford's lithograph *Missionary Packet Morning Star Passing Boston Light.*

DURAND, JOHN (active 1766–82), *New York City, Connecticut, and Virginia.* Durand, probably of French birth or parentage, was a portrait painter and drawing teacher in New York City about 1766. He also painted in Connecticut before going to Virginia in 1770; he was still painting there as late as 1782. There is no further record of his career after that date.

EARL, RALPH (1751–1801), *worked mostly in western Connecticut but also in New York City, Vermont, Massachusetts, and England.* Known chiefly for his portraits in oil, Earl is one of the few American artists who had academic training in England and yet produced work that fits comfortably with more naive artists. Born in Massachusetts, Loyalist Earl left America in 1778 for England where he

received some training from West and Reynolds. After he returned to America in 1785, he continued his career as a painter, helping to create a fashion for portraits in the more formal English style.

EASTMAN, EMILY (active 1820–30), *Loudon, New Hampshire.* Emily Eastman was a portrait painter in watercolor on paper typically twelve by sixteen inches. She worked in Loudon, New Hampshire. Her stylized portraits of women were probably copied from prints.

EATON, MOSES, JR. (1796–1886), EATON, MOSES, SR. (1753–1833), *New Hampshire, Massachusetts, and Maine.* Moses Eaton, Jr., was an itinerant wall painter and decorator using stencils like those seen in his kit in the Society for the Preservation of New England Antiquities in Boston. After his marriage, he settled down to farming in the township of Dublin, New Hampshire, in a section now known as Harrisville. It is believed that his father also stenciled walls.

ELLIS, A. (active ca. 1832), *Maine and New Hampshire.* Ellis painted oil portraits on panel; his sitters included some of the residents of Exeter, New Hampshire, which may have been his home.

ELLSWORTH, JAMES SANFORD (ca. 1802–ca. 1874, most active ca. 1835–ca. 1855), *Connecticut and western Massachusetts.* Ellsworth is best known for his distinctive half-length watercolor miniature portraits often showing the sitter in Victorian chairs which seem to wrap around the hips. A cloudlike formation is often painted behind the head and sometimes at the waist. His draftsmanship is meticulous. About one-half of these small portraits on paper are signed.

EVANS, J. (active 1827–34 and possibly ca. 1840–50), *Portsmouth, New Hampshire, and Boston.* Evans was a watercolor profilist who worked in a style reminiscent of the work of J. H. Davis.

EVANS, JAMES GUY (active ca. 1838–ca. 1860), *New Orleans.* Marine and historical painter whose works include ship portraits and battle scenes from the Mexican War.

FIELD, ERASTUS SALISBURY (1805–1900, portrait activity ca. 1828–42), *central Massachusetts and Connecticut.* Field is a highly regarded nineteenth-century folk painter whose distinctive portraits are often characterized by a formal, stiff pose, a light-colored cloud around the subject's head, elflike ears, and red knuckles. He was born in Massachusetts and in 1824, at the age of nineteen, studied painting in the New York studio of Samuel F. B. Morse. He then painted as an itinerant until 1842. His later paintings, after 1850, included patriotic and biblical subjects. The few later portraits were done in a different style that was heavily influenced by the daguerreotype.

FINCH, E. E. (active 1832–50), *Augusta, Maine, and surrounding area.* A portrait artist working in oils as well as pen and ink. He often signed and dated his work.

FISHER, JONATHAN (1768–1847), *Blue Hill, Maine.* A minister of the Congregational church in Blue Hill for forty-one years, Fisher also painted in oil and watercolor and made drawings and wood engravings. His paintings were mostly portraits, including a self-portrait, and scenes, some of which are views of Blue Hill.

FITCH, CAPTAIN SIMON (1758–1835), *Connecticut.* The work of this portrait painter from Connecticut was first noted in a 1939 WPA survey which listed oil portraits of Noah Cook and Jonathan Cook by Captain Fitch. Fitch's Christian name was first thought to be Beriah. He was a captain in the Connecticut militia. His occupation was given as portrait painter in the memoirs of Rev. Dan Huntington, his brother-in-law.

FREAKE LIMNER (ca. 1674), *Massachusetts.* Approximately seven oil portraits are attributed to this provincial artist working in colonial Massachusetts. It is speculated that he was a house and sign painter who painted in a style he remembered from his youth in England, ca. 1620. His most famous portraits, and the source of his identification, are of Elizabeth Clarke Freake and Baby Mary.

FROST, J. O. J. (1852–1928, active 1920–28), *Marblehead, Massachusetts.* Marine, historical, and genre painter of scenes and events related to Marblehead. A fisherman in early life, he later trained as a carpenter, then went into the restaurant business and later, restricted by poor health, raised flowers for sale to vacationers. He started painting in 1920 using mostly a poster-type paint on board and sold the paintings to help support himself. His style is extremely primitive and colorful.

GIBBS LIMNER (ca. 1675), *Massachusetts.* A portrait painter whose subjects include members of the Gibbs family. Like the Freake and Mason limners, this provincial artist derives his identification from the name of a family for whom he painted portraits.

GUY, FRANCIS (ca. 1760–1820), *Baltimore, Maryland (1800–1817); Brooklyn, New York (1817–20).* Guy came to the United States in 1795 from London, where he had been a silk dyer and calenderer. He settled in Baltimore about 1798 and then became a landscape painter about 1800. He specialized in portraits of gentlemen's estates. He moved to Brooklyn in 1817.

HAIDT, JOHN VALENTINE (1700–1780, active ca. 1745–ca. 1774), *mostly in Bethlehem, Pennsylvania.* Haidt, in the service of the Moravian church, painted religious subjects and portraits for the church. Born in Germany, he started as a goldsmith and began painting when he was about forty-five years old. He came to America in 1754 in a ship owned and operated by the Moravian church.

HAMBLEN, STURTEVANT J. (active 1837–56), *southern Maine and the Boston area.* Brother-in-law to Prior (see WILLIAM PRIOR), Hamblen painted portraits in the flat "Prior" style, first in Maine and after 1839 in Boston. Like Prior he painted in oil or gouache on canvas, academy board, or cardboard. His paintings are difficult to distinguish from Prior's as most are unsigned. He went into the men's furnishings business in 1856.

HATHAWAY, RUFUS (1770–1822), *vicinity of Taunton and Duxbury, Massachusetts.* Hathaway began his career painting full-size and miniature portraits at Taunton in 1791. He was skilled as a wood-carver and woodworker and is believed to have made the frames for his paintings. In 1795 he settled in Duxbury, where he became a physician after studying under Dr. Isaac Winslow of Marshfield, Massachusetts.

HAZARD, MARY (active 1839–50). Mary Hazard was a member of the New Lebanon, New York, Shaker community. While in the community she produced a number of "spirit drawings."

HICKS, EDWARD (1780–1849), *Newtown, Pennsylvania, and vicinity.* Hicks, a professional coach, sign, and ornamental painter, is best known for his one hundred or so versions of the *Peaceable Kingdom.* He also painted appealing views of farms and historical subjects, and he applied considerable talent to some of his signs. Reared in the Quaker household of the Twining family, Edward later became a Quaker preacher and played an active part in Quaker affairs. His pictures are among the most sought-after American folk paintings.

HIDLEY, JOSEPH H. (1830–72), *Poestenkill and Troy, New York, and vicinity.* Hidley is known best for townscape paintings showing the towns nestled in the geography of their sur-

roundings. At least one was reproduced as a lithograph. His early work is distinctly primitive, but his later paintings are more in the academic tradition. He is believed to have also been a cabinetmaker and taxidermist.

HOFMANN, CHARLES C. (1820–82, active 1865–81), *Pennsylvania.* Painted large landscapes, farm and almshouse portraits, mostly in oil on canvas or zinc. Came to the United States from Germany in 1860 and settled in Reading, Pennsylvania. He died a pauper in 1882.

HUGE, JURGAN FREDERICK (1809–78, active 1838–78), *Bridgeport, Connecticut, and New York City.* Watercolor artist and grocer who painted large marines including steamer portraits. Also painted commercial buildings in Bridgeport as well as a number of "residences." He was born in Germany and came to America in his youth.

JACOBSEN, ANTONIO N. G. (1850–1921), *mostly New York City and West Hoboken, New Jersey, area.* A marine artist, Jacobsen painted a large number of ship portraits over a long period of time. His work includes sailing vessels, sail and steam tugboats, coastal and excursion vessels, and finally ocean liners. Most of his paintings are signed.

JENNYS, RICHARD (active ca. 1783–ca. 1798), *Connecticut.* Richard Jennys's style is hard to distinguish from that of William Jennys. From their similar work and the same name it is assumed that the two are somehow related, although this is yet to be shown. Little is known of Richard's life. He painted portraits in Connecticut from about 1792 to 1798. Before that, in 1783, he is known to have advertised for commissions in the papers of Charleston, South Carolina.

JENNYS, WILLIAM (active ca. 1795–1807), *Connecticut, Massachusetts, Vermont, and New Hampshire.* Nothing is known of the life of William Jennys other than the fact that he

worked as an itinerant artist from about 1795 to 1807. His portraits are not in the flat style of many of his contemporaries. The sitter is shown as though illuminated by a brilliant point source of light that throws sharp shadows on the face. Most of his portraits are half-length studies painted in ovals on a rectangular canvas. Clothes are carefully detailed but hands are usually out of sight.

JOHNSTON (or JOHNSON), JOSHUA (active 1796–1824), *Baltimore, Maryland, and vicinity.* Joshua Johnston is one of the few black portrait painters recorded and is believed to be the first of his race to have practiced portrait painting in the United States. His style is similar to that of Charles Peale Polk, nephew of Charles Willson Peale, and for that reason there is speculation that Polk may have been his instructor. Johnston was listed as a limner for a number of years in the Baltimore City directory.

KANE, JOHN (1860–1934), *Pennsylvania.* Kane, a Pittsburgh steelworker, was a self-taught artist who produced strong, powerful pictures.

KEMMELMEYER, FREDERICK (active 1788–1805), *Baltimore, Maryland.* Painter of signs, portraits, miniatures, and paintings of historical and patriotic themes. Several versions are known of his *Washington Reviewing the Western Army at Fort Cumberland, Maryland.*

LANE, FITZ HUGH (1804–65), *Gloucester and Boston, Massachusetts, and Maine.* Lane, an important American marine artist and lithographer is only a guest member of the folk-painting fraternity. A cripple from childhood, he first worked as a lithographer with William S. Pendleton in Boston, ca. 1832, and was then employed by the Boston publishers Keith & Moore, 1837–45. In 1849 he returned to his native Gloucester to paint. He also made summer painting trips to Maine.

MAENTEL (or MÄNTEL), JACOB (1763–1863), active ca. 1810–25 and later), *vicinity of Philadelphia and New Harmony, Indiana.* Maentel, born in Germany, is best known for his distinctive full-length watercolor profile portraits of the Pennsylvania German country people. These pictures were meticulously executed on paper averaging ten by twelve inches in size. The profiles were outlined in ink and painted in watercolor. After 1825 Maentel began to use a less interesting full-face style. In 1830 he settled in New Harmony, Indiana, where he died in 1863.

MARSH, WILLIAM (ca. 1810–ca. 1860), *Boston, Massachusetts.* Marsh worked during the first half of the nineteenth century in oil, pastel, and watercolor, mainly around Boston. He was one of the few in this country to carry on the Mediterranean artists' manner of ship portraiture. His backgrounds frequently include Fort Independence or Boston Light.

MARK, GEORGE WASHINGTON (?–1879), *Greenfield, Massachusetts.* Mark was a portrait, landscape, historical, and mural painter as well as a furniture decorator and probably a sign painter. Some works were painted for his exhibition gallery to which he charged an admission fee.

MASON LIMNER (ca. 1675), *Massachusetts.* Like the Freake and Gibbs limners, this provincial artist derives his identification from the Mason family whose portraits he painted.

MOORE, JACOB BAILEY (1815–93), *New Hampshire.* Moore was born in Candia, New Hampshire. At fifteen he left home for the Boston area where he worked mostly as a clerk. About 1846 he returned to New Hampshire and settled in Manchester, where he worked principally as an artist until about 1860 when he became a newspaper editor. His portraits were done in the flat Prior style.

MOSES, ANNA MARIA ROBERTSON (GRANDMA) (1860–1961). The nostalgic and sentimental genre pictures painted by Grandma Moses, with figures scattered throughout the composition, are well known to almost everyone. She started painting late in life and continued until shortly before her death in 1961.

MOULTHROP, REUBEN (1763–1814, active ca. 1788–ca. 1812), *in and around New Haven, Connecticut.* Moulthrop's portraits in oil were done in various styles as if he copied the styles of others but never developed his own. This inconsistency makes difficult and controversial the attribution of his largely unsigned works. By trade he was a wax modeler and proprietor of a waxworks museum and traveling waxworks exhibition.

PARSONS, CHARLES (1821–1910), *New York City.* Parsons worked as a lithographer for Endicott and Company and also did many ship portraits for Currier and Ives. He was also a marine and landscape painter in watercolor.

PATROON PAINTERS (ca. 1715–ca. 1730), *in areas along the Hudson River.* A name given by James Flexner in his book *First Flowers of Our Wilderness* to a group of a half-dozen or so artists who painted for the powerful Dutch families in New York. Styles represented in this group include the De Peyster Manner and the styles of the Schuyler and Gansevoort limners.

PECK, SHELDON (1797–1868), *Vermont and Illinois.* Peck is believed to have been a native New Englander where as early as 1824 he is known to have painted oil portraits in Vermont. In the 1830s he moved to Illinois, settling in the small town of Lombard close to Chicago. There in the 1830s and 1840s he painted a series of double portraits in room settings. In these, done in his best-

known portrait style, the front edge is sometimes shown in cross section as if the room had been cut off with a saw leaving the sitters on a theater stage setting.

PENNIMAN, JOHN RITTO (1783–ca. 1830), *Roxbury and Boston, Massachusetts.* Penniman, chiefly noted as an ornamental painter, especially for the Seymour cabinetmakers, also worked as a "dial painter" for the Willard clockmakers and as a portraitist and landscapist.

PHILLIPS, AMMI (1788–1865, active 1811–65), *western parts of Massachusetts and Connecticut and adjacent areas in New York.* One of the principal itinerant portrait painters, Phillips is estimated to have completed over one thousand portraits in oil on canvas during his career. His style changed radically from his early "Border Limner" period to the later and more sophisticated "Kent" style. During his career he moved his family to different areas of New York, Connecticut, and Massachusetts.

PINNEY, EUNICE (1770–1849, active 1809–26), *Windsor and Simsbury, Connecticut.* Pinney, née Griswold, was a watercolorist whose fifty-four recorded works include genre scenes, landscapes, buildings, memorials, and allegorical, religious, historical, and literary scenes.

PIPPIN, HORACE (1888–1946). Horace Pippin, a black painter of West Chester, Pennsylvania, specialized in pictures depicting black family life and history.

PORTER, RUFUS (1792–1884, active ca. 1816–ca. 1845), *New England and as far south as Virginia.* Porter is best known as a mural painter who worked throughout New England, although early in his career he also painted landscapes, miniature watercolor portraits, and cut silhouettes. After about 1845 he gave up painting to edit the publication *Scientific American.* Porter trained a number of assistants in mural painting, including his son, Stephen; his nephew, Jonathan D. Poor; Orison Wood; E. J. Gilbert; ? Paine; E. V. Bennett; and ? Swift. Some of these men then painted on their own.

POWERS, ASAHEL LYNDE (1813–43, active 1831–40), *around Springfield, Vermont, and northeastern New York State.* An itinerant portrait artist, Powers's early works, full of anatomical distortion, are in oils, often on wood panels. His later paintings with little distortion are in a more academic style. A majority of his works are signed, but to date no signed portraits have been reported for the period after he moved to Olney, Illinois, in the early 1840s.

PRIOR, WILLIAM MATTHEW (1806–73), *southern Maine, eastern Massachusetts, Rhode Island, and Baltimore, Maryland.* Prior was born in Maine, where he first advertised a "flat likeness" at "quarter price." He moved to Boston in 1839 and continued painting portraits either in the flat or the academic style. Prior made forays to other areas including Rhode Island and Baltimore. His portraits are oil or gouache on canvas, academy board, or cardboard. He also painted large numbers of landscapes, usually imaginary, and did reverse paintings on glass, the most successful being a copy of Stuart's *George Washington.* His brother-in-law, Sturtevant J. Hamblen, as well as Jacob Bailey Moore, George G. Hartwell, and G. Alden, also painted in a style similar to his flat renditions.

RALEIGH, CHARLES SIDNEY (1830–1925), *New Bedford, Massachusetts, area.* A marine painter, Raleigh painted ship portraits including some of whaling ships.

ROPES, GEORGE (1788–1819), *Salem, Massachusetts.* Ropes, a marine, landscape, carriage, and sign painter, studied painting under Michele Felice Cornè about 1802. He was deaf and dumb from birth.

RUSSELL, MOSES B. (ca. 1810–1884), *Boston (1834–50), New York City (late 1850s), and Philadelphia (ca. 1860)*. Russell, a portrait, miniature, and figure painter, was born in either New Hampshire or Massachusetts. His wife, Clarissa (ca. 1810–?), was also an artist who specialized in miniatures. Both exhibited at the Boston Athenaeum. Their son, Albert Cuyp Russell, became an engraver and illustrator.

SALMON, ROBERT (ca. 1775–ca. 1842), *England, Greenock (Scotland), and Boston*. Salmon, an important marine painter, is only a guest member of the folk-painting fraternity, since many consider him to belong in the academic ranks. He is of Scottish descent, if not birth, and worked in England and Scotland before emigrating to America in 1828. He worked as a marine and ship painter in Boston until 1842.

SEIFERT, PAUL A. (1840–1921, active ca. 1870–1915), *Wisconsin*. He is known for his large watercolor paintings of Wisconsin farms. Born in Germany, Seifert came to America in 1867 and earned a living raising flowers, fruits, and vegetables for sale; he later became a taxidermist and a painter on glass.

SHEFFIELD, ISAAC (1798–1845), *mostly in and around New London, Connecticut*. Sheffield specialized in full-size and miniature portraits of sea captains and whaling families. His full-size works in oil were painted on either canvas or wood. A native of Guilford, Connecticut, he settled in New London about 1833 and worked there until his death in 1845.

SHUTE, R. W. and S. A. (active 1830–40), *Massachusetts, New Hampshire, and Vermont*. The Shutes, possibly husband and wife, painted many portraits in both oil and watercolor, mostly posed with a full or almost full face. The watercolor portraits are on large sheets of paper averaging eighteen by twenty-two inches. The oils are usually standard por-trait size on canvas. Many of the portraits were signed on the reverse using a variety of signatures including:

Mrs. R. W. Shute
S. A. and R. W. Shute
Drawn by R. W. Shute—
painted by S. A. Shute

SMITH, JOSEPH B. (1798–1876), SMITH, WILLIAM S. (1821–?), *New York City (Brooklyn)*. Father-and-son partnership important as marine painters although they also did other work. Some of their ship portraits were published by Currier and Ives.

STEWARD, JOSEPH (1753–1822, active 1791–1815), *Connecticut*. The Reverend Steward was a portrait painter and a silhouettist. Ill health forced him to give up preaching, and in 1796 he opened a portrait studio in Hartford and in 1797 a museum in the State House. John Brewster, Jr., was one of his pupils.

STOCK, JOSEPH WHITING (1815–55, active 1832–55), *mainly Springfield, Massachusetts, but also New Haven, New Bedford, Warren, Bristol, and Providence*. Stock is best known for his large, full-length oil portraits of children. Born in Springfield, Massachusetts, he was seriously injured when he was eleven years old and confined to a wheelchair for the rest of his life. In spite of this disability, he was very active as shown by his diary or journal which lists the completion of 938 paintings in the fourteen-year period from 1832 to 1846.

STUBBS, WILLIAM PIERCE (1842–1909), *Boston area and Maine*. Stubbs, principally a marine painter, is best known for his numerous signed ship portraits. Some were executed in good detail but others were done more crudely, probably in response to the amount of the fee. He was born in Bucksport, Maine, and worked in Maine and the Boston area.

THRESHER (or THRASHER), GEORGE (active 1806–12), *New York City and Philadelphia.* Marine artist and art teacher, active in New York City 1806–12. About 1812 he moved to Philadelphia, where he opened a school.

VOGT, FRITZ G. (active 1890–1900), *Albany, New York.* Vogt specialized in house and building portraits, primarily drawn with crayon and pencil on paper. Most were signed and inscribed with details concerning the house and owners.

WALTON, HENRY (?–1865), *upper New York State around Ithaca and Elmira (1835–51), Pennsylvania (1851), San Francisco (1857).* Walton was a lithographer and painter of town views in New York State around Elmira and Ithaca. Concurrently, he painted some portraits in oil but more commonly small ones in watercolor. He journeyed to California in 1851 where he painted at least one portrait and a view of Grass Valley in 1857. He went to Michigan the same year and died there in 1865.

WEST, BENJAMIN FRANKLIN (1818–54), *Salem, Massachusetts.* West was a ship portrait and marine painter working in Salem.

WILLIAMS, MICAH (1782–1837, active ca. 1815–ca. 1832), *New Brunswick, Freehold, Matawan, and nearby towns in New Jersey, also possibly New York City (1829–32).* Williams was a pastel portraitist, although at least one signed oil portrait is known. Most of his pastels are on large sheets of paper averaging twenty-four by twenty inches. He usually lined his work with sheets of newspaper. Many of his sitters were of Dutch origin.

WILLSON, MARY ANN (active ca. 1810–ca. 1825), *Greenville, New York.* An artist and farmer who lived in a log cabin and worked a farm with a Miss Brundage. She sold her watercolor paintings depicting a wide range of subjects. They are greatly distorted in perspective and scale.

WOOD, ORISON (1811–42, active ca. 1830), *Auburn, Lewiston, and Lisbon, Maine, and vicinity.* A pupil of Rufus Porter, Wood was a wall painter, decorator, and schoolteacher. Some of his murals are extant.

YOUNG, H. (active 1820–38), *Centre and Union counties, Pennsylvania.* Made birth certificates executed in watercolor and ink on paper. One of his compositions of two full-length profile figures facing each other with a tripod table between them was also utilized by the Reverend Young (active 1845–50), who is believed to have been the son of H. Young.

SELECTED BIBLIOGRAPHY

Andrews, Edward Deming, and Andrews, Faith. *Visions of the Heavenly Sphere.* Charlottes-
ville: Published for the Henry du Pont Winterthur Museum by the University
of Virginia Press, 1969.

Backlin-Landman, Hedy. "The Art Museum, Princeton University." *Antiques* 92, no.
5 (November 1967), pp. 670–79.

Black, Mary, and Lipman, Jean. *American Folk Painting.* New York: Clarkson N. Potter,
1966.

Black, Mary Childs, and Feld, Stuart P. "Drawn by I. Bradley from Great Britton."
Antiques 90, no. 4 (October 1966), pp. 502–9.

Brett, K. B. "Bouquets and Flower Arrangements in Textiles." *Antiques* 67, no. 4 (April
1955), pp. 307–11.

Brewington, M. V., and Brewington, Dorothy. *Marine Paintings and Drawings in the Peabody
Museum.* Salem, Mass.: Peabody Museum, 1968.

Bye, Arthur Edwin. "Edward Hicks." In *Primitive Painters in America, 1750–1950,* edited
by Alice Winchester and Jean Lipman, pp. 39–49. New York: Dodd, Mead, 1950.

Candee, Richard M. "The Early New England Textile Village in Art." *Antiques* 98, no.
6 (December 1970), pp. 910–15.

Childs, Charles D. "The Eighteenth-Century Portrait Painter and His Public." *Antiques*
53, no. 1 (January 1948), pp. 49–51.

Cortelyou, Irwin F. "Henry Conover: Sitter, Not Artist." *Antiques* 66, no. 6 (December
1954), p. 481.

———. "Micah Williams, Pastellist." *Antiques* 78, no. 5 (November 1960), pp. 459–61.

———. "A Mysterious Pastellist Identified." *Antiques* 66, no. 2 (August 1954), pp. 122–24.

———. "Notes on Micah Williams, Native of New Jersey." *Antiques* 74, no. 6 (December
1958), pp. 540–41.

Crossman, Carl L. *The China Trade.* Princeton: The Pyne Press, 1972.

Dean, Henry. *Dean's Universal Penman.* New York: Geo. F. Hopkins, 1808.

Dods, Agnes M. "Ruth Henshaw Bascom." In *Primitive Painters in America, 1750–1950,*
edited by Alice Winchester and Jean Lipman. New York: Dodd, Mead, 1950.

Dolloff, Francis W., and Perkinson, Roy L. *How to Care for Works of Art on Paper.* Boston: Museum of Fine Arts, 1971.

Drepperd, Carl W. "American Drawing Books." *Bulletin of the New York Public Library* 49, no. 11 (November 1945), pp. 795–811.

Dunlap, William. *History of the Rise and Progress of the Arts of Design in the United States,* 2 vols., edited by Rita Weiss. New York: Dover, 1969; reprint of 1834 edition.

Evans, Nancy Goyne. "Documented *Fraktur* in the Winterthur Collection, Part I." *Antiques* 103, no. 2 (February 1973), pp. 307–18; "Part II." *Antiques* 103, no. 3 (March 1973), pp. 539–49.

Feld, Stuart P. "The Tradition of the Primitive Imagination—Denied." *Antiques* 83, no. 1 (January 1963), pp. 99–101.

Finn, Matthew D. *Theoremetical System of Painting.* New York: James Ryan, 1830.

Flexner, James Thomas. *First Flowers of Our Wilderness.* New York: Dover, 1969; reprint of 1947 edition.

Force, Albert W. "H. Walton—Limner, Lithographer, and Map Maker." *Antiques* 82, no. 3 (September 1962), pp. 284–87.

Gardner, Albert Ten Eyck, and Feld, Stuart P. *American Paintings: A Catalogue of the Collection of the Metropolitan Museum of Art.* New York: The Metropolitan Museum of Art, 1965.

Gerdts, William H., and Burke, Russell. *American Still-Life Painting.* New York: Praeger, 1971.

Giffen, Jane C. "Susanna Rowson and Her Academy." *Antiques* 98, no. 3 (September 1970), pp. 436–40.

Goldsmith, Oliver B. *Gems of Penmanship.* New York: Published by the author, 1835.

Green, Samuel M., II. "Some Afterthoughts on the Moulthrop Exhibition." *The Connecticut Historical Society Bulletin* 22, no. 2 (April 1957), pp. 33–45.

Groce, George C., and Wallace, David H. *The New-York Historical Society's Dictionary of Artists in America.* New Haven and London: Yale University Press, 1957.

Halpert, Edith Gregor. "In Memoriam." *Art in America* 42, no. 2 (1964), pp. 135–38, 158–62.

Holdridge, Barbara, and Holdridge, Lawrence B. "Ammi Phillips, 1788–1865." *Connecticut Historical Society Bulletin* 30, no. 4 (October 1965), pp. 97–145.

[Huge, J. F.]. "When Bridgeport Was Beautiful: A Portfolio of Paintings by J. F. Huge." *American Heritage* 25, no. 4 (June 1974), pp. 16–31.

Jensen, Oliver. "Side-Wheels and Walking Beams." *American Heritage* 12, no. 4 (August 1961), pp. 40–49.

[Karolik]. *M. and M. Karolik Collection of American Paintings, 1815–1865,* 2 vols. Cambridge, Mass.: Harvard University Press, 1949.

[Karolik]. *M. and M. Karolik Collection of American Water Colors and Drawings, 1800–75,* 2 vols. Boston: Museum of Fine Arts, 1962.

Karr, Louise. "Paintings on Velvet." *Antiques* 20, no. 3 (September 1931), pp. 160–65.

Kauffman, Henry J. *Pennsylvania Dutch American Folk Art.* New York: Dover, 1964. Reissue of 1946 work.

Keck, Caroline K. *How to Take Care of Your Pictures.* New York: The Brooklyn Museum, The Brooklyn Institute of Arts and Sciences, 1954.

Kelly, Francis. *Art Restoration.* New York: McGraw-Hill, 1972.

Lichten, Frances. *Folk Art of Rural Pennsylvania.* New York: Charles Scribner's Sons, 1946.

Lipman, Jean. "Joseph H. Hidley." In *Primitive Painters in America, 1750–1950,* edited by Alice Winchester and Jean Lipman. New York: Dodd, Mead, 1950.

Lipman, Jean. *Rufus Porter, Yankee Pioneer.* New York: Clarkson N. Potter, 1968.

Little, Nina Fletcher. *The Abby Aldrich Rockefeller Folk Art Collection.* Colonial Williamsburg, 1957.

———. "Asahel Powers, Painter of Vermont Faces." *Antiques* 104, no. 5 (November 1973), pp. 846–53.

———. "John Brewster, Jr., 1766–1854." *Connecticut Historical Society Bulletin* 25, no. 4 (October 1960), pp. 97–129.

———. "Primitive Painters of the Eighteenth Century." In *Primitive Painters in America, 1750–1959,* edited by Alice Winchester and Jean Lipman. New York: Dodd, Mead, 1950.

———. "William Matthew Prior." In *Primitive Painters in America, 1750–1959,* edited by Alice Winchester and Jean Lipman. New York: Dodd, Mead, 1950.

———. "William M. Prior, Traveling Artist, and His In-Laws, the Painting Hamblens." *Antiques* 53, no. 1 (January 1948), pp. 44–48.

Lyman, Grace Adams. "William M. Prior, the Painting Garret Artist." *Antiques* 26, no. 5 (November 1934), p. 180.

Meissonnier, Jean. "A Dynasty of Marine Painters: The Roux Family of Marseilles." *Antiques* 86, no. 5 (November 1964), pp. 583–87.

———. "Ship Painters of the Mediterranean." *Antiques* 83, no. 3 (March 1963), pp. 304–8.

Nash, Ray. *American Penmanship, 1800–1850: A History of Writing and a Bibliography of Copybooks from Jenkins to Spencer.* Worcester: American Antiquarian Society, 1969.

Nesbitt, Alexander. "Calligraphy." In *The Concise Encyclopedia of American Antiques,* edited by Helen Comstock, pp. 793–95. New York: Hawthorn Books, 1965.

Pleasants, J. Hall. "Francis Guy—Painter of Gentlemen's Estates." *Antiques* 65, no. 4 (April 1954), pp. 288–90.

Plenderleith, H. J., and Werner, A. E. A. *The Conservation of Antiquities and Works of Art.* London: Oxford University Press, 1971.

Real Pen Work. Pittsfield, Mass.: Knowles & Maxim, 1881.

Rehner, Leigh. "Henry Walton, American Artist." *Antiques* 97, no. 3 (March 1970), pp. 414–17.

Ring, Betty. "Memorial Embroideries by American Schoolgirls." *Antiques* 100, no. 4 (October 1971), pp. 570–75.

Robinson, Frederick B. "The Eighth Wonder of Erastus Field." *American Heritage* 14, no. 2 (April 1963), pp. 12–17.

Rumford, Beatrix. "Nonacademic English Painting." *Antiques* 105, no. 2 (February 1974), pp. 366–75.

Rumford, Beatrix T. "Memorial Watercolors." *Antiques* 104, no. 4 (October 1973), pp. 688–95.

Savage, Norbert, and Savage, Gail. "J. A. Davis." *Antiques* 104, no. 5 (November 1973), pp. 872–75.

Schwartz, Esther. "Notes from a New Jersey Collector." *Antiques* 74, no. 4 (October 1958), pp. 329–33.

Sears, Clara Endicott. *Some American Primitives.* Boston: Houghton Mifflin, 1941.

Shaffer, Ellen. "Fraktur: The Colorful Art of the Pennsylvania Germans." *Antiques* 95, no. 4 (April 1969), pp. 550–55.

Shelley, Donald A. *The Fraktur-Writings or Illuminated Manuscripts of the Pennsylvania Germans.* Allentown, Pa.: Pennsylvania German Folklore Society, 1961.

Shepard, Hortense O. "Pilgrim's Progress: Horace Bundy and His Paintings." *Antiques* 86, no. 4 (October 1964), pp. 445–49.

Sherman, Frederick Fairchild. "James Sanford Ellsworth." In *Primitive Painters in America, 1750–1950,* edited by Alice Winchester and Jean Lipman. New York: Dodd, Mead, 1950.

Sniffen, Harold S. "James and John Bard." In *Primitive Painters in America, 1750–1950,* edited by Alice Winchester and Jean Lipman. New York: Dodd, Mead, 1950.

——. "Marine Paintings and Prints." In *The Concise Encyclopedia of American Antiques,* edited by Helen Comstock, pp. 699–745. New York: Hawthorn Books, 1965.

Stoudt, John Joseph. *Early Pennsylvania Arts and Crafts.* South Brunswick, N.J.: A. S. Barnes, 1964.

Thomas, Ralph W. "Reuben Moulthrop, 1763–1814." *Connecticut Historical Society Bulletin* 21, no. 4 (October 1956), pp. 97–111.

Turner, Maria. *The Young Ladies' Assistant in Drawing and Painting.* Cincinnati: Corey and Fairbank, 1833.

Warren, William Lamson. "Ammi Phillips: A Critique." *Connecticut Historical Society Bulletin* 31, no. 1 (January 1966), pp. 1–18.

——. "Captain Simon Fitch of Lebanon, 1758–1835, Portrait Painter." *Connecticut Historical Society Bulletin* 26, no. 4 (October 1961), pp. 97–129.

——. "A Checklist of Jennys Portraits." *Connecticut Historical Society Bulletin* 21, no. 2 (April 1956), pp. 33–64.

——. "The Jennys Portraits." *Connecticut Historical Society Bulletin* 20, no. 4 (October 1955), pp. 97–128.

——. "John Brewster, Jr.: A Critique." *Connecticut Historical Society Bulletin* 26, no. 2 (April 1961), pp. 45–48.

Waring, Janet. *Early American Stencils on Walls and Furniture.* New York: Dover, 1968; reprint of 1937 publication.

Wilmerding, John. *A History of American Marine Painting.* Boston: The Peabody Museum of Salem and Little, Brown and Company, 1968.

[Balken]. *American Folk Art: A Collection of Paintings Presented in 1958 by Edward Duff Balken of the Class of 1897 to the Art Museum, Princeton University.*

[Calligraphy]. *Calligraphy and Handwriting in America, 1710–1962.* Peabody Institute of Baltimore, Maryland, November 1961–January 1962. Compiled by P. W. Filby. Caledonia, N.Y.: Italimuse, Inc., 1963.

[Cornè]. *Michele Felice Cornè.* Summer Exhibition. Salem: The Peabody Museum, 1972.

[Ellsworth]. Mitchell, Lucy B. *James S. Ellsworth, Portrait Painter.* Williamsburg: The Colonial Williamsburg Foundation, 1974.

[Garbisch]. *101 American Primitive Watercolors and Pastels from the Collection of Edgar William and Bernice Chrysler Garbisch.* Washington: National Gallery of Art, n.d.

[———]. *101 Masterpieces of American Primitive Painting from the Collection of Edgar William and Bernice Chrysler Garbisch.* New York: American Federation of the Arts, 1961.

[Haidt]. Nelson, Vernon. *John Valentine Haidt.* Williamsburg: The Abby Aldrich Rockefeller Folk Art Collection, 1966.

[Hemphill]. *The Herbert Waide Hemphill, Jr., Collection of 18th, 19th, and 20th Century American Folk Art.* Heritage Plantation of Sandwich and Columbus Museum of Arts and Crafts, 1974.

[Little]. *Land and Seascape as Observed by the Folk Artist.* Williamsburg: The Abby Aldrich Rockefeller Folk Art Collection, 1969.

[Marine]. *American Ship Portraits and Marine Paintings.* Syracuse, N.Y.: Everson Museum of Art, Syracuse, 1970.

[Pennsylvania]. *Pennsylvania Folk Art.* Allentown: Allentown Art Museum, 1974.

[Phillips]. Holdridge, Barbara B., and Holdridge, Lawrence B. *Ammi Phillips: Portrait Painter, 1788–1865.* New York: Clarkson N. Potter, 1968.

[Rockefeller]. *Folk Art in America: A Living Tradition.* Atlanta: The High Museum of Art, 1974.

[Sales]. Sotheby-Parke Bernet, Inc., New York.
The Edith Gregor Halpert Folk Art Collection, Sale no. 3572, November 1973.
Important Frakturs, Embroidered Pictures, Theorem Paintings, Cutwork Pictures and Other American Folk Art from the Collection of Edgar William and Bernice Chrysler Garbisch. Part I, Sale no. 3595, January 1974; Part II, Sale no. 3637, May 1974; Part III, Sale no. 3692, November 1974.

[Shaker]. *The Gift of Inspiration: Religious Art of the Shakers.* Hancock Shaker Village, 1970.

[Tillou]. *Nineteenth-Century Folk Painting: Our Spirited National Heritage.* Storrs, Conn.: University of Connecticut, William Benton Museum of Art, 1973.

[Watercolor]. Savage, Gail; Savage, Norbert H.; and Sparks, Esther. *Three New England Watercolor Painters.* Chicago: The Art Institute, 1974.

[Whitney]. Lipman, Jean, and Winchester, Alice. *The Flowering of American Folk Art, 1776–1876.* New York: The Viking Press, 1974.

Exhibition Catalogues

Index

Page numbers in boldface refer to illustrations.